COLOR

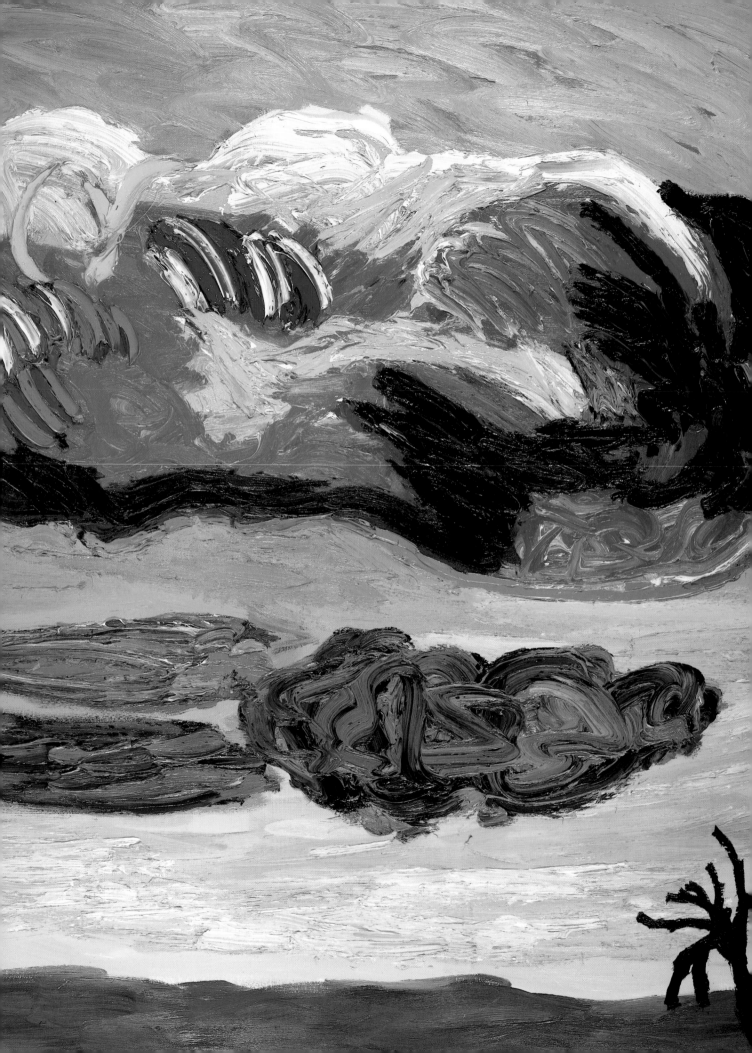

COLOR

SECOND EDITION

Paul Zelanski and Mary Pat Fisher

Prentice Hall, Englewood Cliffs, NJ 07632

To Josef Albers

and his students

and the students of his students

ISBN 0–13–310715–9

This book was designed and produced by
CALMANN AND KING LTD, LONDON
A CALMANN AND KING BOOK

Layout by Andrew Shoolbred
Typeset by Harrington's
Printed in Singapore by Toppan Ltd

Frontispiece: Karel Appel *Sky with Clouds*, 1984
Oil on canvas. Annina Nosei Gallery, New York.

Front cover: Robert Delaunay, *Windows Open Simulta-
neously (First Part, Third Motif)*, 1912. Oil on canvas, 18
x 14³/₄ ins (45.7 x 37.5 cm). Tate Gallery, London.

Back cover: Ndebele house, South Africa. (Photogra-
pher: M. Courtney-Clarke.)

Contents

Preface

Color is addressed to artists and art students in all media, in both fine and applied arts. It provides an informative but non-dogmatic introduction to the many different approaches to understanding color, including aesthetics, science, psychology, and history. Illustrations for the chapters on color concepts are taken from all media. Special aesthetic and practical considerations for color usage in each medium—such as ways that graphic designers use and specify printers' inks—are also discussed in chapters on applied art. The realities of color use are accentuated by direct quotes from working artists. Technical terms are carefully defined in the text and also in a glossary. Those appearing in the glossary are printed in small capitals when first used in the text.

True familiarity with the potentials of color requires first-hand experience and experimentation. For lab courses a special instructors' manual of studio problems with papers, paints, computers, and colored lights is available. Those honoring the experiential teaching methods of the great colorist Josef Albers might like to begin with the first two chapters to develop a general orientation and a basic vocabulary before launching into studio work, and continue with the more theoretical and practical material introduced later in the book once students have made some discoveries on their own. Professor Zelanski is a former student of Albers and has found this method highly successful in thirty-seven years of teaching.

Special Features of the Second Edition

This second edition of *Color* reflects the tremendous increase of color choices in the studio and the marketplace. There are now millions of colors available through computer graphics, more than the human eye can even distinguish. The section on computer graphics has therefore been updated and expanded, with description of sophisticated color printing technologies in common use. Photographic reproduction is also now accessible to limitless computerized alterations. Color photocopy was not commercially available when the first edition was written, but now the ready availability of this technology offers new directions for color manipulation. Color choices in such crafts fields as ceramics and glass are also mushrooming as they cross the soft boundary between fine and applied arts.

In addition, aesthetic tastes in color use are also expanding. This second edition of *Color* therefore illustrates and discusses works of outsider art, naive art, and art from non-industrial cultures. Color psychology is increasingly important in industrial design, from beverages to backpacks. All these new possibilities are brought out in this revised edition, to further engage students in the excitement of contemporary as well as historical uses of color.

Acknowledgments

Among the many artists in various media with whom we have worked in preparation of this book, we would like to pay a special tribute to the late Arthur Hoener. His pioneering work in optical color mixtures is still ahead of its time. In addition to those artists quoted in the first edition, we are pleased to be able to share the words of painter Deborah Muirhead and computer artists Douglas Kirkland and David Em. In developing computer graphics skills and curricula, Professor Zelanski has found great value in the seminars and training programs offered by professional computer organizations such as Sigraph.

In addition to those professors who reviewed the first edition and offered suggestions, the second edition has benefited from the comments of the following reviewers: Marilyn Hamman, University of Kentucky; James D. Howze, Texas Tech University; Cynthia Kukla, Southern Illinois University; Richard Roth, Ohio State University; Dennis Will, Drexel University; and Michael Youngblood, Southern Illinois University.

At Calmann and King, Damian Thompson has capably and enthusiastically served as editor for this edition, and photo researchers Jill-Ann and Mirco de Cet have helped in tracking down the new images for reproduction. Our dear friend Laurence King, Managing Director of Calmann and King, continues to be supportive and helpful. Norwell F. Therien, our American editor at Prentice Hall, has firm conviction of the value of this book in helping students understand and make full use of the complexities of color.

Now more than ever, with the second author living in India at Gobind Sadan, Annette Zelanski has been of invaluable help in preparing the manuscript and illustration program. We owe her a very special debt of gratitude.

Paul Zelanski
Mary Pat Fisher
April 1994

Why Study Color ?

Color is perhaps the most powerful tool at the artist's disposal. It affects our emotions beyond thought and can convey any mood, from delight to despair. It can be subtle or dramatic, capture attention or stimulate desire. Used more boldly and freely today than ever before, color bathes our vision with an infinite variety of sensations, from clear, brilliant hues to subtle, elusive mixtures. Color is the province of all artists, from painters and potters to landscape and product designers.

Because the possibilities of color are ceaseless, the art of using color well is an open-ended, complex discipline which incorporates many different points of view and poses many questions. Scientists have tried for centuries to understand what creates colors in our world, and how we see them; yet we still have no absolute answers to these questions. Theories put forth by those studying the physics of light and the anatomy and physiology of vision still lie in the realm of hypothesis. Color theorists have

▼ **1.1 Jules Olitski,** *Twice Disarmed,* **1968** Acrylic on canvas, 9ft 10ins x 16ft (2.9 x 4.8m). Metropolitan Museum of Art, New York.
What is Olitski doing with color here? How? What colors does he create? How do you see them? How do they affect you?

tried to condense the infinite number of visible color variations into a few basic colors and to form theories about their relationship. But no one color theory has been generally adopted as satisfactorily explaining all color phenomena. Psychologists are studying the impact of various colors on our emotions and health, but they find that individuals tend to differ in their responses. Art historians analyze the different ways in which color has been used in different times and places. Those interested in design try to discern how colors affect compositional factors, such as unity, emphasis, balance, contrast, and spatial awareness. Other specialists offer suggestions and attempts at standardization in the realms of mixing colors with lights and pigments, for there is a special science of color creation for each discipline.

To tap into the tremendous potential of color, artists must explore all of these intellectual approaches. The answers they will find, however, are only partial. Each separate way of looking at color is as incomplete as the proverbial blind men who seize different parts of an elephant and try to describe the whole creature based on the piece they are holding: "It's a leathery cylinder." "It's a hairy tail." "It's a great flapping ear." "It hangs down from the sky and blows air out of two holes." Once

you have read Chapter 2 ("Color Basics," which discusses the physical properties of color), can you explain the mysterious and beautiful effects of Jules Olitski's *Twice Disarmed* (**1.1**) using what you have learned about wavelengths? After you have studied Chapter 3 ("Perceiving Colors"), can you explain the experience in terms of color perception? Or can it be analyzed only in terms of the psychological effects of colors (Chapter 4), pigment mixing (Chapter 7), color interactions (Chapter 9), or the historical and cultural use of color (Chapter 10)? Obviously not, although all these perspectives and those explored in other chapters increase the amount of proverbial elephant you can grasp.

Beyond these very important perspectives lies direct experience with color. Actually working with color, exploring its characteristics and potentials, carefully observing how colors work together, will teach you in ways that no theory can. The theories are useful ways of narrowing the field of exploration. Intellectual information provides a general map so that you do not have to wander randomly through the myriad halls of color. Beyond the intellect, one works intuitively, experimentally, with all senses alert. Only in this way can you discover the realities of color—and the journey is endless.

Color Basics

To develop a vocabulary for talking about colors, we must delve briefly into the physical properties of what we see as colors. While this vocabulary is useful, it is not always precise, for much of it is based on theoretical or scientific observations that do not necessarily hold true in artistic practice. And although the same terms are often used for describing colored lights and colored pigments, such as paints, they are quite different phenomena. When talking about colors, it must be made quite clear to which of these one is referring.

The Physics of Light

Physicists explain color as a function of light. A current theory is that energy from the sun consists of a series of separate energy packets, or quanta, traveling as continuous electromagnetic waves. They stimulate color sensations in our visual perception when they strike objects.

In the seventeenth century, the great physicist and mathematician Sir Isaac Newton (see Chapter 6) conducted a series of experiments demonstrating, among other things, that sunlight contains all the colors of the rainbow. He admitted a ray of daylight into a darkened room through a hole in a window shade and placed a glass prism where the ray would pass through it. As it did so and then came out the other side, the ray of white light was bent, or REFRACTED, breaking it down into its constituent colors which could be seen on a white wall beyond, as shown in Figure **2.1.**

Newton identified seven basic colors in the breakdown: red, orange, yellow, green, blue, indigo, and violet. Each is now thought to correspond to a certain portion of the range of wavelengths of radiant energy that can be distinguished by the human eye, called the VISIBLE SPECTRUM. A WAVELENGTH is the distance between crests in a wave of energy. Wavelengths in the visible spectrum are measured in NANOMETERS, each of which is only one-billionth of a meter. Differences between colors involve tiny differences in wavelengths. Figure **2.2** shows the designation of SPECTRAL HUES, or the colors that can be seen in a rainbow, in terms of the wavelengths indicated by each hue name. "Red," for instance, is the name given to everything from about 625 nanometers to 740 nanometers, although we can distinguish many gradually differing reds within that range, some of them merging into the

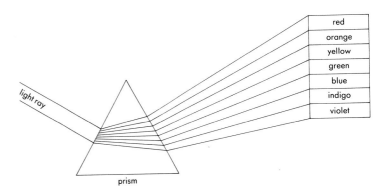

▲ **2.1** A modern rendition of Newton's experiment, breaking white light into the colors of the spectrum by passing it through a prism.

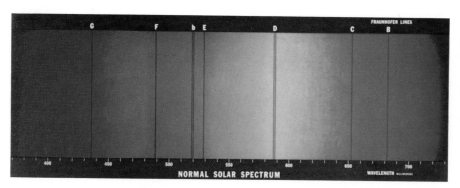

◀**2.2** Colors of the visible spectrum are here identified as regions of certain wavelengths, measured in millimicrons (nanometers). The dark "Fraunhofer" lines represent some of the fine dark lines seen in a pure spectrum, revealing wavelengths that are missing in the light sample.

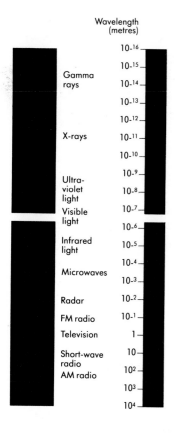

◀**2.3** In the electromagnetic spectrum, only a very small portion of all radiant energy can be seen by humans.

◀**2.4** Newton's proposed color wheel, created by joining the two ends of the visible spectrum. Although this model does not correspond to the linear array of wavelengths, it is useful for analyzing relationships among colors.

area we call "orange." Red has the longest wavelengths; violet has the shortest.

Beyond red and violet at each end of the visible spectrum lie wavelengths of radiant energy that humans cannot see, beginning with infrared and ultraviolet. As illustrated in Figure **2.3** the electromagnetic spectrum comprises radiations from the universe ranging from gamma rays to radio waves. The greatest portion of this spectrum is invisible to human sight.

Additive Color Relationships

Although red and violet are quite different in terms of wavelengths, they are visually similar at their outer extremes and can be mixed to produce purples that cannot be seen in the spectrum itself. Newton therefore proposed that the straight band of spectral hues could be bent into a circular model with the two ends joined (**2.4**). At its center was white—the result of mixing lights of all colors, as Newton had demonstrated by reconverging the colors of the spectrum through a second prism into a single ray of white light (**2.5**).

In Newton's color circle, as one moved outward from the center, as in point Z (2.4), the more "intense" the color would become. "If Z fall upon the Circumference," Newton wrote in his *Opticks*, "the Colour shall be intense and florid in the highest Degree." And if Z were on or near the line between O (the center) and D (the point between red and violet), "the Colour compounded shall not be any of the prismatic Colours, but a purple, inclining to red or violet, accordingly as the point Z lieth on

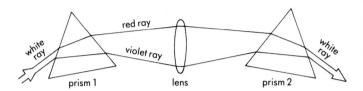

▲ **2.5** Newton demonstrated that white light is the composite of all spectral hues by breaking it down into the visible spectrum, then converging these rays through a second prism back into white light.

the side of the line DO towards E or towards C."[1]

This was the first COLOR WHEEL—an attempt to illustrate visual relationships among hues. Newton's color circle was adopted by many later aesthetic theorists as a way of explaining relationships between different colors.

Color theorists often speak of the colors in light as ADDITIVE: the more they are mixed with other colors, the lighter they become. White light can even be recreated by mixing only three carefully-chosen colored lights: green, blue-violet, and orange-red. These same colors can be used to mix most of the colors that humans can distinguish, but cannot themselves be mixed from other colors. They are therefore known as PRIMARY COLORS. As illustrated in Figure **2.6**, where the primaries orange-red and green overlap, they create yellow; green and blue-violet can be mixed to form indigo (known as cyan in printing and photography); and blue-violet and orange-red overlap to form magenta. The yellow, cyan, and magenta formed by mixing two primaries are called SECONDARY

COLORS; in light mixtures, these are more luminous than primary colors. White, as we have seen, results from mixing all three primaries together at the proper intensities; black is the absence of all light.

Light mixtures can be created by superimposing lights of different colors, by showing two different colors in rapid succession, or by presenting small points of different colors so close to each other that they are blended by our visual apparatus. In the past, experiments with light mixing had to be done by projecting and overlapping colored lights on a wall. However, the advent of computer graphics has opened a vast world of instantaneous and mechanically precise light mixing for aesthetic exploration. Cathode ray tubes used in video receivers and computer graphics monitors have three electron guns corresponding to the light primaries. When the beams from these guns strike the light-sensitive PHOSPHORS on the surface of the screen in varying combinations and intensities, they can create a great array of luminous color sensations.

In the fractal computer image shown in Figure **2.7**—the beautiful visual expression of a mathematical formula—the lightest areas occur where the rays are most concentrated and the darkest areas where the rays are least concentrated. The stunning yellows are entirely mixed; there is no yellow gun in a cathode ray tube. If you examine a yellow image on a television screen very closely, you can see that it is formed by the juxtaposition and overlapping of orange-red and green bits of light.

Pigment Colors

Colors seen on the surface of objects operate in a very different way from those seen in beams of light. When daylight or some other kind of incident light strikes a surface, certain wavelengths may be absorbed and others reflected by its PIGMENTS, or coloring matter. The REFLECTED wavelengths blend to form the color "seen" by the viewer. To cite a simple example, the surface of an apple absorbs all wavelengths except those which create the sensation of red; these are reflected into the eye of the viewer. An object that appears black absorbs almost all wavelengths (in the darkest of pigments, carbon black, 97

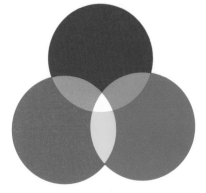

◀ **2.6** If colored lights in the light primaries red-orange, green, and blue-violet are projected in overlapping circles, they mix to form the light secondaries, yellow, magenta, and cyan. Where all three primaries overlap, they produce white.

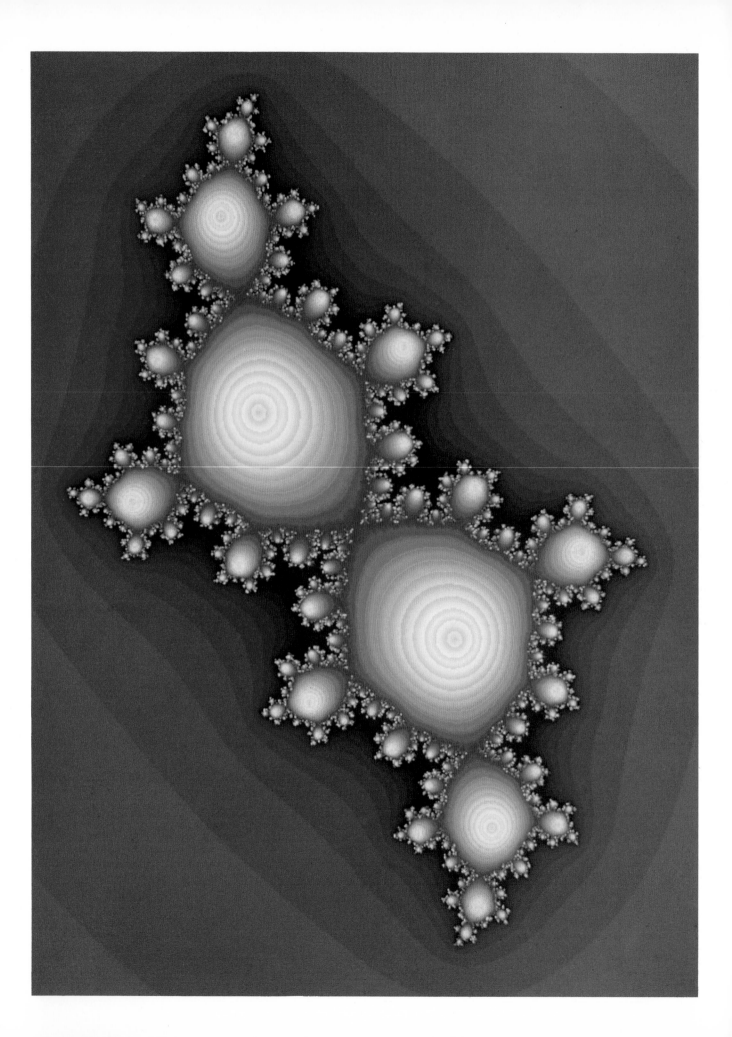

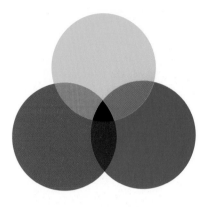

◀ 2.8 Subtractive colors Any colored object has pigmentation that enables it to absorb some waves and reflect others. An artist using paints is working with this subtractive color rather than actual light rays, or additive color. This diagram shows the pigment primaries and secondaries.

▼ 2.9 On the conventional color wheel of pigment hues, the primaries are red, blue, and yellow; the secondaries are orange, green, and purple; and the tertiaries are mixtures of adjoining primaries and secondaries. If colors are mixed with their complement, lying opposite on the wheel, a neutral gray is created, as indicated in the center.

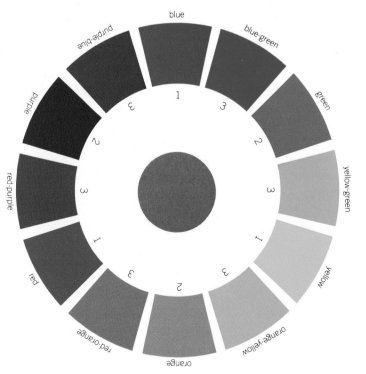

◀ 2.7 Heinz-Otto Peitgen and Peter H. Richter, fractal image based on the process $x \rightarrow x^2 + c$.

percent of the incident light is absorbed). In theory, a surface that appears white absorbs no wavelengths; all are reflected and mixed. This ideal is never met in practice; the closest one can come is to coat cold metal with magnesium oxide smoke, resulting in absorption of only two percent of the incident light.

In traditional color theory, there are three pigment colors—red, blue, and yellow—that cannot be mixed from other colors and from which all other colors can be mixed (see **2.8**; more on this in Chapter 7). These characteristics would define them as primary colors. However, with pigments, the ability to mix all other colors from only three primaries is possible only in printers' inks and color photography.

Transparent inks or photographic dyes in chrome yellow, magenta, and cyan, plus black, and the white of the paper can be used to approximate most colors that the eye can see. But in paint mixing, it is not possible to mix all colors from any basic three primaries. Some theories would therefore add green to the list of paint pigment primaries to make more mixtures possible. The color standardist Albert Munsell proposed five pigment primaries: green, blue, purple, red, and yellow (which he called PRINCIPAL HUES). We recommend that new students use ten paint colors and mix all others from them. These pigment mixing issues will be dealt with in detail in Chapter 7; the point here is that the concept that only three primaries exist is more theoretical than real when one is dealing with paint pigments rather than lights.

Be this as it may, mixtures of the pigment primaries red, blue, and yellow, theoretically yield the pigment secondaries orange, green, and purple. When these secondaries are mixed with their adjacent primaries, they yield TERTIARY COLORS: red-purple, red-orange, yellow-orange, yellow-green, blue-green, and blue-purple. If one starts with three primaries, one gets three secondaries and six tertiaries, giving a total of twelve colors, as shown in Figure **2.9**.

Saturation, Hue, Value

Between each of these twelve colors are many more possible gradations as adjacent colors are mixed. It is also

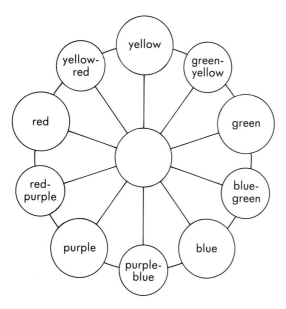

▲ **2.10** Color theorists have proposed other color models, including this one by Albert Munsell, which is based on five principal colors and the intermediate colors that can be obtained by mixing them.

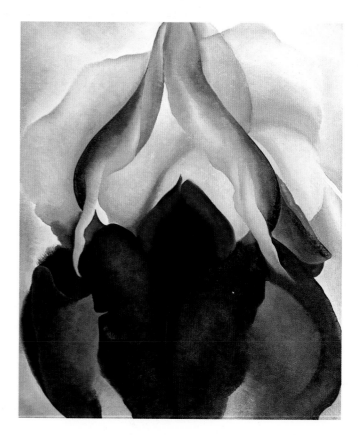

▲ **2.11 Georgia O'Keeffe, *Black Iris*, 1926** Oil on canvas, 33 x 24 ins (83.8 x 60.9cm). Metropolitan Museum of Art, New York.
The subtle color variations in this painting are based on value gradations in a single area of the color wheel: purples and red-purples.

possible to mix colors that are not adjacent to each other. Mixing those that lie opposite each other on the color wheel, for example, tends to yield a chromatic gray. Two colors that are opposite each other on the color wheel are called COMPLEMENTARIES. As we will see in Chapter 9, although complementary colors gray each other when mixed, they tend to intensify each other optically when placed side by side.

The degree to which colors are grayed by being mixed with their complementaries is called SATURATION, also known as "intensity." In their purest, most brilliant state, colors are at maximum saturation; as they become more and more neutral, they are said to be lower in saturation. In Figure 2.9, colors decrease in saturation as they approach the gray in the center of the wheel.

The matching up of complementaries is not a precise science, however. The twelve-point wheel shown in Figure 2.9 is only one of many suggested models for color relationships. Drawing a line through the center of this wheel shows yellow and purple, red and green, and orange and blue to be pairs of complementaries. But the ten-point color wheel that results from Albert Munsell's five primaries (**2.10**) yields slightly different results: yellow is the complement of purple-blue, green of red-purple. Only the pairing of blue and yellow-red (orange) remains the same as on the twelve-point wheel. Because the mixtures and intensifying interactions between complementaries are of great importance in some approaches to color usage, artists must experiment and observe

carefully to see which combinations best produce the effects they seek.

Saturation is not the only way of describing the variations among colors. HUE is the quality we identify by a color name, such as "red" or "purple." It corresponds to the distinctive wavelength of a color. A third property of colors is VALUE, sometimes known as "brightness" when light mixtures are being discussed. Value is the degree of lightness or darkness in a color, and in pigment mixtures it can be adjusted by the addition of black or white. The potential gradations are infinite, though there is a finite limit to the number of differences in value humans can distinguish. Georgia O'Keeffe's *Black Iris* (**2.11**) is executed solely in values of purple and red-purple, from near-white to near-black. The lightest values are referred to as "high," the darkest as "low."

When pigments of equal value are mixed, the resulting color is darker rather than lighter, since more wavelengths are absorbed. Because this process subtracts from the light reflected, pigment mixing is called SUBTRACTIVE

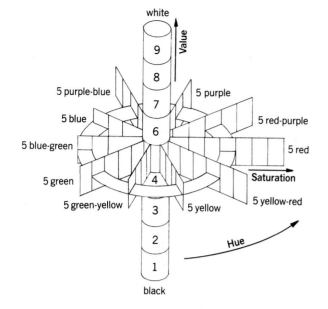

COLOR MIXING. This darkening, which occurs during actual paint mixing, is not demonstrated in the traditional color wheel of pigment relationships shown in Figure 2.9.

One way of introducing variations in value into the diagram showing color relationships is to make a three-dimensional model. Albert Munsell's color "tree" represents value gradations along a vertical axis, with variations in hue indicated by changes around the perimeter, and variations in saturation presented as horizontal steps from the vertical axis (**2.12**). Any color along the vertical axis—from white at the top, through grays, to black at the

bottom—is called a NEUTRAL. Colors ranging horizontally from this axis can be called CHROMATIC HUES, to distinguish them from neutrals. A colored version of the model is shown in Figure 6.10. Note that the model is not symmetrical. If saturation is measured in equal steps, each hue is found to have a different number of potential steps and to reach maximum saturation at a different point along the value scale. Vertical slices through this color solid (**2.13**) reveal, for instance, that yellow reaches its maximum saturation at the eighth step of value, whereas blue reaches maximum saturation at the fourth, with yellow having a total of fourteen possible saturation steps from the center, and blue only nine. For purple, of which the purest form is a dark color, maximum saturation occurs even lower on the value scale, at the third step.

Although many terms commonly used in describing colors are obviously subject to question—some theories even find fault with the terms "additive" and "subtractive"—the concepts of wavelengths, light mixtures, pigment mixtures, primaries, secondaries, hue, value, saturation, and complementaries will be useful as we pursue our study of color.

▲ **2.12** In Munsell's three-dimensional model of color relationships, hues are presented around a central axis that represents value changes. Saturation is measured outward from this axis, from the grays of the central pole to the highest saturation possible for each hue. The degree of saturation at the fifth step of value is shown here.

▶ **2.13** Sample representations of change in value and saturation for two hues: yellow and blue.

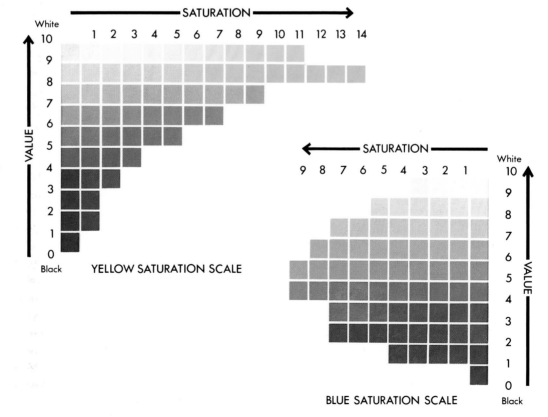

Perceiving Colors

3

The colors we see are not simply a function of differing wavelengths; they are also a complex series of effects that occur in our perceptual apparatus. This involves the way our eyes register colors, classify the inputs, and transfer them to the brain, and the way the brain decodes the signals. At our present state of scientific knowledge, much of this process can only be described theoretically. We simply do not know how we see colors. Furthermore, the brain may override what the eyes tell it. And some of us are able to perceive colors with senses other than our vision, such as hearing and feeling.

The Human Eye

Lights, varying in wavelength and brightness, enter the human eye through its transparent outer covering, the cornea. The muscles of the iris contract and expand to admit less or more light through the pupil, depending on the amount of light available. The light which has been admitted is then focused on the back surface of the eye by three refracting media: the aqueous humor, the crystalline lens, and the vitreous humor (**3.1**).

The back of the eye is covered by the RETINA, which consists of many specialized cells arranged in layers. The layer most important to color vision consists of the photoreceptors called RODS and CONES. They are so named because of their differing shapes. Rods allow us to distinguish forms in dim light, but only with black and white vision; cones function under brighter lighting to allow us

to perceive hues. Thus we cannot perceive hues well at night. It appears that rods function in light as well as darkness, for stimulation of the cones also excites the rods.

Before light reaches the rods and cones, it must also pass through layers of nerve cells, as indicated in Figure **3.2**. Only about 20 percent of the light that reaches the retina actually registers in the photoreceptive rods and cones. The rest is simply unseen.

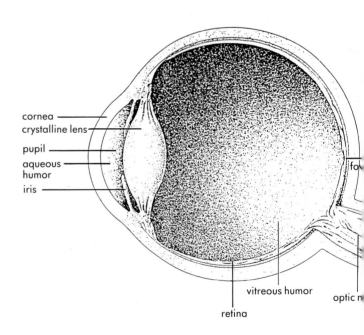

cornea
crystalline lens
pupil
aqueous humor
iris
fo
vitreous humor
optic n
retina

▲ **3.1 The structure of the eye** Discrimination of colors begins when light entering the pupil reaches the retina, which lines the inside of the eye.

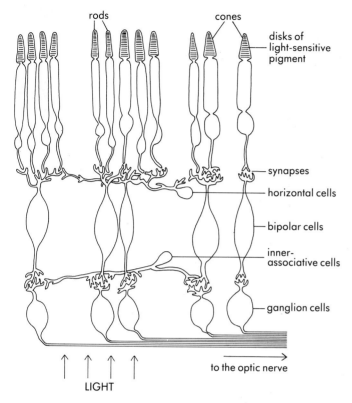

▲ **3.2 Rods and cones** After light excites the light-sensitive pigments in the rods and cones, electrochemical messages are relayed to the visual cortex in the brain across a network of nerve cells.

At the center of the back of the eye is an area about one millimeter in diameter known as the fovea. It contains only cones. Light falling on this small area gives the sharpest color definition. When we are examining details in an image, we automatically move our eyes until what we want to see is centered on the fovea.

The approximately 100 million rods and 6½ million cones in each eye communicate with the brain via the optic nerve. The photoreceptors send their electrochemical messages to the optic nerve across synapses in a complex network of optic nerve fibers. The bipolar and ganglion cells are thought to gather and pass on signals from the rods and cones; the horizontal and inner associative cells seem to integrate activities across the retina. In the fovea, each cone is connected with a single bipolar cell and a single ganglion cell, whereas signals from rods and cones on other parts of the retina are bundled together.

Information from the two eyes is transmitted to various areas on both sides of the brain, where it is somehow reintegrated to form a single image. Almost one-third of the gray matter of the cerebral cortex is involved in this process.

Seeing Colors

After centuries of analyzing the anatomy and physiology of color vision, scientists still have no definite proof of how the cones work. They do know that the rods contain disks of a light-sensitive pigment called visual purple, or RHODOPSIN. When light strikes this pigment, it bleaches, reducing the electrical signals for darkness otherwise transmitted by the rods. In the dark, our rods have large amounts of unbleached rhodopsin, allowing us to perceive forms with very little light present. The rods can function at light levels up to one thousand times weaker that the visual system based on the cones.

Like rods, cones also contain light-sensitive pigments, called IODOPSINS, but their nature and functions are still matters of conjecture. Of the many theories advanced, the one in current favor is that there are three general kinds of cone pigments: one for sensing the long (red range) wavelengths, one for the middle (green range) wavelengths, and one for the short (blue-violet range) wavelengths. These primary levels of response are thought to mix to form all color sensations, just as additive mixtures are made from colored lights. Yellow, for instance, is a sensation triggered by activation of the green- and red-sensitive cones. Red-sensitive and green-sensitive cones predominate in the retina, with relatively few blue-sensitive cones. The idea of three basic kinds of cones is called the TRICHROMATIC THEORY. It was first advanced in 1801 in a somewhat different form by the English physicist Thomas Young and developed in the mid-nineteenth century by the German physicist Hermann von Helmholtz.

This theory, however, only explains what happens in the photoreceptors under direct light stimulation. It is now thought that electrochemical signals transferred from these receptors to the brain are handled somewhat differently, though not fully understood as yet. In this second stage of a process that may actually have other

unknown stages, colors may perhaps be discerned in pairs of opposing colors. According to the OPPONENT THE-ORY, some response mechanism, perhaps specialized cells in the visual cortex, registers either red or green signals, blue-violet or yellow. In each pair (red/green, blue-violet/yellow) only one kind of signal can be carried at a time, while the other is inhibited. These pairs correspond roughly to the complementary colors on color wheels. Another set of cells responding to variations between white and black is thought to operate in a non-opponent fashion, yielding a range of values.

The opponent theory, which has been supported by electrical analysis of nerve cells in various animals, helps to explain why we do not perceive a reddish-green or a bluish-yellow. It can also be used to explain phenomena such as AFTER-IMAGES, visual sensations that occur briefly after a color stimulus is gone. In some cases we "see" an illusionary image that is the color opposed to one we have been staring at. It may be that when the signaling mechanism for one color is fatigued, its opponent color is no longer inhibited. The result is not a mixture of the two but the exact opposite, as you can verify by staring

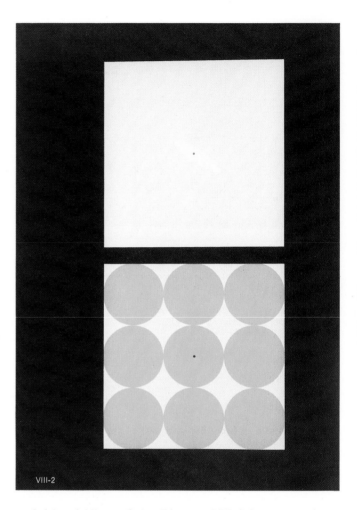

▲ **3.4 Josef Albers, Color Diagram VIII–2** Stare at the dot in the center of the yellow circles for 30 seconds. Then quickly look at the dot in the white square above. Note everything you see in each case.

for several minutes at the dot in the center of the red turtle in Figure **3.3** and then transferring your gaze to the dot on its right. This after-image effect is also called SUC-CESSIVE CONTRAST. After-images occur in our visual perception all the time, but most of us are not usually aware of this phenomenon. If you spend some time looking at a person with brightly colored clothing and then look away, you can perceive an after-image of the person in complementary colors.

After-images cannot be explained simplistically, however. Consider Figure **3.4**, created by Josef Albers, whose work centered on what happens visually in the interac-

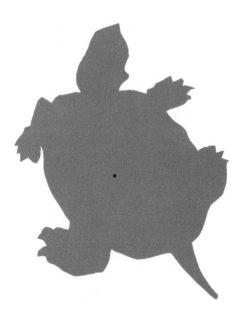

▲ **3.3** Stare at the black dot in the center of the red turtle for 15 to 30 seconds. Then transfer your gaze to the black dot to the right. The luminous blue-green after-image "drawn out of" the white is a successive-contrast phenomenon.

tion between object, eye, and brain. If you stare at the black dot in the center of the yellow circles for quite a while and then suddenly transfer your gaze to the black dot on the white square, you will see not only a luminous blue-violet after-image of the circles but also, and even more conspicuously, yellow diamonds corresponding to the spaces between the circles. We can only guess at what is happening in our perceptual apparatus to create this effect. In fact, nobody yet knows how we see the simplest of color phenomena, let alone the extremely complex array of colors that we perceive every waking moment.

A discovery that has complicated attempts to discover structures in the eye and brain corresponding directly to the colors we perceive—and to wavelengths of light—was described in 1959 and 1977 by E. H. Land, the developer of the Polaroid instant photograph process. In his original work, Land projected two black-and-white slides taken of the same scene from two projectors in such a way that they overlapped exactly. One slide was taken with a red filter and projected through a red filter; the other was taken with a green filter and projected with white light. When projected on top of each other, they reproduced an approximation of the hues of the original scene, including blues, yellows, oranges, and greens. Land's experiment was also successful when yellow and red lights were used in the projectors. Neither traditional wavelength theories nor trichromatic theories can explain this phenomenon, for Land's subjects discerned colors with much less information that was ever thought possible. No blue wavelengths needed to be present for people to "see" blue, for instance.

One explanation for Land's results would be that higher structures in the brain were interpreting the colors of familiar objects rather than "seeing" them. But in Land's later experiments, people successfully perceived the hues in abstract patterns of colored squares, like those in the work of Piet Mondrian, for instance. Land proposed that there is some mechanism in the human brain that makes it work differently from a camera. In red late-afternoon sunlight, a camera will record a lemon as reddish rather than yellow, as it appears under white midday sunlight. But we humans still see the lemon as yellow. This COLOR CONSTANCY, Land suggested, must be the result of some perceptual apparatus in the visual cortex of the brain that

works in conjunction with the color perceptors in the retina of the eye. His retinex—"retina" plus "cortex"—theory has been vindicated by neurobiological research that demonstrates the existence of a network of tiny "blobs" in the visual cortex at the back of the human skull. These seem to compare visual information from an object with what is seen immediately surrounding it. Colors in the immediate vicinity seem more important in these mental computations than colors at a distance. If a red fruit is seen against a green leaf at sunset, the fruit will still look redder than the leaf because the ratio of wavelengths coming from the fruit and the leaf—its immediate neighbor—remains the same, even though the larger environment is totally bathed in reddish light.

Variables in Color Perception

It seems safe to say that color sensations occur in the responses of our perceptual apparatus. They are not inherent properties of objects. In fact, few animals other than humans even seem to see in colors. And humans may differ in their color responses. Given our individual differences in all other physiological areas, it is highly likely that we also differ in color vision. Major variations from the norm can be discovered as forms of color blindness. But even those who are not color blind have no way of knowing whether they are seeing precisely the same red when looking at the same Coca-Cola label, even though the input to both sets of eyes will be of the same wavelength.

Wavelengths—which are useful measurements for scientists—can also be of use to artists because of the many factors affecting our perception of a color. Those we will consider here are the size of the colored area, its surroundings, the lighting under which it is seen, and the surface texture of the object from which it is reflected.

All other things being equal, a large expanse of color will generally appear brighter than a very small area of the same color. When Barnett Newman first exhibited his large-scale canvases (10.21) he increased the intensity of their impact by having them displayed in such a manner that viewers were unable to back away, thus diminishing the area of color seen. It filled their entire field of vision,

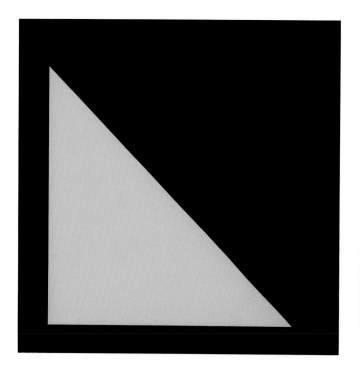

▲ **3.5** Carefully compare the two yellow triangles. Do you perceive any difference between them? Both are printed in the same PMS ink mixture, but their differing size may affect perceptions of their relative value and saturation.

▼ **3.6** The line through the center is actually a solid, uniform gray, but next to darker grays, it appears light and next to lighter grays, it appears dark.

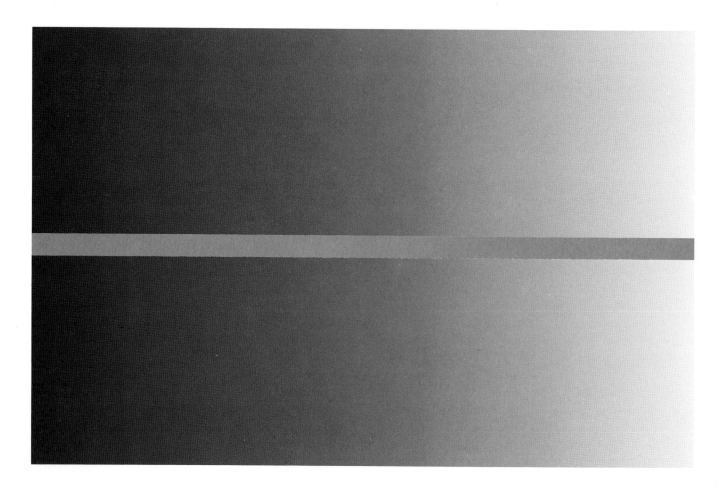

with no relief. If a color field is very small or far away, it will tend to dull and lose the sharpness of its edges. In Figure **3.5**, the small triangle of yellow is likely to appear slightly darker and less saturated than the larger yellow triangle, though they have both been printed with the same ink color.

Thus in some cases, a small area of a color appears darker than a larger area. However, the effect will also depend heavily on the color of the background. The only hard and fast rule that can be applied is that *all colors are affected by the colors around them*. Consider the apparent shift in value of a uniform gray strip in Figure **3.6**. As its

surroundings get darker, it appears lighter; as its surroundings get lighter, it appears darker. Adjacent colors can also change each other's apparent hues. In Op Artist Richard Anuszkiewicz's *All Things Do Live in Three* (**3.7**), the background is actually a uniform red; the light blue, medium green, medium blue, and yellow dots on it change its appearance considerably. The only way to see the "true" color of the red is to cover the dots, so powerful are they in affecting our perception.

The third important situational variable in color perception is the light in which we see an object. Typical fluorescent light has a blue cast; incandescent light is somewhat yellow. The color of daylight continually varies as the sun's angle changes in relationship to the earth; clouds and particles in the atmosphere also cause variations in light diffraction. In general, with some particulate matter in the air, daylight will shift in color from blue in the early morning through white to red late in the afternoon. These changes in turn affect the colors reflected from objects.

▼ **3.7 Richard Anuszkiewicz, *All Things Do Live in Three*, 1963** Acrylic on masonite, 21⅞ x 35⅞ ins (55 x 91cm). Private collection.
Stare at this Op Art painting for a while. How many different reds do you perceive? The only way to see that a single red has been used throughout is to cover the dots upon it.

We nonetheless tend to perceive colors as unchanging, because of our visual memory. A white card will still look white to us, whether we see it under a yellow candlelight or "white" daylight. Because of this tendency, called COLOR CONSTANCY, we might say that our house "is" the medium brown that it appears at midday under a slightly overcast sky, even though its color, early in the morning, is a dark blue-brown, and, late in the afternoon, a reddish brown, and the areas in shadow, moreover, are much darker than those in direct sunlight. Something in our brains compensates for the actual changes, allowing us to generalize our color perceptions and therefore recognize familiar objects so that we do not, for example, think we have come home in the evening to the wrong house. E. H. Land, in noting that we will compensate for the extra redness in tungsten filament lights without believing that the objects illuminated have changed in color, suggested that

> the eye, in determining color, never perceives the extra red because it does not depend on the flux of radiant energy reaching it. The eye has evolved to see the world in unchanging colors, regardless of always unpredictable, shifting and uneven illumination.[1]

Although this mental process is automatic, protecting us from visual chaos, those who choose to be more observant can override it. In search of visual truth, the French Impressionist Claude Monet (1840–1926) observed and painted the exact same scenes—haystacks, poplars along a canal, the face of a cathedral—under many different lighting conditions, documenting the great changes that actually occurred. Discarding the idea that objects possess a certain color, Monet trained his eye to see each moment in its freshness. He stated:

> This is what I was aiming at: first of all, I wanted to be true and accurate. For me, a landscape does not exist as landscape, since its appearance changes at every moment; but it lives according to its surroundings, by the air and light, which constantly change.[2]

To observe the effects of light on Rouen Cathedral, Monet rented a room opposite the cathedral and spent months there working at paintings on different easels corresponding to the different times of day. Of the twenty canvases in the completed series, the two shown in Figures

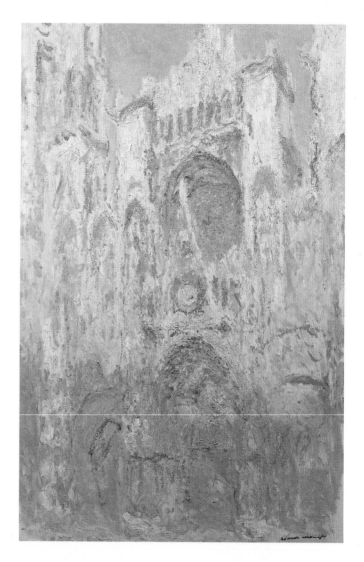

▲ **3.8 Claude Monet, *Rouen Cathedral, Effect of Sun, End of Day*, 1894** Oil on canvas, 39 $^2/_5$ x 25 $^3/_{10}$ ins (100 x 64.3cm). Musée Marmottan, Paris.
Monet overruled the human optical tendency to color constancy, recognizing and portraying the actual color shifts that occur with changing lighting.

▶ **3.9 Claude Monet, *Rouen Cathedral, The Portal and the Albane Tower. Full Sunlight. Harmony in Blue and Gold*, 1894** Oil on canvas, 42 $^1/_{10}$ x 28 $^1/_2$ ins (106.9 x 72.3cm) Musée d'Orsay, Paris.

3.8 and **3.9** illustrate the great differences he observed even in the color of stone. In full midday sunlight, the façade is awash with gold, with slight blue shadows, and some surfaces are bleached almost white by the brightness of the sun. At sunset, by contrast, Monet saw the surface as a pale bluish pink, with rich oranges and reds in the building's recesses.

Lighting is important to artists not only in observing

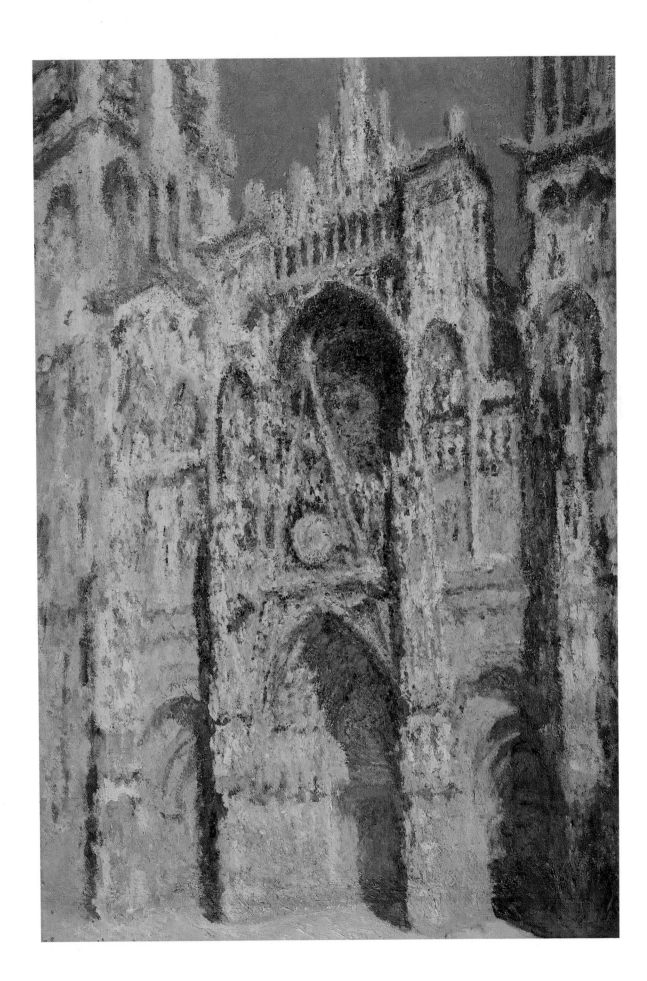

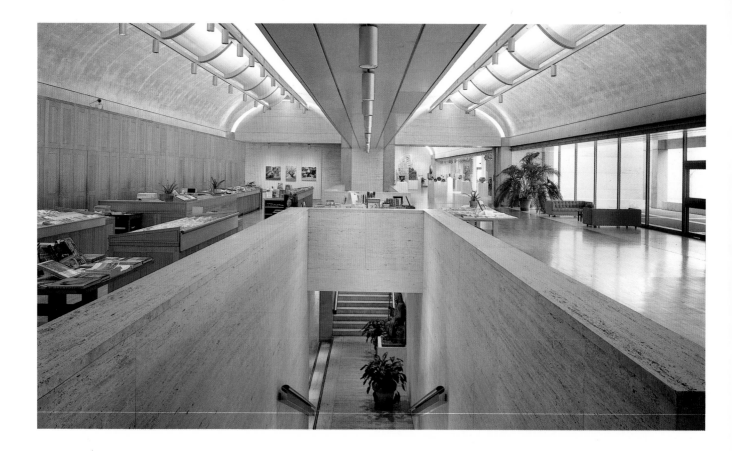

▲ **3.10 Louis Kahn (architect), Interior, Kimbell Art Museum (detail)** Fort Worth, Texas.

the world around them but also in creating and displaying their works. Paintings and frescos created hundreds of years ago were painted by natural light or artificial light from candles or oil lamps. Under stronger lighting in modern museums, their hues may look brighter than they did to their creators, if the surfaces have not faded. In the northern hemisphere, some artists seek natural northern lighting for their studios because this light changes the least during the day as the sun moves through the sky from east to west; in the southern hemisphere, a southern exposure is more unchanging. Artificial lighting is preferred by others because it does not change at all, assuming that no natural light comes in at the window, and because works are ultimately most likely to be seen under such lighting. These lights do affect color sensations, however. Since regular fluorescent lighting is bluish, a warm pink fluorescent tube may be paired with a bluish one to give a more even white light. "Full-spectrum" fluorescent tubes are also available now. Colors created under yellow incandescent lighting may appear more brilliant when taken outside.

The effect of natural lighting on works of art is strikingly apparent at the Kimbell Art Museum in Fort Worth, Texas (**3.10**). It was designed by Louis Kahn, who once said that "you cannot make a building unless you are joy-ously engaged." Colors really come alive in this museum, where works of art hanging on the off-white travertine walls are lit by natural daylight coming through long skylights in vaulted ceilings. Because the ultraviolet light in sunlight can be destructive to paintings, the light is screened and reflected off the concrete ceiling. Light itself almost becomes the subject of this architectural environment, an effect that is in keeping with Kahn's philosophy:

> All material in nature, the mountains and the streams and the air and we, are made of Light which has been spent, and this crumpled mass called material casts a shadow, and the shadow belongs to Light.[3]

Ideally perhaps, artists should work under identical lighting conditions to those under which their art will finally be seen. This ideal is hard to put into practice, however. In developing the paintings for the Rothko Chapel in Houston, shown in Figure 4.7, Mark Rothko created a model of the chapel in his New York studio. His desire to light the chapel in the same way as his studio—with a skylight—was so strong that the original architect, Philip

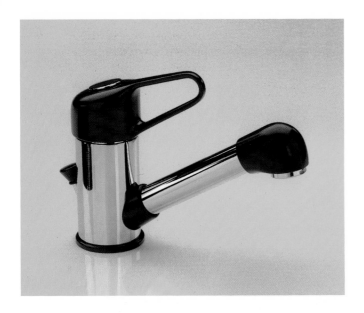

▲ **3.11 Davide Mercatali and Paolo Pedrizzetti, Tap/mixer, *Hi-Fi*** The shiny chrome of this faucet is so reflective that its own color is difficult to distinguish from those of reflected surrounding colors.

Johnson, left the project because he had envisioned a different lighting system. Even though Rothko got his way, the great difference between the bright, direct sunlight of Texas and the smoggy light that filtered through the urban grime on his New York skylight meant that the colors were washed out by the bright sun when displayed in the Texas chapel. Under bright sunlight, for example, black appears gray, and the dark blacks are very important to Rothko's effects. As Rothko himself had pointed out: "The pictures have their own inner light, and if there is too much light the color in the picture is washed out and a distortion of their look occurs."[4] To compensate for the Texas sun, filters had to be placed over the skylight in the Houston chapel to keep the colors as Rothko had intended them.

In addition to size, surroundings, and lighting, the color we perceive depends, in the case of pigments, on the characteristics of the surface from which it is reflected. In general, a shiny surface will reflect more light and thus seem lighter; a rough or porous surface will absorb more light and therefore appear darker.

A shiny surface will also reflect the colors around it. The chrome finish of Davide Mercatali and Paolo Pedrizzetti's sink faucet (**3.11**) carries an array of reflections, including the yellow beneath and the black of its own fittings. Such glossy surfaces also develop a direct range of values, from highlights to dark values, as in the many reflected yellows that derive from the solid yellow of the surroundings.

Nonvisual Color Perception

A final limitation of scientific theorizing on the artist's use of color perception phenomena is the fact that many of us perceive colors through senses other than our vision. The ability to feel colors with our hands is not uncommon among blind people. Try it yourself: take several sheets of silk-screen colored papers in different hues, close your eyes, and run your hands over them. Can you feel any differences? Yellow, for instance, may feel much clearer and "faster" than red.

Some people perceive colors when hearing sounds. Associations between colors and musical keys, notes, or instruments are so common that a body of research exists surrounding this kind of SYNESTHESIA (the combining of two forms of perception). The composer Scriabin, for instance, associated musical keys with colors. He experienced the key of C as red, G as orange, D as yellow, A as green, E as light blue, B as whitish blue, and so on. Scriabin even composed a special symphony, *Prometheus*, with a part for projected colored lights as "a powerful psychological resonator for the listener."[5] Scriabin's vision, never fulfilled, was to use

> . . . a great white hall with a bare interior dome having no architectural decorations. From this dome the shimmering colors would rush downwards in torrents of light.[6]

People with synesthetic perception tend to experience rising pitch or quickening tempo as lighter colors; somber passages are readily perceived as dark colors. As the painter and art theorist Wassily Kandinsky asserted: "The sound of colors is so definite that it would be hard to find anyone who would try to express bright yellow in the bass notes, or dark lake [a red-purple] in the treble."[7]

The association of colors with certain sounds, however, is, on the whole, a subjective matter. Rimsky-Korsakov "saw" the key of A as "rosy," rather than Scriabin's green. Our acquired associations with colors are part of the psychological research into color effects to be explored in the next chapter.

Psychological Effects of Color

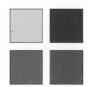

It is universally accepted that colors affect us emotionally. Bright reds, oranges, and yellows tend to stimulate us, while blues and greens often make us feel more peaceful. Colors can therefore be used to express emotions and even to evoke them. Here again, however, we must beware of simplistic assumptions, for very slight differences in colors can produce quite different effects.

Warm and Cool Colors

We associate the colors of fire—reds, yellows, oranges—with warmth. This is not just an abstract notion, for physiological research indicates that under red lighting our bodies secrete more adrenalin, increasing our blood pressure and our rate of breathing, and actually raising our temperature slightly. Imagine how warm you would feel in the sitting room designed by David Hicks shown in Figure **4.1**. Yellows and oranges have a similar effect, though they are not as warming as strong reds.

By contrast, feel the coolness of the greens and blues in the poolside area of a Los Angeles house designed by Luis Ortega (**4.2**). We associate blues and greens with the cooling qualities of water and trees, and physiological research shows that green or blue lights will slow our heartbeat, decrease our temperature, and relax our muscles.

Hues in the red area of the color wheel are therefore often referred to as "warm," while those in the blue and green range are called "cool." These terms are relative rather than absolute. Notice how the intensity of the red walls and floor in Figure 4.1 makes the oranges, yellows, and pinks of the painting over the sofa seem cool by contrast; the "hot" pinks in the easel painting on the left seem positively icy.

In addition to the influence of surroundings, it is possible to discern warmer and cooler variations on a single hue. As the value of a hue becomes lighter, it generally appears cooler. And the addition of a small amount of a cooler hue to a red or a warmer hue to a green will create what could be called a "cool red" or a "warm green." In Figure **4.3**, which compares colors mixed by printers' ink formulas numbered according to the Pantone Mixing System (PMS), just a single unit of yellow has been substituted for one of the eight units of Rubine Red in PMS 219 to create PMS 205. Does PMS 219 feel warmer to you than PMS 205? Surely PMS 217, which has only one part of Rubine Red to thirty-one parts of white, is cooler than either of the darker reds.

Physiological Effects

Mystics have long held that we emanate a colored glow, or aura. Some feel that its presence has been verified by Kirlian photography, a special process for capturing the usually invisible energies that radiate from plants and animals. The color of the aura, as seen by clairvoyants, is thought to reflect the state of a person's health and spirituality. According to the mystic Corinne Heline, gold is the auric color of spiritual illumination, clear blue or

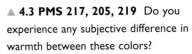

▲ **4.3 PMS 217, 205, 219** Do you experience any subjective difference in warmth between these colors?

◀ **4.1 David Hicks, Sitting room of a house in Oxfordshire, England, 1970s** Red is usually experienced as a warming color.

▼ **4.2 Luis Ortega, House and pool designed for Duke Comegys, Los Angeles** Blues and greens are considered cooling.

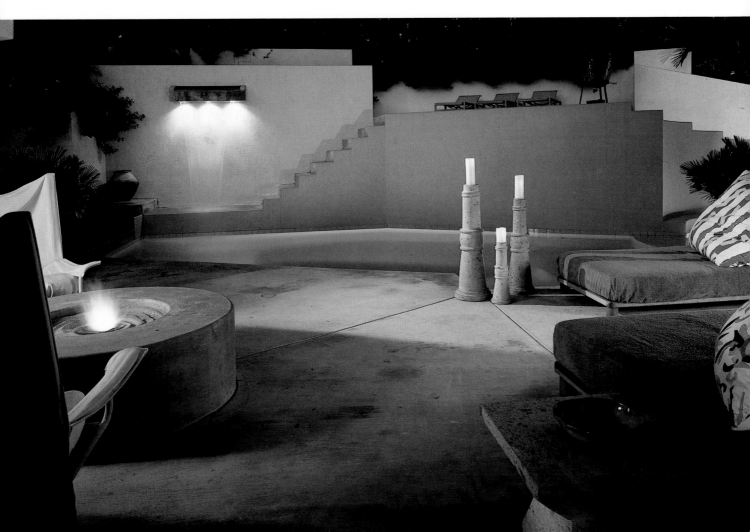

lavender indicates a high spiritual development, orange a predominant intellectuality, clear green a sympathetic nature, and pure carmine or rose-red an unselfish affectionate quality. Duller colors are associated with materialistic, fearful, or selfish qualities; a dark gray aura with brown and red in it accompanies depression.

In CHROMOTHERAPY, or healing with colors, people are bathed with colored lights, placed in colored environments, or asked to meditate on specific colors, thought to stimulate particular glands. This form of treatment dates back thousands of years to the "color halls" of the ancient Egyptians, Chinese, and Indians. In addition to the glandular relationships already mentioned, red is believed to stimulate physical and mental energies, yellow to stimulate the nerves, orange to stimulate the solar plexus and revitalize the lungs, blue to soothe and heal organic disabilities, green to exercise a calming influence and heal disorders such as colds, hay fever, and liver problems, and indigo to counteract skin problems and fevers.

Although color healing has remained largely an occult science, the medical profession also makes use of color in certain treatments. For example, premature babies with jaundice are cured by a chemical reaction triggered by exposure to blue light for several days.

A more prominent use of color therapy occurs in environmental design. Psychological literature is full of attempts to determine how specific colors affect human health and behavior and how best to put the results into effect. Bright colors, particularly warm hues, seem conducive to activity and mental alertness and are therefore increasingly being used in schools. Cooler, duller hues, on the other hand, tend to sedate. Henner Ertel studied the effects of environmental color among schoolchildren in Munich. The interior design colors with the most positive intellectual effects in Ertel's study were yellow, yellow-green, orange, and light blue. Surrounded by these colors, children's IQ scores rose by up to 12 points. In white, brown, and black environments, IQ scores fell. In addition, Ertel found that an orange environment made the children more cheerful and sociable and less irritable and hostile.

In some institutional situations, a calming environment is beneficial. In a study conducted by Harry Wohlfarth and Catharine Sam of the University of Alberta, the color environment of fourteen severely handicapped and behaviorally disordered eight-year-olds was radically altered. It was changed from a white fluorescent-lit classroom with bright orange carpeting and orange, yellow, and white colored walls and shelves (Phase 1). to one with full-spectrum fluorescent lighting and brown and blue walls and shelves (Phase II). In the quieter color environment, the children's aggressive behavior diminished and their blood pressure dropped. When the environment was then changed back to the way it had been before (Phase III), aggressive behavior and blood pressure returned to their previous levels.

Interestingly, the same effects were found in both blind and sighted children in Wohlfarth and Sam's study, suggesting that we are affected by color energies in ways that transcend seeing. One hypothesis is that neurotransmitters in the eye transmit information about light to the brain even in the absence of sight, and that this information releases a hormone in the hypothalamus that has numerous effects on our moods, mental clarity, and energy level. In what Wohlfarth calls the science of "color-psychodynamics," colors that seem to increase blood pressure, pulse and respiration rates are, in order of increasing effect, red, orange, and yellow. Those decreasing these physiological measures are green (minimal effect), blue (medium effect), and black (maximum effect).

The nurses in Wohlfarth and Sam's study were initially skeptical about color changes affecting the difficult children, but found that there were indeed recognizable differences. The reaction of a nurse named Chris is typical:

My first reaction to the Phase II room was that it must have been painted the wrong color and that the color and the lights would drive us all crazy. I guess the color was not what I had expected at all – too dark – I expected pastel blue.

However, I found the children and myself considerably more relaxed in the new room. The afternoons seemed less hectic and instead of running out of time for our activity, we ran out of activities.

I also found at lunch I was more relaxed and was able to eat something without feeling sick. . . . The noise level really went down in the Phase II room, which seemed to keep everyone from getting upset as the day went on.[1]

The legendary Notre Dame football coach Knute Rockne

attempted to use awareness of the physiological effects of colors competitively. To stir up his own players, he painted their locker room red. He had the visiting team's locker room painted in blue-greens, thus sedating them both before the game and when they returned to relax at half-time. Similarly, the influence of environmental color was demonstrated in one factory where workers were complaining about feeling cold. Rather than raise the thermostat above its 72 degree Fahrenheit setting, the blue-green walls were painted coral. The complaints stopped.

Lest we hasten to repaint everything in attempts at behavior modification, we should note that physiological color responses are complex. The precise variation of a hue has a major impact, but one that is rarely addressed by psychological research. One shade of pink may be calming, while another may be stimulating. While mystics find certain blue-violets conducive to a very high spiritual state, a group of college students said that a blue-violet they were shown tended to make them feel sad and tired. These same students found that a color described by the researchers as "cool green" made them feel angry and confused.

Furthermore, initial responses to a color environment may be reversed over time as our body accommodates itself to the new stimulus. It is known that some time after blood pressure is raised by red light it drops below the normal level; after blood pressure is lowered by blue light, it eventually rises to a higher-than-normal level.

Color Symbolism

Our responses to colors are not just biological. They are also influenced by color associations from our culture. In the West, where most adults drive cars and are familiar with stop lights, there is an automatic association of red with "stop" and green with "go." Not surprisingly, in China this clear-cut association does not exist.

In Western industrial cultures, black is associated with death; mourners wear dark clothes and the body is transported in a black limousine. In ancient Egypt, however, statues of Osiris were painted black to indicate the period of gestation when seeds are sprouting beneath the earth; black is associated with preparation for rebirth

rather than with an ending of earthly life. People in the West Indies use bright colors to commemorate deaths, in celebration of the soul's departure for a happier existence. In China the color used for mourning is white—perhaps because of the humility of wearing undyed cloth, or perhaps because of the association of white with non-living metal or with the West, the place where the sun sets. In some Native American tribes, black is associated with the West and with introspection; white is seen as the color of winter, of purification and renewal.

Red is associated with vigorous life in many cultures, probably because it is the color of blood. The earliest humans were buried with red ocher pigments. We have no way of knowing what symbolism was intended, but perhaps it was hoped that the color would help the deceased to live on in another plane. The red-painted Incan wooden face (**4.4**) was apparently used as part of a bundle of special spiritual aids which accompanied a mummified corpse into the next life. Highly saturated reds are often linked with sexuality or fertility, while light values of red-pinks may be used to express affection and sweetness.

Variations on the same hue may have different symbolic associations. In Catholic religious art, the blue of a clear sky is often used to symbolize heaven. The Virgin Mary's robe is usually a blue, often a more saturated ver-

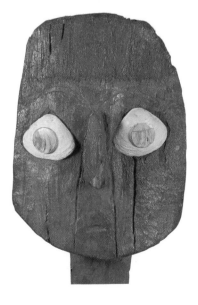

◄ **4.4 Incan red-painted wooden funerary face with shell eyes.** Kemper Collection, Zurich. Animistic groups often use red as a symbol of life, to sustain the dead in the after-life.

sion of the color, symbolizing the quiet power of her serenity. If she is dressed in a darker blue-black, this color may be interpreted as an expression of her sorrow over the death of her son.

Personal Color Preferences

Not only have we inherited cultural associations, but we also respond to colors in individual ways. Imagine that you are standing in Larry Bell's neon-lit installation piece (**4.5**). How do these particular blues affect you personally? If you compare your responses with those of other people, you may find some significant differences.

Psychological research has revealed some variables that help explain individual differences in color responses. To wit: we are most responsive to the pleasure of sheer color as children. Among adolescents, the sensation-seeking prefer red, while the more reserved prefer blue. Elderly people have a significant preference for light over dark colors, but yellow is the color they like least. People with certain mental illnesses—particularly schizophrenia—show a preference for nonchromatic, neutral colors (white, black, brown, gray), while "normal" people and manic-depressives tend to prefer chromatic hues. Extroverts tend to prefer warm hues; introverts like cool hues. However, people may be drawn toward colors representing qualities they lack, for balance. Red, for instance, is usually the preference of vibrant, outgoing, impulsive people, but timid people may also be drawn to it. Those who are feeling frustrated or angry may be repelled by red.

According to the work of the psychologist E. R. Jaensch, people from strongly sunlit countries tend to prefer warm, bright colors, while those from countries with less sunlight tend to prefer cooler, less intensely saturated colors. Jaensch speculated that in brighter environments, people's eyes have adapted to protect them from sunlight so there is a physiological bias toward these warm colors. In areas where the sun is not so bright, people's eyes are more accustomed to drawing ambient light from the sky and are thus biased toward cool colors. Scandinavians tested showed a preference for blue and green, while Mediterranean people preferred red.

Our own color preferences are important to us. A study of six- to eleven-year-olds wearing goggles with colored eyepieces while doing a pegboard test (imagine this situation!) showed that they completed the test much quicker and more accurately when they were wearing goggles of their favorite color.

Unconscious color prejudices are also sometimes apparent in artists' works. However, to use a musical analogy, it is limiting to try to play everything on the violin when a whole orchestra of instruments is at one's disposal. Artists can explore the entire range of hues, at all levels of value and saturation, in order to create any effect they desire.

Emotional Effects

Although psychologists have conducted experiments to see how people respond to certain colors in isolation, we see hundreds of thousands of colors in infinite combinations and unique contexts. The actual emotional effect of a specific color in an artwork depends partly on its surroundings and partly on the ideas expressed by the work as a whole. To be surrounded by blue, as in the Larry Bell installation (4.5), is quite different from seeing a small area of blue in a larger color context, such as the blue covers on the poolside chaises shown in Figure 4.2. And to illustrate the importance of thematic context, when the artist George Segal uses an impersonal white plaster for his human figures, the bright colors of their industrial surroundings (as in *The Gas Station,* **4.6**) do not feel inviting; they suggest artificiality covering a true bleakness of the spirit.

For many of us, the emotional effects of art may be difficult to articulate. For example, people of all religions and cultures have journeyed to Houston, Texas, to spend time within the nondenominational Rothko Chapel (**4.7**). Within this monastically simple architectural environment, the dark, subtle colors of Rothko's large color field

▶ **4.5 Larry Bell, *Leaning room II*, 1970** Collection of the artist. Sheet rock, paint, and fluorescent light installation based on leaning room, artist's studio, Venice.

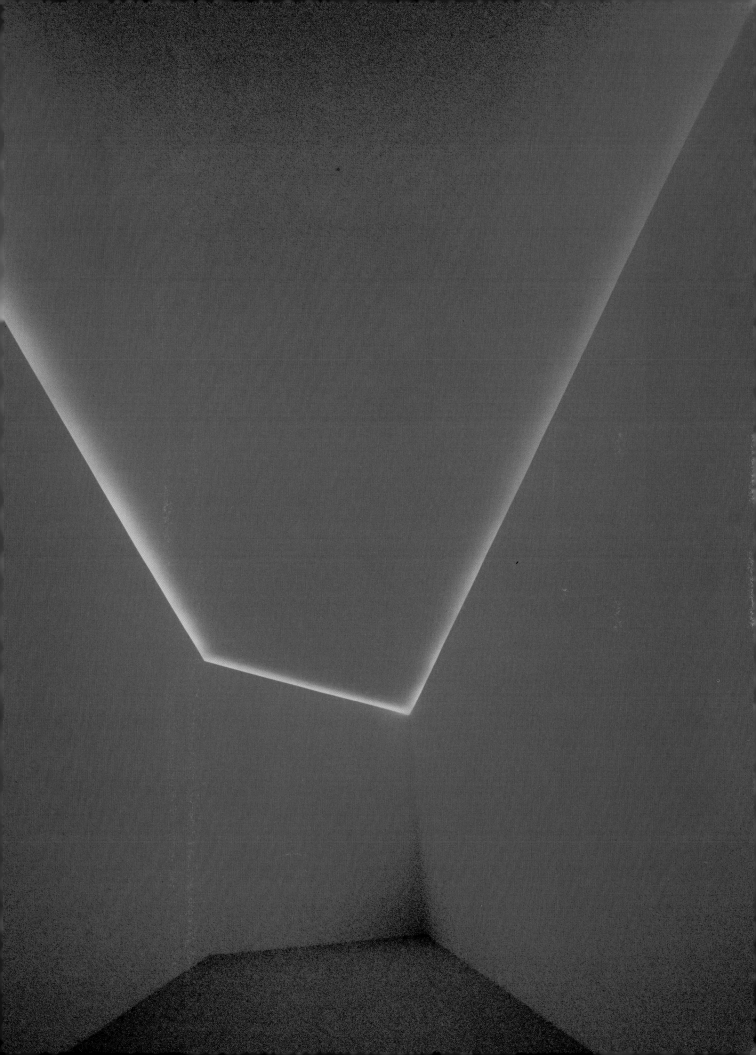

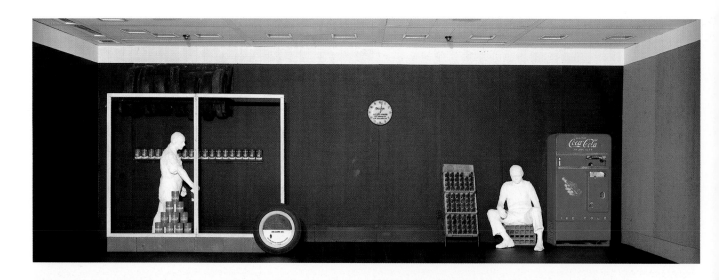

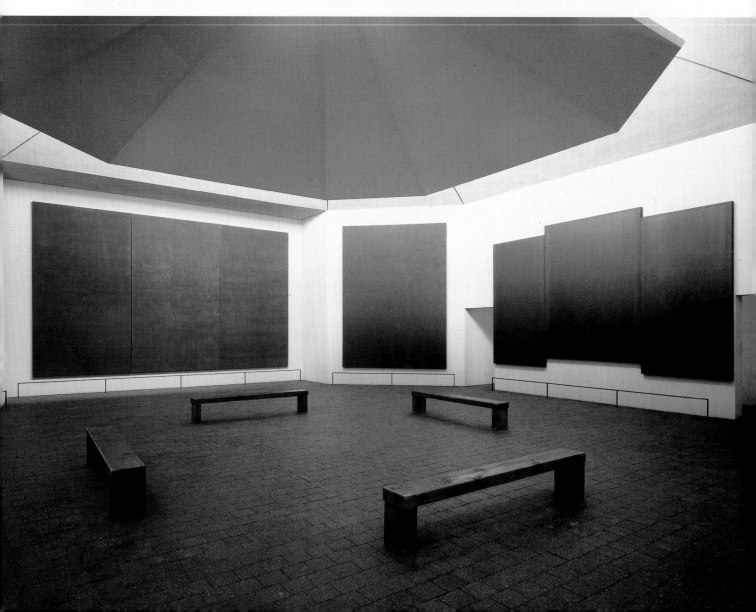

◄ 4.6 George Segal, *The Gas Station*, 1963–64 Plaster, metal, glass, stone, and rubber, 8 x 22 x 5ft (2.4 x 6.7 x 1.5m). National Gallery of Canada, Ottawa.
Do the highly saturated colors seem exciting or bleak in this context? Do you feel any difference in the industrial pigments surrounding each of the two human figures?

◄ 4.7 Mark Rothko: North, Northeast and East paintings, 1965–66 Oil on canvas. The Rothko Chapel, Houston. Surrounded by the somber, mysterious hues of Rothko's paintings, people tend to become very quiet and contemplative.

paintings seem to affect viewers profoundly. They enter very quietly and may linger for up to an hour, just sitting on the benches staring into the paintings, practicing yoga on the floor, or meditating.

▲ 4.8 Still from the film *Red's Dream,* produced by Pixar on Pixar Image Computer, 1987 "A Night in the Bike Store" is computer-rendered in local color, complete with shadow effects.

Local and Expressive Color

There are two opposite ways of using color in representational art. At one extreme is LOCAL color – the color that something appears from nearby when viewed under average lighting conditions. We think of the local color of a banana as yellow, for example. Local color can, however, be deceptive: many colors can be perceived across the surface of a banana. In the realistic scene from the computer-generated film, *Red's Dream* (**4.8**), the artists have programmed the computer to take into account the light from five different light sources; two of them cast shadows that affect both value and hue.

At the other extreme is the EXPRESSIONISTIC use of color, whereby artists use color to express an emotional rather than a visual truth. Whereas some sunsets are extraordinarily vivid and multihued, the highly saturated colors used by Karel Appel in *Sky with Clouds* (frontispiece) seem to reflect and evoke an inner response. Although the title gives no overt clue, Appel's emotional subject could be interpreted as the Dutch awareness of a possible airborne nuclear disaster. Colors usually associated with more cheerful situations may here be considered alarming, for we know they do not belong in the sky. Expressionistic use of color is open to individual interpretation, however. Someone with little fear of nuclear disaster and a love for intense sensation might revel in this tumult of colors, as if glorifying in the energy of an on-coming storm.

Compositional Effects of Color

5

A nalyzing color use from a strictly design-oriented point of view, we find that in addition to its emotional influence, colors can strongly affect the composition of a work. Color choices may be based as much upon their influence on perceptions of space, unity, and emphasis as upon the artist's desire for realism or psychological suggestion. Shapes and textures are part of this organizational process, but color also plays a major compositional role. In this chapter, we will be analyzing the effects of color irrespective of the ways artists have used shapes and textures; in reality, however, all elements of design are interrelated.

Spatial Effects

Colors can influence our spatial perceptions in many ways. For one thing, hues that are lighter at maximum saturation (yellows, oranges) appear larger than those that are darker at maximum saturation (blues, purples). In Jean-Luc Manz's *Lack auf Leinwand* ("varnish on canvas," **5.1**), all three circles are physically the same size. But optically the yellow seems to spread more than the red, which itself looks larger than the blue. According to the Munsell system of classifying colors, yellow reaches maximum saturation at step 8 of value, whereas red does so at step 5, and blue at step 4. And colors that are highly saturated tend to appear larger than those that are less saturated.

When a color expands visually, it may also seem clos-

▲ **5.1 Jean-Luc Manz, *Lack auf Leinwand,* 1986** Varnish on canvas, 15½ x 15½ ins (39.3 x 39.3cm). Collection of Banque Contanale Vaudoise, Lausanne.
Look carefully at the three circles here. Do they all appear the same size? What effects do the split ground colors have on the blue and red?

▶ **5.2 Beverly Dickinson, Greek landscape** Photograph.
Color contrasts are greatest in areas that are closest to the viewer; distant areas lose color contrast and may be tinged with a blue atmospheric haze.

◄5.3 David Bomberg, ***North Devon Sunset—*** ***Bideford Bay, 1946*** Oil on canvas, 24 x 30 ins (60.9 x 76.2cm). Laing Art Gallery, Newcastle upon Tyne.
How has Bomberg used color to push the far reaches of the bay back into distant space?

►5.4 Gene Davis, ***Diamond Jim, 1972*** Acrylic on canvas, 72 x 96 ins (182.8 x 243.8cm). Courtesy Gene Davis estate.
If you stare at Davis's painting, it will lose its flatness and become a complex series of intervals which seem to exist on different planes in space.

er to the viewer than those that seem to contract, leading to the common statement that warm colors advance while cool colors recede. In fact, artists can bring any color forward or push it back, depending on what other spatial tricks they use.

Nevertheless, an awareness of these color effects is often useful. Interiors that are physically small can be made optically larger through avoidance of large areas of highly saturated warm colors, which tend to fill the space visually. In David Hicks' room (4.1), red seems to be advancing into the room from all sides—walls, floor, and furniture—creating a cozy atmosphere. A high ceiling can be made to appear lower by painting it in a color that advances optically. In landscape design or painting, spatial planes can be set up by using both colors that advance visually and colors that recede visually.

Spatial advancing or receding also results from contrasts between colors. Through our experiences in the

world, we have learned that hue and value contrasts are greatest in things close to us, and less apparent in things seen at a great distance. This effect is called AERIAL PERSPECTIVE. In areas where there is particulate matter in the air, distant forms also appear bluish because of the scattering of short blue wavelengths in sunlight. In Beverly Dickinson's photograph of a Greek landscape (5.2), the greens get progressively bluer as distance increases. The monasteries are made of the same materials but the furthest one does not appear as bright. The apparent blueness of the landscape beyond almost merges with that of the sky. Automatically our brain assigns different spatial planes to these decreasing contrasts.

Representational artists have long used aerial perspective as one means of creating on a two-dimensional surface the illusion of deep space. So well established is this convention—and the real-life experiences on which it is founded—that contemporary artists can evoke sensations

of three-dimensional space through use of color alone. The scene in David Bomberg's somewhat abstract painting of sunset over Bideford Bay (**5.3**) appears to recede into very deep space without sacrificing lushness of color, largely because the blues of the water and the oranges and pinks of the sky both lighten in value across the centre of the canvas. Because the upper part of the canvas becomes dark again in contrast to the light area in the distance, it appears to advance over our heads, making the whole work appear to narrow vertically toward a distant vanishing point from the areas below and above our point of view.

In nonobjective as well as representational art, we interpret contrasts in hue and value as having spatial meaning. In contemporary nonobjective art, some areas appear to pop forward, while others seem to recede into the background. Gene Davis's *Diamond Jim* (**5.4**) is painted in stripes that continually vary in degrees of hue and value contrasts. At first glance it appears totally flat, but as you continue to stare at it without trying to hold it flat mentally, it will quickly develop a spatial pattern that goes in and out. Analyzing how each area works is very instructive. But Davis warns that he himself has used no color theories in creating his stripe paintings. He says:

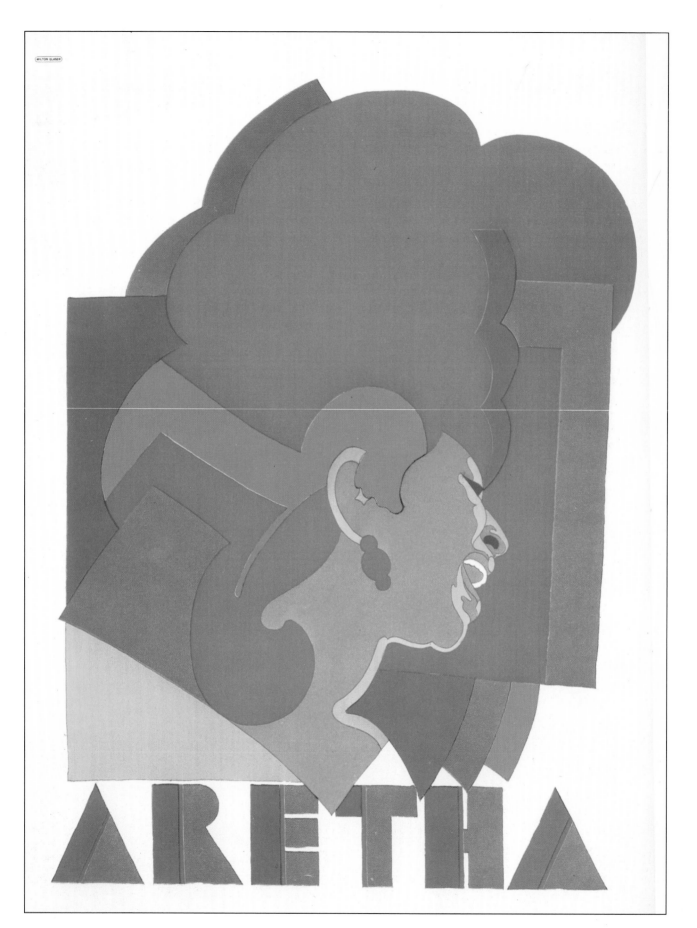

My whole approach to color is intuitive. If a certain color seems called for, I tend to use the reverse. Actually, I'm interested in color to define intervals . . . I'll put a red here on the right and, let us say, three feet away I will use another red. Now, that's going to define the interval between those two stripes in a way it would not do if I made this other stripe green, because then there would not be a dialogue established between those two stripes . . . My work is mainly about intervals, that is, like in music. Music is essentially time interval, and I'm interested in space interval.[1]

◄ **5.5 Milton Glaser, fold-out poster of Aretha Franklin**
With the exception of Aretha's face, Glaser's flat shapes appear to be lying side-by-side across a two-dimensional plane. Economical use of chiaroscuro gives the face a three-dimensional appearance.

▼ **5.6 Andreas Agas, Whales Point 38, 1987** Oil on linen, 4¹/₂ x 8ft (1.3 x 2.4m). Louis K. Meisel Gallery, New York.
The boldness of the solid red seems to balance the busy details of the multi-hued square exactly.

When colors are held to a consistent value and saturation level, even highly contrasting hues will appear quite flat. Mark Rothko (4.7) was one of the contemporary Western artists who asserted the reality of the two-dimensional surface. He and Adolf Gottlieb declared that "We are for flat forms because they destroy illusion and reveal truth."[2] Milton Glaser, in designing the Aretha Franklin poster (**5.5**), claimed that the flat shapes refer back to Art Deco and the work of Matisse. All except the yellow areas are consistently high in saturation; the yellows are lower in value than the high light of a highly saturated yellow, and thus correspond to values similar to those of the other hues. For the most part, the shapes lock together two-dimensionally like pieces of a jigsaw puzzle. They do not appear to overlap, a visual clue that would suggest three-dimensional space, because the uniformity of value and intensity hold them all on the same plane.

The only area of the Aretha Franklin poster that appears three-dimensional is the singer's face. By adding areas in a single lighter value, Glaser gives us the impres-

sion of a more rounded form in three-dimensional space. With great economy of means, he has achieved a CHIAROSCURO effect. Developed to a high art by Renaissance painters, chiaroscuro (literally, "light and shade") is the portrayal of the effects of light and shadow across a three-dimensional form. Areas facing a light source are executed in lighter values, while those curving away from the light are depicted in darker values. The mind of the viewer immediately interprets this information as evidence of three-dimensionality.

Leonardo shared his observations about some subtleties of chiaroscuro effects in real life:

> Colors seen in shadow will display less variety in proportion as the shadows in which they lie are deeper. And evidence of this is to be had by looking from an open space into the doorways of dark and shadowy churches, where the pictures which are painted in various colors all look of uniform darkness. Hence at a considerable distance all the shadows of different colors will appear of the same darkness. [3]

Balance and Proportion

In addition to suggesting spatial concepts, colors also give a visual suggestion of a certain weightiness or lack thereof. Generally speaking, highly saturated or busily detailed areas will draw attention and therefore seem to carry more weight than less saturated or visually simpler areas. In balancing the painting shown in Figure **5.6**, Andreas Agas found that a block of solid red was strong enough to offset all the business of the multicolored slashes of slightly less saturated hues on the right. If it did not, the painting would give the unsettling impression of being about to tip to the right from the balancing point in the center.

Artists may manipulate colors more for the sake of bal-

◀ **5.7 George Herriman, "Krazy Kat" strip, January 17, 1937** How has Herriman used colors to achieve visual balance in this cartoon strip?

ance in a composition than to establish a certain mood or to give a true representation of the external world. In a graphically brilliant cartoon strip of Krazy Kat (**5.7**), the artist George Herriman begins with a black sky in which floats a red and green moon, a fittingly isolated and eerie backdrop to Krazy Kat's statement, "I are illone." The sky and earth then change hues throughout the remaining panels, setting up blocks of color that are satisfyingly varied but yet visually balanced. The large rectangle of black sky on the bottom anchors the whole work and repeats the visual theme stated in the first panel. This repetition invites the viewer to compare the two, reinforcing the discovery that Krazy Kat's assumption of solitude is not at all true.

In some cases, artists create a feeling of imbalance with the help of color, but they do so in intentional violation of the principle of balance. Either way, the sense of balance or imbalance is usually achieved largely through intuitive manipulation of the elements of design (symmetry, light-and-dark contrast, intensity of color, for example). Colors affect each other so strongly that no absolute statements about relative visual weight can be made that would apply to all cases.

In contrast to balancing lighter and heavier visual weights, another kind of color balancing is designed to satisfy the viewers sense of aesthetic proportion. In every work of more than a single color, areas of light, dark, and medium values exist in a certain mathematical relationship to each other, as do more and less saturated colors and warm and cool colors. These relationships have been translated by some color theorists into rules for proper color use. Some theorists feel that warm and cool hues should cover approximately equal areas in a work, thus creating a satisfying symmetry of hues. A further theory, called the TRIADIC COLOR SYSTEM, taught early in the twentieth century by John M. Goodwin, recommended that in painting there should be an equal balance between "sunlight" hues (yellow and red) and "shadow" hues (blues). To achieve this effect, there were to be three parts of yellow to five parts of red to eight parts of blue (3+5=8). Other such recommendations will be discussed in Chapter 6, where we examine color theories. It must be noted, however, that many successful works do not conform to any theory of color balance.

Deneuve
by
Catherine.
—

Inside
every woman
is another
woman.
I designed
this perfume
for the
other woman
in you.

Deneuve

Call 1-800-622 · Pens for Catherine Deneuve to tell you more.
PARFUMS PHENIX © 1987

◀ **5.8 Advertisement for Deneuve perfume by Parfums Stern and Bloomingdale's**
The surprise and visual contrast of the red nose catches our attention; the yellow of the perfume is also accentuated by contrast.

Emphasis

A stronger consideration for many artists is the desire to emphasize certain areas of a work, drawing them immediately to the viewer's attention. This objective is particularly crucial in advertising art, for the viewer's attention must initially be seized and then guided in such a way that the product name and image will be noticed, despite all the visual distractions of modern life. One strategy involves visual understatement of everything surrounding the product so that it will stand out better, by contrast. In the two-page advertisement for Catherine Deneuve's perfume (**5.8**), everything on the right-hand page is neutral grays and black except for the elegantly sensual bottle of perfume, which is yellow and consequently appears extremely luscious and desirable in contrast with the neutrality of its setting. The real attention-grabber is on the left-hand page of the spread: the red nose on Deneuve's beautiful but grayed face. The red captures our attention and immediately makes us wonder why. To find out, we must slow down enough to read the hand-written messages on the right-hand page: "Inside every woman is another woman. I designed this perfume for the other woman in you." As we finish reading the message, we are back at the perfume bottle and the product name.

Sometimes a whole work calls attention to itself by contrast with its surroundings. Brightly colored sculptures such as George Sugarman's *Purple and Yellow* (9.6) stand out vigorously in dull-colored urban environments. When an artist uses an open palette—that is, choosing hues from all parts of the color wheel—at high saturation, as Milton Glaser did in his Aretha poster (5.5), we cannot help but notice the work. However, when an open palette is used with hues at very high or low values, rather than at maximum saturation, the effect will be much quieter, much subtler.

Unity

In a sense, there are many principles of design that can subtly unify a work of art. One that is often associated with the term "unity," however, is repetition. An organizational strategy in which color is used to unify a composition often revolves around repetition of a certain color theme. One possibility is a very LIMITED PALETTE. Instead of throwing in a bit of everything, the artist chooses only a few non-contrasting hues, perhaps combined with neutral whites, browns, grays, or black. The result is usually coherent because nothing pulls away from the central colors. A surprising use of a limited palette is *Wooden Door with Windows* by Vera Lehndorff

and Holger Trulzsch (**5.9**). Vera has been painted to look like a continuation of the door, in browns, whites, and blues that largely eliminate her natural skin tones. Where the transformation is successful, she almost blends optically with the building. We can hardly distinguish her arm against the white plaster, for there is very little contrast in value and hue between the two. Edges of shapes and forms become soft and nebulous when there is little color contrast between them, whereas edges of highly contrasting hues, as in the Aretha poster (5.5), are "hard," or sharply defined.

It is also possible to repeat colors throughout a composition when a more open palette is used. One way of doing so is to mix a little of a single main color into everything else, giving that color a subtle prominence in the work. Another approach is to allow the color of a single undertone to show through and thus influence all areas of the work. In Jules Olitski's *Twice Disarmed* (1.1), it is the orange that is repeatedly revealed, drawing together the soft pinks, blues, blue-greens, and yellows that appear to lie on top of it.

Although unity is a traditional objective in art, many contemporary artists have departed from tradition to create works that do not look or feel unified. Even Gene Davis, whose paintings are clearly unified by the repetition of stripes (5.4), muses:

> One of the things that really interests me a great deal is the idea of shattering the unity of a work of art. In other words, who says a work of art must have unity? Why not something that's fragmentary? . . . Fragments are often very interesting. . . When is a work finished? . . . Oftentimes when a work is just a fragment, it's better than it is when it's finished.[4]

This iconoclastic, intuitive approach is a counterpoint to heavily theoretical, intellectual approaches to color theory, which will be explored in some detail in the next chapter.

▶ **5.9 Vera Lehndorff and Holger Trulzsch,** *Wooden Door with Window* **(detail), 1975** Cibachrome photograph, 19¹/₂ x 19¹/₂ ins (49.5 x 49.5 cm).
With a limited palette, there may be variations in value but little variety in hue. Veruschka's natural coloring has been painted to match the limited palette of her surroundings.

Theories of Color Relationships

6

In order to work with colored lights and particularly with colored pigments, artists have long sought a framework for understanding the great variations among colors—how desired colors can be mixed from materials at hand and how these mixtures relate to each other visually. Specifics of color mixing will be covered in the next two chapters. In this chapter we will look at a number of attempts to devise a systematic framework for explaining the similarities and differences among colors.

Few artists have ever worked exclusively from a single color model. Thus theories can be useful and, like fingering and scale exercises on a musical instrument, help us both to recognize and employ the full potential of our media.

Early Theories

The ancient Hindu *Upanishads,* the early Greek philosophers and physicians, and the Arab physicist Alhazen all developed theories about color vision—what colors are and how we see them—to help explain the world around them. Aristotle's ideas drew particular attention. He explained similarities among colors by "the common origin of nearly all colors in blends of different strengths of sunlight and firelight, and of air and water" and recognized that "darkness is due to privation of light." To Aristotle, all variations among colors were the result of mixtures of darkness and light. Crimson, for example, was a combination of a certain amount of blackness with firelight or sunlight.

For many centuries after Aristotle, colors were explained according to his theories. The reds seen at sunrise and sunset were thought to result from the mixture of white sunlight with the darkness of night that was just departing or approaching; the red seen in fire was a mixture of the white light of the fire and the darkness of the smoke. Green was more shadow that light, and blue was more shadow still. These ideas followed Aristotle's procedure: "Verifications from experience and observation of similarities are necessary," he wrote in his *De Coloribus,* "if we are to arrive at clear conclusions about the origin of different colors."[1]

Leonardo da Vinci

Ever curious, always combining his dual passions for science and art, the great Renaissance artist Leonardo da Vinci (1452–1519) included color theorizing in his explorations. Although earlier philosophers had not treated white and black as colors, Leonardo included them among the "simple" colors that are the artist's basic tools: white, yellow, green, blue, red, and black. He observed the phenomenon later known as SIMULTANEOUS CONTRAST, which demonstrated that complementary hues intensify each other if juxtaposed:

> Of different colors equally perfect, that will appear most excellent which is seen near its direct contrary: a pale color against red; a black upon white; . . . blue near a yellow; green near red: because each color is more distinctly seen when opposed to its contrary, than to any other similar to it.[2]

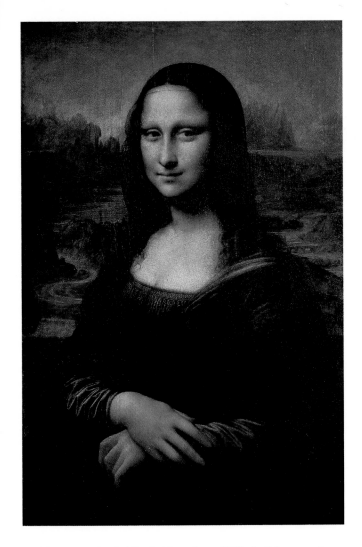

▲ **6.1 Leonardo da Vinci, *Mona Lisa*, 1503–6** Oil on panel,
30¼ x 21ins (76.8 x 53.3cm). Louvre, Paris.
Leonardo was a master at using subtle gradations of color to
create softly rounded forms and the illusion of deep space, known
as aerial perspective.

In the compilation of Leonardo's notes, published
posthumously in 1651 as the *Treatise on Painting,* he
devoted considerable attention to his observations on
blueness in the atmosphere. He concluded that we only
see this blue by contrast with black.

> I say that the blueness we see in the atmosphere is not intrin-
> sic color, but is caused by warm vapour evaporated in
> minute insensible atoms on which the solar rays fall, render-
> ing them luminous against the infinite darkness of the fiery
> sphere which lies beyond and includes it. . . . As an illustra-
> tion of the color of the atmosphere I will mention the smoke
> of old and dry wood, which, as it comes out of a chimney,
> appears to turn very blue, when seen between the eye and
> the dark distance. But as it rises, and comes between the eye

and the bright atmosphere, it at once shows of an ashy gray
color; and this happens because it no longer has darkness
beyond it, but this bright and luminous space . . . Colors will
appear what they are not, according to the ground which
surrounds them.[3]

In addition to carefully noting the optical effects of color
combinations, Leonardo also described aerial perspective
and shadow effects in considerable detail. He used his
observations of color to improve his own paintings,
developing to a fine art the subtly graded values and
hues of chiaroscuro modelling and the softly blended,
smoky quality known as SFUMATO, hauntingly represent-
ed in the hands, face, and hazy background landscape of
his famous *Mona Lisa* (**6.1**).

Newton

In contrast to Leonardo's careful observations of color
phenomena in real-life situations, the British physicist Sir
Isaac Newton (1642-1727) turned color theory into a lab-
oratory study of the properties of light, in an attempt to
derive some systematic, logical framework for under-
standing color. As we noted in Chapter 2, Newton
demonstrated that all the spectral hues are present in
white light and made from them the first color circle rep-
resenting color relationships (2.4). The segments of his
circle stood for the seven hues he distinguished in the
spectrum, although the choice of seven seems to have
been mystically based on the seven Musical Tones and
the seven Heavenly Spheres. He called these "primary
colors," and noted their "best" aspect falling on the cir-
cumference of the wheel midway between the lines
dividing the hues. Newton did not present his model in
color, but he envisioned that hues would be most
"intense and florid" on the circumference, becoming
gradually "diluted" with whiteness as they approached
the center. The center of his color circle was white, the
mixture of all hues in light. Newton noted that if only
two hues lying opposite each other on the wheel were
mixed, the result would not be white but "some faint
anonymous Colour." He suggested the possibility of pro-
ducing white by mixing three primaries but was unsuc-
cessful in his experiments:

I could never yet by mixing only two primary Colours pro-
duce a perfect white. Whether it may be compounded of a
mixture of three taken at equal distances in the circumfer-
ence I do not know, but of four or five I do not much ques-
tion but it may. But these are Curiosities of little or no
moment to the understanding of the Phaenomena of Nature.[4]

Moses Harris

Working with pigments rather than lights, an English
entomologist and engraver named Moses Harris devel-
oped the first model of pigment primaries. Following the
discovery by a French printer, J. C. Le Blon, in 1731, that
all hues could be reduced to mixtures of red, yellow, and
blue pigments, Harris created a beautiful illustration of
the theory. In his *The Natural System of Colors* (1766), a
highly influential though extremely rare volume, he
offered a detailed color circle in hand-tinted color (6.2).
In its center are the three pigment primaries, which he
called "primitives"—red, blue, and yellow—from which
all other colors could theoretically be mixed. From them
he derived the secondary or "compound" hues: orange,
purple, and green. Mixtures of primitives and com-
pounds yielded two intermediate stages, in which the
hue less represented in the mixture was named first
("orange-red" for instance, is more red than orange). The
eighteen colors so derived were then graded into shades
(darker values—cleverly created by optical mixing with
ever more closely placed black lines) and tints.

Goethe

In 1810 Johann Wolfgang von Goethe (1749–1832), the
great German poet who thought his color theory would
be of greater historical importance than his poetry, pub-
lished his book *Zur Farbenlehre,* or *Theory of Colors.* In
it he vigorously attacked Newton's theories of the physics
of light, which were still controversial, and returned to
the observational tradition of Aristotle and Leonardo.
Contrary to Newton, Goethe concentrated on color as a

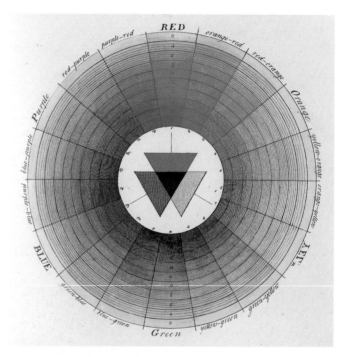

▲ **6.2 Moses Harris, color circle from**
The Natural System of Colors, c.1766 Royal Academy of Arts,
London.

From an initial set of three primaries, Harris derived a color circle
with 18 hues, shaded with black as they approached the center.

visual phenomenon happening in the eye, rather than as
an aspect of light. It was Goethe who gave us extremely
detailed descriptions of visual phenomena that are still of
interest to artists, such as colored shadows, simultaneous
contrast, and successive contrast.

As far as colored shadows are concerned, Goethe
observed that strong midday sunlight produces a black or
gray shadow on white—or a darker value of the sur-
face—but that under other conditions, shadows will be
the hue complementary to the hue of the light. These
other necessary conditions were that the light be of some
hue other than white and that the shadow be somewhat
illuminated by a secondary light source. The stronger the
colored light, the paler the shadow; thus the most bril-
liant colored shadows result from the palest colored
lights. Roger Crossgrove's photographic study of colored
shadows (**6.3**) employs a bank of red, green, blue, and

yellow lights with rheostats for dimming the lights to increase the saturation of the shadows. Where the shadows overlap, you can see secondary mixtures, such as orange and purple.

Although Goethe gives instructions for producing colored shadows experimentally, he also describes their natural occurrence in scenes like the following, which took place in snow- and frost-covered mountainous terrain:

During the day, owing to the yellowish hue of the snow, shadows tending to violet had already been observable; these might now [at approaching sunset] be pronounced to be decidedly blue, as the illumined parts exhibited a yellow deepening to orange. . . But as the sun at last was about to set, and its rays, greatly mitigated by the thicker vapours, began to diffuse a most beautiful red colour over the whole scene around me, the shadow colour changed to a green, in lightness to be compared to a sea-green, in beauty to the green of the emerald. The appearance became more and more vivid: one might have imagined oneself in a fairy world, for every object had clothed itself in the two vivid and so beautifully harmonising colours, till at last, as the sun went down, the magnificent spectacle was lost in a grey twilight, and by degrees in a clear moon-and-starlight night.[5]

The Impressionists and Postimpressionists acknowledged these observations, adding color shadows to the bright hues of some of their work, as in Monet's paintings of Rouen Cathedral (3.8 and 3.9) and Van Gogh's *Still-Life with Drawing Board and Onions* (**6.4**). Here the shadows of plate and book are indigo, rather than simply a darker yellow as one might expect, and reflection off the gold borders of the book creates a secondary shadow of the complementary purple.

Goethe also described complex color sensations such as the "catotropical" colors seen when colorless light strikes a colorless surface, such as a spiders web or mother-of-pearl, and the colors seen in halos around the moon. He suggested two models for relationships between colors. One was a circle with lines linking complementary hues superimposed on two triangles delineating primary and secondary triads (**6.5**). The second was a triangle (**6.6**) with red, blue, and yellow at its outermost points and the secondaries green, orange, and purple in the middle. Dividing primaries and secondaries were further triangles denoting the less saturated, lower-value tertiaries that would theoretically result from mixing two secondaries with the adjacent primary.

◀ **6.3 Roger Crossgrove, *Study in Colored Shadows*, 1987** Photograph.
The cast shadows seen here are the complementaries of the lights used to make them, true to Goethe's observations.

▲ **6.4 Vincent van Gogh, *Still-Life with Drawing-Board and Onions*, 1889** Oil on canvas, 19¹/₂ x 25¹/₄ins (45 x 64cm). Collection State Museum Kroller-Müller, Otterlo, The Netherlands.

Van Gogh's use of brilliant colors included color shadows in this painting, following Goethe's observations that a colored light will create shadows in its complementary color.

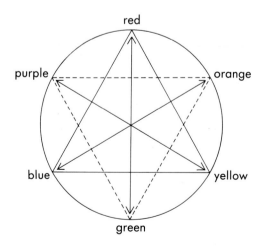

▲ **6.5 Goethe's color circle** Triangles join the triads of primaries and secondaries and, in this reconstruction, arrows link complementary hues.

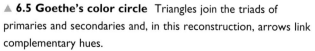

▲ **6.6 Goethe's color triangle** Goethe offered an alternative model in which the primaries red, blue, and yellow were the corners of a triangle, secondaries the sides, and tertiaries the mixtures of the three surrounding colors. The tertiaries were therefore probably of low saturation, but we do not have an actual colored sample of what Goethe envisioned.

Runge

The same year that Goethe published his *Farbenlehre*, the German painter Philipp Otto Runge (1777–1810) published *Die Farbenkugel* (*The Color Sphere*)—the first attempt at a three-dimensional model of color. Runge presented color relationships as a sphere with hues around its equator, graded in two steps toward white at the top and two steps toward black at the bottom (**6.7**). One hundred and fifty years later, Johannes Itten, a great German teacher of the art of color, adopted and adjusted the same model, considering it "the most convenient for plotting the characteristic and manifold properties of the color universe."[6] Itten displayed the whole sphere at once by opening it into a twelve-pointed star, with the white top as its center (**6.8**).

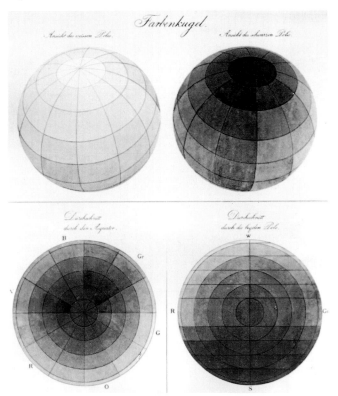

▲ **6.7 Philipp Otto Runge, color sphere from *Die Farbenkugel*, Hamburg, 1810** Collection Faber Birren. Runge presented his pioneering model of a color sphere from various angles to show its three-dimensional relationships.

Chevreul

Interest in codifying and understanding color relationships was so strong in the early nineteenth century that another major contribution soon appeared: *The Principles of Harmony and Contrast of Colors* by Michel Eugène Chevreul, a renowned chemist and director of the dye house for Gobelins tapestries in Paris. Chevreul (1786–1889) developed a finely graded two-dimensional color circle. His work with liquid dyes verified the usefulness of red, yellow, and blue as primaries and orange, green, and violet as secondaries. His greater contribution to the art of color, however, was his elucidation of the laws governing the visual effects of colors upon each other: simultaneous contrast, successive contrast, and optical color mixtures. From these he derived certain suggestions about how colors should best be used: the principles of harmony.

▲ **6.8 Johannes Itten, Runge's color sphere presented as a star** In Itten's version of Runge's model, certain color relationships—such as complementarity, value gradations, and close harmonies (analogous colors)—can readily be seen.

Chevreul noted that colors with little contrast, such as hues adjacent to each other on a color circle (ANALOGOUS HUES), will tend to blend optically, whereas highly contrasting colors (such as complementary colors lying opposite each other on the color circle) used in sufficiently large quantities will make each other appear more brilliant, without any optical change in their hue. If small areas of opposite colors are presented together, on the other hand, they will tend to blend visually and thereby create a duller overall color sensation. These effects, to be explored in Chapter 9, led Chevreul to recommend that highly contrasting colors be used in large juxtaposed areas, whereas analogous colors should best be used in small, diffused amounts. He stated: "The contrast of the most opposite colors is most agreeable. . . The complementary assortment is superior to every other."[7] When using analogous hues, Chevreul asserted that combinations worked best when the key hue was a primary.

Chevreul's book is full of such prescriptions. While they were of great interest to many painters of the times, such as the Impressionists and Postimpressionists, few consciously followed his recommendations for proper color harmonies. Monet rejected theories; Pissarro read Chevreul's work but claimed there was no intellectual basis for what he was trying to do in his paintings. Georges Seurat, however (9.26), attempted to apply the laws of color theory precisely to the craft of painting, and in doing so relied not only on Chevreul but also on his successor, Ogden Rood.

Rood

Trained as an artist as well as a scientist, the American Ogden Rood performed extensive research into the optics of color, declaring it to be "a sensation existing merely in ourselves" rather than an absolute fact of the physical world. He identified the three major variables that determine the differences between colors as purity (saturation), luminosity (value), and hue. Through painstaking experiments with a variety of spinning disks and other equipment, he demonstrated that pigment hues can be mixed optically to form the sort of luminous mixtures one would get when mixing lights.

▲ **6.9 Ogden Rood, circle of complementaries from** *Modern Chromatics*, **1879** Rood's experiments with optical color-mixing contraptions enabled him to develop this precise matching of complementary hues.

Such mixtures would be blended by the eye if lines of color or "a quantity of small dots of two colors very near each other" were viewed from a certain distance. "For instance," he wrote in his 1879 classic, *Modern Chromatics*,

> Lines of cobalt-blue and chrome-yellow give a white or yellowish-white, but no trace of green; emerald-green and vermilion furnish when treated in this way a dull yellow; ultramarine and vermilion, a rich red-purple, etc. This method is almost the only practical one at the disposal of the artist whereby he can actually mix, not pigments, but masses of coloured light.[8]

Rood felt that it was important for artists to know exactly which colors were directly complementary to each other, so that they

> . . . are made to glow with more than their natural brilliancy. Then they strike us as precious and delicious, and this is true even when the actual tints are such as we would call poor or dull in isolation. From this it follows that paintings, made up almost entirely of tints that by themselves seem modest and far from brilliant, often strike us as being rich and gorgeous in colour, while, on the other hand, the most gaudy colours can easily be arranged so as to produce a depressing effect on the beholder.[9]

From his experiments, Rood developed the circle of contrasting colors shown on Figure **6.9**.

Rood's work has been highly influential among artists, beginning with POINTILLIST techniques of optical blending. Yet he himself deplored the ways his theories were used, considering the results most unattractive. His son, an enthusiastic student of the Impressionists, described Rood's reaction to an exhibition of their paintings:

'. . . by a lot of Frenchmen who call themselves "Impressionist," some are by a fellow called Monet, others by a fellow called Pissarro, and a lot of others.'

'What do you think of them?' I ventured.

'Awful! Awful!' he gasped.

Then I told him what these painters said of his theories.

This was too much for his composure. He threw up his hands in horror and indignation, and cried—

'If that is all I have done for art, I wish I had never written that book!'[10]

Munsell

For all his painstaking experiments, Rood himself was unable to devise a "scientifically accurate color-system," as he admitted to Albert Munsell. Working with references to Rood's systems and methods to devise a system simple enough for schoolchildren to understand, Munsell himself developed the standards for color notation still

▼ **6.10 The Munsell Color Tree** Albert Munsell's model attempted to show gradations in saturation horizontally without changing value, which was represented along the vertical axis. Gradations in saturation were presented as mixtures of hues with their complements, based on the opposite hues in a 10-point color circle.

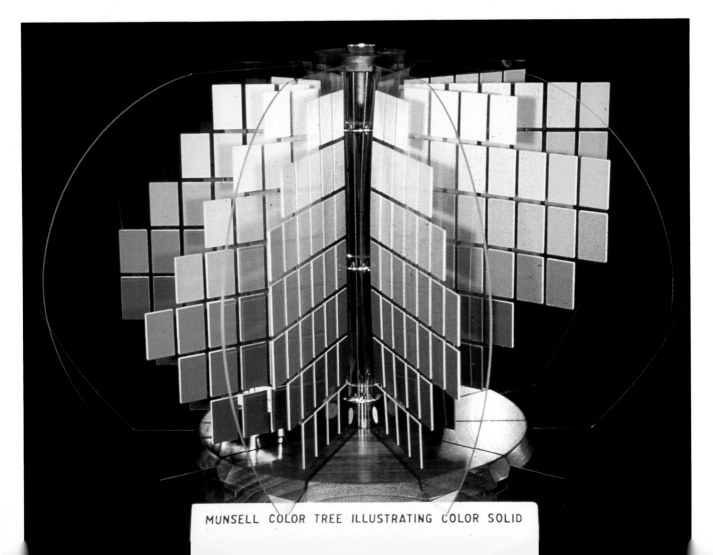

MUNSELL COLOR TREE ILLUSTRATING COLOR SOLID

PLATE I.

Y

G

B

R

P

Light Values

Middle Values

Dark Values

P B G Y R

Y

G

R

B

P

Arithmetical gray scale

Geometric gray scale

▲ **6.12** Following the work of Gustave Fechner, Ostwald made use of the visual fact that to achieve optically equal steps in value gradation, one must use geometrically rather than arithmetically changing pigment percentages.

used as the basis for pigment specifications in the United States, Great Britain, Germany, and Japan. These were first published in 1905 in his book *Color Notation.*

Munsell used three dimensions for describing color variations: hue, value, and chroma (saturation), each graded in equal steps, as measured by a photometer. These dimensions form an irregular three-dimensional model (**6.10**, shown in dissection in Figure **2.11**), for the hues reach maximum saturation at different steps of value and also vary in the number of steps from neutral gray to maximum saturation (**6.11**). Munsell gave each step in each direction a distinctive number reflecting the three dimensions, replacing the murky vocabulary of popular color names, such as "hellish blue" and "celestial blue." As we noted in Chapter 2, Munsell departed from tradition by using five primary hues—red, yellow, blue, green, and purple—instead of three, thus placing rather different hues opposite each other as complementaries. Whereas Rood had emphasized the truth of visual sensations, without being able to derive a mathematically log-

ical system from his observations of color realities, Munsell sought an objective standard for precise pigment specifications.

Ostwald

Another early-twentieth-century color theorist, the German scientist Wilhelm Ostwald (1853-1932), won the Nobel Prize in 1909 for his work in chemistry, and his color model bears the stamp of a highly scientific mind. To quantify color variations, Ostwald based them on mathematical steps from black to white, in geometric rather than arithmetical progression, and on an analysis of the light apparently reflected or absorbed by a surface. Arithmetical progression, in which the absorption value of a gray is added to itself in increments of one—1, 2, 3, 4, 5, 6, and so on—does not give the visual appearance of equal distance between steps. This effect is obtained instead by increasing the value geometrically—1, 2, 4, 8, 16, and so on. Both are illustrated in Figure **6.12**.

Ostwald's system of color specification, first presented

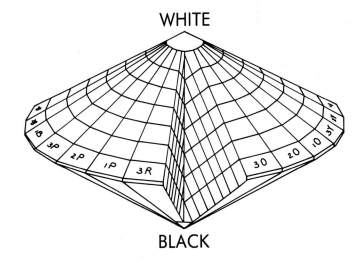

WHITE

BLACK

▲ **6.13 Wilhelm Ostwald, color solid from *Color Science*, 1931** Ostwald's double pyramid model is based on a series of double triangles in which pure hues form the equator, and black and white the poles. Within this framework, mixed colors are derived in quite a different manner than in Munsell's model.

◀ **6.11 Albert Munsell, diagram of equal steps to maximum saturation** Munsell noted that different hues reach maximum saturation at different steps of value, and that they also differ in the number of equal steps from neutral gray to maximum saturation.

▶ **6.14 A generic slice through the Ostwald solid** Ostwald's notation gives the mathematical percentages of "pure color" (C), white (W), and black (B), used as a basis for his model.

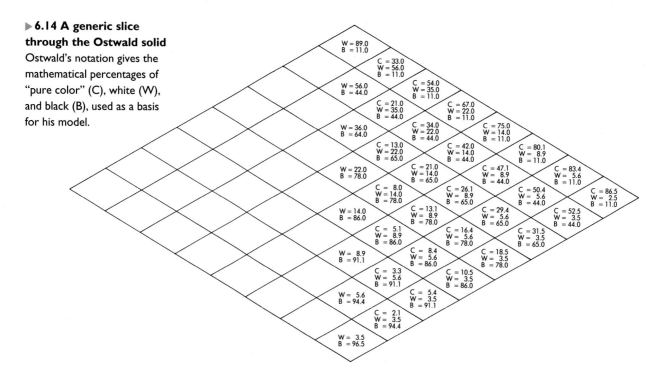

in 1917, was portrayed as a three-dimensional series of triangular cross-sections. White formed the upper pole or top of the triangles, black the lower pole, and 24 pure hues circled the equator (**6.13**). To create the twelve double triangular charts from which the solid is constructed (**6.14**), Ostwald mixed the fully saturated hues with measured amounts of black and white and gave each sample a notation with percentages of color (C), white (W), and black (B). Moving diagonally toward white from the equator, the amount of black is held constant as white increasingly takes the place of the original hue, which Ostwald called the "full color." This process is called TINTING. The opposite process, called SHADING, adds black and decreases the full color, while white is held constant. Moving directly toward the center is called TONING; here both white and black increase while the full color is decreased, thus graying it.

Ostwald's addition of black and white is quite a dif-

ferent procedure from Munsell's system of graying hues by mixing them with their complement. Moreover, some artists have rejected Ostwald's model as being too scientific to use in the actual creation of art or to represent the dynamic realities of color. The colorist Adolf Holzel was strongly opposed to the limitations of trying to make all color differences fit into variations of black and white content. Holzel himself held that colors contrasted with each other in seven ways: hue, saturation, area, value, complementarity, warmth and coolness, and simultaneous contrast. The artist Paul Klee was particularly disturbed by what he considered Ostwald's "negative reaction to colour."[11] Nevertheless, Ostwald's symmetrical system well suited certain rational approaches to art, such as the Bauhaus attempt to merge technology with the arts and crafts. And it has been useful in grading colors for printing processes, one of the subtractive methods of color mixing to be explored in the next chapter.

Subtractive Notation and Mixing

7

One of the most complex aspects of contemporary color use is the mixing and specification of precise colors. Until the nineteenth century, painters and dyers mixed their own colors from private recipes. However, with the growth of industry and the availability of premixed oil paints, the need arose for precise means of communication between suppliers and users of pigments. "Cadmium red medium" from one paint company differed from paint of the same name from another. Furthermore, industrial processes brought expectations that colors could be precisely replicated in printing and dyeing or matched exactly to a sample. To standardize ways of specifying and mixing colors, a number of systems have been developed. None is as sophisticated as the human eye. Under optimal lighting conditions, an average human being can distinguish up to ten million different colors. But matching colors by eye is a subjective business, for different people see colors somewhat differently. Standardization of prepared pigments, moreover, diminishes the amount of guesswork in pigment mixing, which remains a complex art.

Dye and Pigment Sources

The major subtractive colorants—those whose apparent color depends on the wavelengths they reflect—are dyes and pigments. DYES are coloring materials dissolved in a liquid solvent; PIGMENTS are bits of powder suspended in a medium such as oil or acrylic. Materials to be colored absorb dyes, whereas pigments sit on the surface. LAKES are pigments made from dyes, extending the range of pigment colors.

Since the end of the Ice Ages, humans have used natural plant and animal materials to form dye solutions into which fabrics were dipped. Berries, fruits, leaves, lichens, and roots were found to have different coloring properties. The root of the indigo plant was for centuries the only source of blue dye. The stigma of the crocus yielded a yellow dye called saffron. Cochineal, a brilliant red dye, was created from the dried bodies of certain female scale insects that fed on tropical American cactus plants. And royal purple dye used in Greek and Roman courts was derived from the glandular mucus of a certain sea snail. Synthetic dyes first appeared in 1856, with the discovery that the addition of alcohol to coal-tar yielded a purple that could dye silk. The family of dyes derived from this method—which include black, green, and red—are called ANILINE DYES. A few years later, a more color-fast, vivid, multihued family of dyes called AZO DYES were developed synthetically from petroleum. Farms producing precious natural dyestuffs, such as madder roots in Europe and indigo in India, were largely put out of business by these new discoveries. Experimentation with synthetics continues apace. By 1980 three million synthetic dyes had been discovered and several new ones are announced every week.

The colors produced by pigments and their mixtures are more difficult to predict, for light is reflected from the surfaces of the pigment particles. While natural dyes were substances that would dissolve in water, those used as pigments were usually insoluble. The earliest pigments

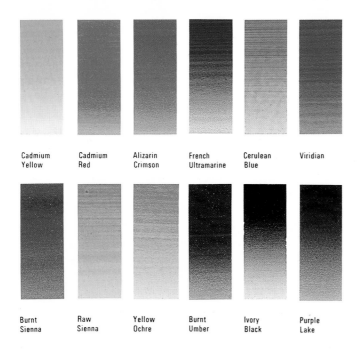

Cadmium Yellow Cadmium Red Alizarin Crimson French Ultramarine Cerulean Blue Viridian

Burnt Sienna Raw Sienna Yellow Ochre Burnt Umber Ivory Black Purple Lake

▲ **7.1 Chart of contemporary paint pigments**

were minerals extracted from the earth, used by cave dwellers for unsaturated yellows, browns, reds, and black. As early as 40,000 B.C., however, many were heated to increase the range of colors available. Over the centuries, the deep blue of ultramarine was made from lapis lazuli, the Romans' bright cinabar red from a sulphide of mercury, the cadmium yellows and oranges from greenockite, and the green so often seen in medieval paintings from malachite.

The next major progression in the pigment palette available occurred during the Middle Ages, when pigments were chemically combined or changed to form new colors. The green of verdigris was the result of hanging copper plates over vats of vinegar to form a green crust on the copper. Certain blues were copper-ammonia compounds made from this verdigris. Zinc white is an oxide of zinc. And as in dyes, laboratory experimentation with petroleum has yielded a vast array of artificial pigments whose saturation, purity, and durability often exceed that of natural pigments. These are now available to painters in premixed tube colors, some of which are labeled to reflect their resemblance to natural pigments as well as their place within one of the numerical color specification systems. A sample palette of paint pigments is shown in Figure **7.1**.

Today, the same pigments are used in many forms— oils, acrylics, chalks, egg tempera, watercolors. Only the media, binders, and range of pigments used differ among these forms. We will explore the complexities of pigment mixing in two popular media—oils and acrylics—below, after first examining attempts to standardize ways of examining colors and specifying desired pigmentation.

Lighting

In addition to the sources of coloring material, the apparent color of a reflective surface will also depend upon the light falling on that surface. For CRITICAL COLOR MATCHING—the technical term for mixing colors to match a given sample—natural daylight from the north (in the northern hemisphere) is used as a standard. As shown in Figure **7.2**, north sky daylight at 7400 Kelvin (a measure of the color temperature of the light source) contains a balanced combination of all visible wavelengths, with a tendency toward the blue end of the spectrum. By contrast, incandescent lighting is high in red and yellow wavelengths, with relatively little energy from the greens, blues, and violets (**7.3**). As indicated in Figure **7.4**, ordinary fluorescent lights have sharp peaks in certain areas of the visible spectrum. These color distortions in incandescent and fluorescent lights will obviously affect the colors seen.

Because optimal north sky daylight is not reliably available, critical color matching must be done under special lights. Some fluorescent lights attempt to provide a fuller spectrum of wavelengths; filtered tungsten lamps and quartz halogen lights are said to approximate north sky daylight more closely. However, because many colors will actually be viewed under regular fluorescent or incandescent light, colors are often compared under equivalent lighting conditions.

The Munsell Notation System

The most widely adopted way of communicating about colors is the system developed by Albert Munsell and subsequently refined and recognized by the National Bureau of Standards, the Munsell Laboratory, and the

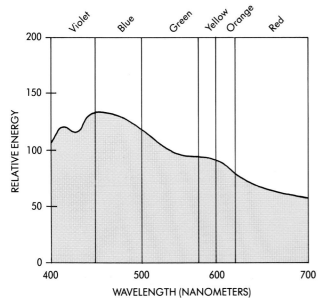

▲ **7.2 Relative energies of wavelengths in natural daylight**

▲ **7.3 Relative energies of wavelengths in incandescent light**

▲ **7.4 Relative energies of wavelengths in fluorescent light**

Optical Society of America. It is the basis for standards used in the United States by various official color councils, by the Japanese Industrial Standard for Color, the British Standards Institution, and the German Standard Color System.

As we saw in Chapter 2, Munsell graded colors in equal visual steps along three variables: hue, value, and chroma (saturation). Hues are divided into 100 equal steps and displayed around a circle (**7.5**) based on ten major hues: red, yellow-red, yellow, green-yellow, green, blue-green, blue, purple-blue, purple, and red-purple. Each is designated by its beginning initials in the inner circle and in some Munsell notations. Between each of these major hues are many intermediate hues, indicated by an infinitely expandable decimal system. These can be expressed either as points from 1 to 100, as on the outer circle, or as ten steps from one major hue to another, as in the intermediate circles, with the hue initials included in the designation and the number 5 indicating the midpoint in each hue family. The central N represents neutral gray.

▼ **7.5 The Munsell 100-hue circle** Two ways of specifying colors are provided—the numbers from 1 to 100 around the circumference, or the letter and numbering system in the inner circles.

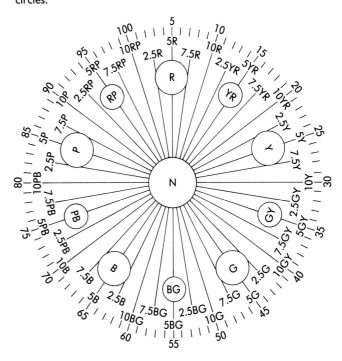

Values are expressed numerically as steps from absolute black (0/) to absolute white (10/), with the symbol 5/ used to indicate middle gray and its value equivalent in all the chromatic hues. In reality, absolute white and absolute black are never seen in material form. The third designation in the Munsell color notation is chroma, conceived as equal steps from neutral gray to the greatest saturation seen in each hue at that level of value. The complete notation combines all three variables as hue/value/chroma. A brilliant vermilion red might be designated as 5R 5/14, whereas a less saturated "rose" red of equal value might be 5R 5/4. Finer distinctions in each variable can be indicated by decimal division (that is, 4.5R 4.3/11. 8).

The C.I.E. System

To standardize color notations further, the 1931 International Commission on Illumination (*Commission Internationale de l'Eclairage,* or C.I.E.) developed a visual means for precise color matching that relied on mechanics rather than subjectivity. This system is based on lights and is therefore only indirectly applicable to pigments.

A COLORIMETER—a computerized SPECTROPHOTOMETER, which measures the light energy given off by each wavelength in a reflective sample or light source—is used to measure three variables. One is LUMINANCE, the intensity of the light given off. We will look at this variable in Chapter 8. The other two, of relevance to subtractive mixtures, are hue and saturation. Together their values determine what is called the CHROMATICITY of the color by placing it on the horseshoe-shaped CHROMATICITY DIAGRAM developed by the C.I.E. (**7.6**). Pure spectral hues are placed by wavelengths around the perimeter, with nonspectral purples represented by a straight line across the bottom. The center is the neutral sum of all hues. This point is white in light mixtures; in pigment mixtures, adding hues to each other "subtracts" light, creating a darker mixture that reflects less light.

Note that the areas covered by certain wavelengths in the C.I.E. diagram—particularly the blues and greens—are far larger than the yellow, orange, and red segments.

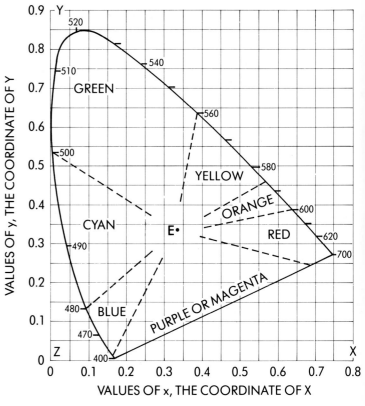

▲ **7.6 The C.I.E. chromaticity diagram** The purest spectral colors are located on the outside of the flat-iron shape, with nonspectral purple across the bottom and the neutral sum of all hues (E = equal energy) in the center.

This is so because the shape of the diagram is based on the color visibility or SPECTRAL SENSITIVITY CURVE shown in Figure **7.7**. According to scientific research, a person with normal vision looking at colored lights of equal energies under good illumination will perceive the yellow-green part of the spectrum (peaking at 555 nanometers) as brighter than all other parts. The visibility of lights drops off sharply toward each end of the spectrum. However, using this characteristic of vision distorts the eye's ability to distinguish between different colors, making differences seem greater in the green part of the diagram and smaller in the red part, than they are in visual truth. The concept of *just-noticeable difference* is important in some color-matching situations; one may have to know how many steps of just-noticeable difference are allowable in approximating the color of a given sample. Because the shape of the standard C.I.E. chromaticity diagram distorts just-noticeable difference, uniform chromaticity charts have been developed for use in some disciplines.

Despite its limitations in representing the degree of noticeable difference between colors, the C.I.E. system offers a standard which is objective and does not depend on the permanence of pigmented swatches used as a control. The sample-based Munsell and Ostwald systems have now been improved by the establishment of C.I.E. values for the standard swatches; if these fade, new ones can be prepared in accordance with the relevant C.I.E. classification.

Interestingly, the fact that C.I.E. measurements are based on wavelengths rather than actual color composition means that the same color can be created from many different mixtures. If a paint company wants to make sure that a new batch of a certain red-purple matches its previous batches, it can analyze the new batch with a spectrophotometer. If the new batch deviates numerically from the standard values of luminance, hue and saturation for that red-purple, quantities of pigment can be added until the new batch is the numerical equivalent of older ones—even though its actual pigment composition may be different!

◀ **7.7 Spectral sensitivity of the normal eye** Cone vision is used to assess the relative brightness of colored lights of equal energies but varying wavelengths.

Mixing Oils and Acrylics

As an artist, you can apply this same scientific principle of considering many possibilities for mixing a desired color. But you cannot mix colors using traditional two-dimensional color circles (2.6) for reference because they typically show all hues at maximum saturation—and therefore different steps of value. As a tool to guide paint mixing, Binney and Smith, suppliers of Liquitex oils and acrylics, have prepared color maps that display not only hue but also value and saturation relationships, two-dimensionally (**7.8**). To offer a broader mixing palette than that based on the ten-hue Munsell system, the color map adds yellow-orange and yellow-green, for a total of twelve basic hues, arranged horizontally. Vertically they are graded by value. Changes in saturation are represented within each color chip. Each starts on the left with the most saturated form available at that level of value (many of which are available premixed as tube colors—those that must be mixed by the artist have a palette knife symbol below). One is then shown, in two steps, the effects of mixing increasing amounts of a neutral gray of the same value, thus lowering the saturation of the color. Less saturated versions of a hue can also be mixed by adding amounts of its complementary; doing so tends to "muddy" the mixture, as shown in Figure **7.9**. Some colors opposite each other on various color wheels may not be exact complementaries, and thus do not produce a neutral gray when mixed. For some purposes, however, an imprecise, softened, or muddy mixture may be what is required.

To mix hues not immediately available in a premixed tube, there are at least three possibilities, as indicated in Figure **7.10**: adjacent diagonals, a horizontal mixture, or a vertical mixture. To mix a yellow 5, for example, one could mix yellow-green 6 and yellow-orange 4, or yellow-orange 6 and yellow-green 4, or yellow-orange 5 and yellow-green 5, or yellow 6 and yellow 4. The color map can be bent into a cylinder, just as Newton bent the straight spectrum into a circle, thus juxtaposing the red-purple end and the purple end for mixing purposes. Any of the adjacent combinations will yield an approximation of the desired color in the middle, depending on the exact amount and characteristics of the mixing colors used. Tube colors vary in permanency, clarity, intensity, and

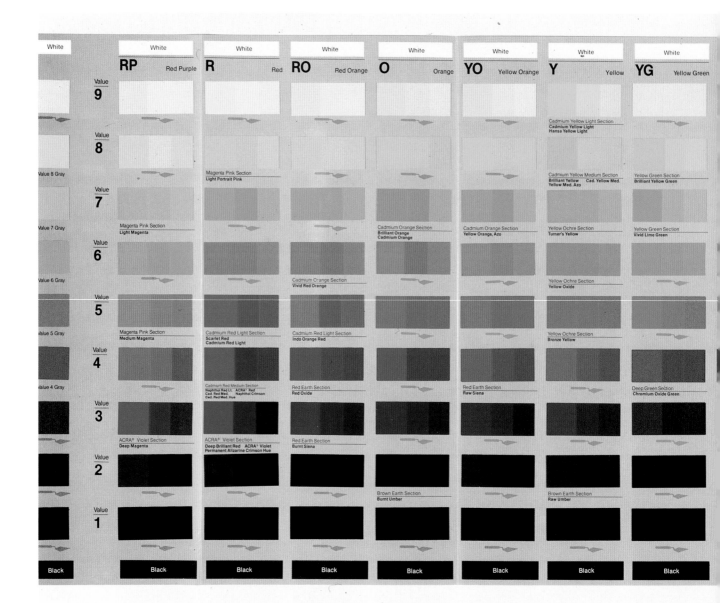

tinting strength. The natural form of chrome yellow, for example, turns green or even greenish black over a long period of time; natural cadmium yellow is far more permanent but harder to use since it quickly dulls when mixed. Tube colors also vary in cost and toxicity, two factors one may also need to consider before purchasing a basic palette of tube colors.

Although many color theories posit that all colors can be mixed from three primaries, in practice this cannot be done with paint pigments. Yellow is a particular problem, for a high-value maximum saturation yellow cannot be created by adding white to a value 5 yellow, since this will decrease its saturation while lightening its value. Furthermore, if black is added to a high-value yellow to lower its value and saturation, the result is greenish, no matter what brand of paints is being used. Contrary to the idea that yellow is a primary color that cannot be mixed, we find that it can be mixed from the hues around it on the color map, as indicated above.

To mix all the colors in the color map, we therefore

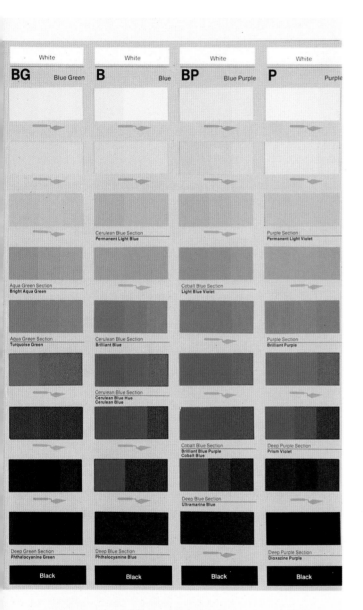

▲ **7.9** If its complementary is added to a hue, they will gray each other in a "muddier" fashion than if a neutral gray of the same value is added.

▼ **7.10** To create a hue with reference to the color map shown in Figure 7.8, a diagonal, horizontal, or vertical combination of the two colors on either side of the desired hue can be mixed. Using more distant colors for mixing distorts the result.

▲ **7.8 The Liquitex® acrylic color map** Hues are represented horizontally and values vertically, with two steps of decreasing saturation given on each paint chip. The Liquitex oil color map is almost identical to this one.

The best results are usually achieved by mixing the Liquitex® colors nearest to the desired Mixed Color. Mixed Colors will vary slightly depending upon the nature and proportion of the Manufactured Colors chosen.

This Physical Fact reduces to this Psychological Effect

recommend that students start with a basic set of twelve tubes of oils or acrylics: value 5 of red-purple, red, yellow, green, blue, and purple; value 8 yellow; value 3 red; base value blue-green; base value 75 blue-purple, Titanium White, and Mars Black. Higher values can be created by mixing in some white; darker values can be mixed by adding black or the appropriate base value—a very dark step in the hue. These measures will tend to lower the saturation of the brilliant tube colors. Saturation can also be lowered by mixing complementaries or adding neutral gray. To lower saturation without lowering value, some white may be added.

Additional hues can be mixed from adjacent colors in any of the four possible directions mentioned above. However, if the mixed pigments are of equal value, they will produce a result of lower value, for pigment mixing is a subtractive process. It may be necessary to compensate by reaching slightly higher in value in one or both hues.

GLAZES—paints thinned to transparency with a medium, used both in oils and acrylics—also alter the color

This Physical Fact produces this Psychological Effect

▶ **7.12 The Weber–Fechner Law.**

▼ **7.11** Tube colors vary when used as glazes or tints. Each is shown in its original form in the center of the chip, with its appearance when used as a glaze indicated on the left and as a tint on the right.

seen. Figure **7.11** shows the effect of glazing and tinting treatments with tube colors from each part of the spectrum. The differences between some tube colors are more apparent here than when they are shown at full-strength. The colors labelled by Liquitex as "Deep Brilliant Red" and "Cadmium Red Deep," for instance, look almost identical in the tube form, shown in the central rectangle of each trio. But note how different they become as glazes or tints.

When mixing paints, the WEBER-FECHNER LAW must be applied if colors visually equal in value are to be mixed. If one continually adds equal parts of white or black to raise or lower value, the rate of optical change will decrease. To create an optically equal series of differences, geometrically increasing parts of black or white must be added. The Weber-Fechner Law, formulated by Weber and Fechner in the nineteenth century, is stated thus: "The visual perception of an arithmetical progression depends upon a physical geometric progression." The difference between adding arithmetically increasing parts (1 + 2 + 3 + 4, etc.) and adding geometrically increasing parts (1 + 2 + 4 + 8, etc) is shown graphically in Figure **7.12**, and in value steps in Figure 6.12.

All the above comments on paint mixing can be applied to both oils and acrylics. The pigments used today in both forms are the same; only the media are different. This is not to say that the two have the same visual effect. Oil is typically more glossy; acrylic tends to have a more matte finish, unless a lot of the medium is used. Oils can be blended wet to wet since they dry slowly; acrylics dry quickly. Over a long period of time, a quality acrylic paint should retain the original color of its pigment, for the medium dries as clear as glass, albeit somewhat darker than the wet tube paint. Oil paint also tends to darken somewhat as it dries, and yellow as it ages.

Ceramic Glazes

Ceramics are often given one or more coatings of glaze, which is brushed, dipped, poured, or sprayed onto the piece and then fired to waterproof, often glossy hardness. Glazes are made of chemical combinations known as silicates. Their fired color may not be apparent until after firing, so potters typically make or consult glaze samples for color references. Some are bright from glossiness as well as pigmentation, with either transparent or opaque characteristics. If a transparent glaze is used over something other than white clay, the color of the clay itself will show through. A matte glaze has a dull surface when fired. FRITTED GLAZES have shattered bits of water-soluble, molten chemicals added, increasing their color clarity. And some fire with a crackled or crystalline effect, as in Marc Hansen's porcelain bottle shown in Figure **7.13**.

Students new to ceramics may work with commercially prepared glazes to lessen the uncertainties and chemical hazards of the process. Glazes must be matched with the clay body used, both in the temperature at which they mature when fired and thereafter, in the degree of shrinkage during cooling. Lead is a common ingredient in glazes; without it, glazes are harder to brush, flowing less readily and drying more quickly. Lead, however, like some other glaze ingredients, is toxic and must be used or handled only with care.

Many experienced potters prefer to compound their own glazes from a variety of chemicals. Recipes for those that work are prized and saved, with samples. The recipes include three basic chemical ingredients: silica, which forms the glassy surface and is provided both by the clay (kaolin) and feldspars (potash, sodium, calcium, alumina, and silica); flux, to help the glaze and clay body fuse; and alumina, which makes the glaze more viscous

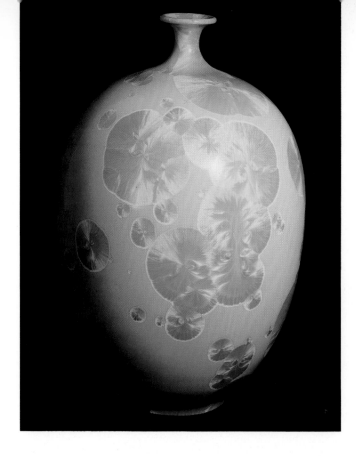

and hardens it. There will also be pigments in glazes used for coloring, such as manganese dioxide, chromium, copper sulfate, or cadmium. For example, a recipe for a "barium blue" glaze to be fired at cone 6 includes specified percentages of potash feldspar, barium carbonate, zinc oxide, copper carbonate, and methocel or gum. However, glaze colors will vary considerably depending on differences in firing kiln temperature, length of firing time, and clay body used. Skillful ceramists prepare test chips to study these variables by changing only one factor and keeping other factors constant. Figure **7.14**, for instance, is part of a series of tests by potter Susan Peterson to study the color effects of firing the same opaque glaze formulation at three representative kiln temperatures: low (cone 4), medium (cone 5), and high (cone 10). The results show that hues are most saturated at low firing temperatures. Vanadium totally loses its yellow hue under high firing; copper carbonate shifts from a blue-green at cone 4 to a much less saturated blue-gray hue at cone 10.

Colored Glass

From the third millennium B.C., the people of Mesopotamia knew how to create objects of colored glass. When soda, silica, and lime were heated together, the glass was usually of blue-green hue because of the iron impurities in sand, which took the form of silica in the formula. The Romans learned to neutralize such impurities by adding manganese or antimony to produce a colorless clear glass. Brilliant hues could be produced by adding metallic oxides, with the results affected by the temperature of the firing. Copper was used at different temperatures to produce turquoise, dark green, or deep reds.

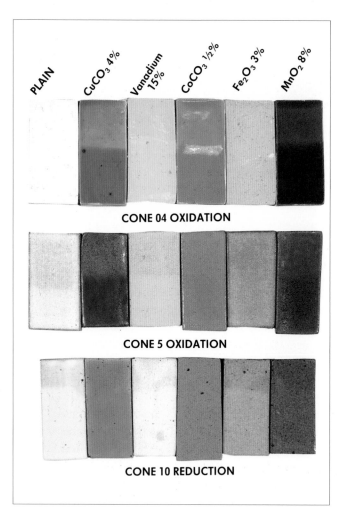

PLAIN CuCO₃ 4% Vanadium 15% CoCO₃ ½% Fe₂O₃ 3% MnO₂ 8%

CONE 04 OXIDATION

CONE 5 OXIDATION

CONE 10 REDUCTION

▲ **7.13 Marc Hansen, porcelain bottle** Many glazes such as this crystalline glaze invite a measure of happenstance in their color effects.

◀ **7.14** Susan Petersen's glaze tests demonstrate the effects of different firing temperatures on glaze colors.

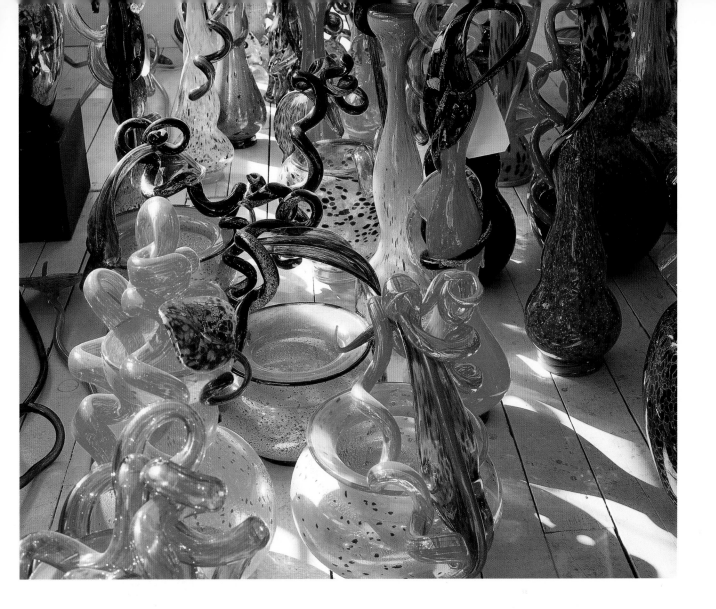

▲ **7.15 Dale Chihuly, *Evelyn Room with Stems and Venetians,* 1991** In transparent glass works, colors can be juxtaposed three-dimensionally.

Very small portions of metal oxides produce highly saturated hues in glass. An intense blue results from adding only one part of cobalt oxide to 10,000 parts of the base glass. These jewel-like colors are made even more brilliant by the light that passes through transparent or translucent glass. Glass artists are also able to juxtapose hues of varying colors by techniques which allow the fusing of bits of differently colored glass to the main form. Threads of a contrasting colored glass may be trailed over the piece, or bits of colored glass may be picked up as the piece is being formed and incorporated into the surface. After the base and colorants are fused, the additions may be left to stand in low relief or flattened for a smooth surface. Dale Chihuly's *Venetians* series (**7.15**) is an exuberant exploration of such juxtapositions of color and elaborations of form. Chihuly often tells his assistants to "punch up the color," and says of the resulting works, "People seem to like them."[1]

Color Printing

Inks, like dyes, are colorants dissolved in a medium. In graphic design, they are generally used for mass reproduction of artworks originally created in some other medium. There are two ways of doing this: FOUR-COLOR PROCESS and FLAT (or MATCH) COLOR.

In four-color process, it is possible to mix most colors from three primaries plus black and the white of the paper (if it is white) by printing the same surface four times in the process, or primary, ink colors. These ink primaries are magenta, cyan, and yellow. In four-color process printing, tiny dots of these hues are juxtaposed so that they will be mixed visually by the viewer's eye.

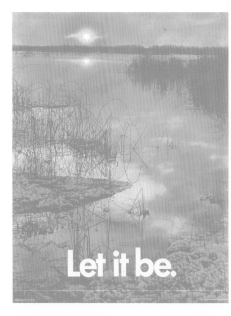
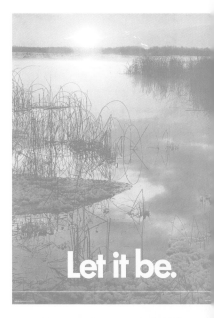

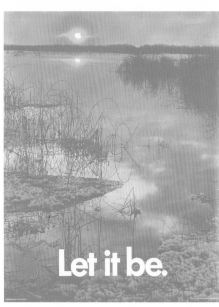

Black dots are added to deepen the dark areas and increase contrast. This system is therefore often referred to as CMYK, for cyan, magenta, yellow, and black.

Four-color process is typically used for the reproduction of CONTINUOUS TONE artworks (in which there are unbroken shifts in value, as opposed to shifts in value reproduced by dots), such as paintings and watercolors or, preferably, photographed transparencies of such reflective art. The process begins with photographic or electronic COLOR SEPARATION of the original continuous tone work. That is, the work is photographed or scanned through filters in the additive primaries—red, green, and blue. The red filter allows only blue and green to pass through, creating cyan. The green one allows only red and blue, creating magenta. And the blue filter allows only red and green light to pass through, creating yellow.

◀ **7.16 The color separation process**
Color separations from a 1970 poster by graphic designer Peter Good, employing a photograph by Bill Ratcliffe.
The image has been separated by the printer—The Hennegan Company—into 200-line yellow, cyan, magenta, and black screens. They are printed in that order to reproduce the final image.

The positives printed from these filters are also SCREENED, turning values into varying densities of tiny dots. They are then printed one color at a time, starting with yellow, building up to a print that closely resembles the colors of the original even though when seen under magnification, it is quite different (**7.16, 7.17,** see p.70). The screens for each color are set at varying angles to each other, rather than being directly printed one atop the other or set at regular angles that would cause undesired geometric moiré (wavy) patterns. When printed, the tiny juxtaposed dots give the illusion—if not the reality—of smooth transitions in values and hues.

It is difficult to match colors precisely with four-color process. For one thing, printing inks are not yet totally pure, so each of the primaries absorbs some of the light it is supposed to reflect. Various means of correcting

▶ **7.18** A page of color finder tints, in which the yellow part of the mixture is 30 percent throughout, with percentages of magenta and cyan varying.

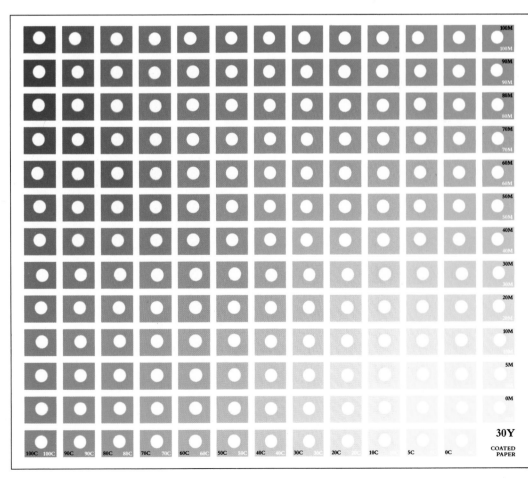

color imbalances caused by this imperfection are therefore used by printers when high-quality reproduction is desired. Another problem is the impossibility of using the four colors to reproduce certain colors accurately—such as turquoise (which is warmer than cyan), orange-reds, lemon yellow, and fluorescent colors. An expensive option, when high-quality reproduction is needed, is to add one or two more process colors, such as lemon yellow, to increase the range of possibilities. Some specialized printers therefore have six- and even eight-color presses for fine-art work.

A typically less expensive way of introducing broad areas of color into a printed piece—such as a poster or advertisement (as in Figure 9.10)—is the FLAT COLOR method. Here the designer may prepare transparent overlays indicating areas to be printed in one to four colors, or may simply mark regions of a single original for the printer to print in different colors. There are two ways of choosing and communicating these flat ink colors to the printer. One is based on the process colors. Tint charts (a sample page of one is reproduced in Figure **7.18**) have been developed with varying percentages of yellow, magenta, and cyan. Usually these charts hold magenta and cyan percentages constant and vary the amount of yellow from 0% to 100% through a series of charts. The one shown here mixes a 30% screen of yellow with all possible mixtures of cyan and magenta. The effect of percentage screens in these hues can be seen along the outer edges. As the dots get close together, resulting in a higher percentage of the color in mixtures, the value becomes darker. To gauge the effect of adding black as an extra color, the printing company that prepared this chart also offers a transparent acetate overlay with percentages of black. It can be held over any of the rectangles representing mixtures of the process colors. Colors are then matched with samples and specified in percentage terms. For instance, one of the subtle, unnameable colors on this chart would be called 30%Y, 10%C, 60%M. Because subtractive mixtures tend to muddy as pigments are added, a rule of thumb is that the sum of percentages should not exceed 240%.

A second, commonly used system for color matching and specification is the Pantone Matching System (PMS). It is now based on nine "basic colors" carried by printers (**7.19**) plus black and transparent white, which are mixed

◀ **7.17** An enlargement of an area of Peter Good's poster (7.16), revealing the underlying dot structure of the screens.

▶ **7.19 PMS Basic Colors**

PANTONE® Basic Colors 1 XR

PANTONE Yellow C

PANTONE Warm Red C

PANTONE Rubine Red C

PANTONE Rhodamine Red C

PANTONE Purple C

PANTONE Violet C

PANTONE Reflex Blue C

PANTONE Process Blue C

PANTONE Green C

C = Coated Paper

© Pantone, Inc. 1963, 1987

according to PMS formulas to form a total of 1000 colors. To choose colors and communicate them to the printer, a graphic designer can use any of a number of tools displaying the PMS colors. Figure **7.20**, for example, shows the Pantone Color Guide in the form of a fan. Each page of the fan displays seven similar colors that vary slightly in formula for comparative purposes. Pages from different parts of the fan can also be compared. To increase the number of colors available, the designer can specify slight alterations in the formulas. If one wanted a red right between 198 and 205, one could suggest a slight shift in the ratio of Rubine Red to Yellow, such as 6.5 parts Rubine Red, 1.5 parts Yellow, and 8 parts Transparent White. The C or U following the Pantone numbers indicate "coated" or "uncoated" paper. All colors are shown on both coated and uncoated stock, for they are considerably more brilliant on the former, which has been sealed with a clay covering so that inks will sit on the surface rather than be absorbed.

Actually, there are a great number of variables in color printing, whether by flat-printing mixtures of colored inks or by screen printing from CMYK color separations. The paper's grain and absorbency will make a difference to the visual effect of inks applied to it, and of course its own color becomes one of the factors in the color mixture. The appearance of the inks themselves is affected by variables such as the sequence in which the colors are printed, the opacity or transparency of the ink formulation, the amount of water in the ink, the surrounding temperature, the size of pigment particles, the dryer used in the ink, its viscosity and tackiness, and the amount of ink used in the job. As the paper is passed through the press, the printing speed, humidity in the area, and drying time are among the many factors that can alter the final results and should be carefully controlled.

Color Photography

Whereas black-and-white photography must record differences in value, color photography must also record differences in hue and saturation. The procedures and chemistry used to do so are complex and involve both additive and subtractive color mixing systems.

For both color prints and transparencies, the recording of colored images on film typically begins with an INTEGRAL TRIPACK: film with three thin layers of gelatin which

▶ **7.20** The PMS fan, with ink formulas for each of 1,000 colors, printed on both coated and uncoated paper.

will produce the equivalent of three color negatives. The top layer carries an emulsion of silver halide crystals which are sensitive to blue light. Beneath it is a yellow filter to block blue light from traveling to the lower two layers, both of them sensitive to blue light but one also sensitized to green light and the other to red light. These layers acknowledge all colors contained within the light striking the film when it is exposed, for blue, green, and red are the light primaries. In fact, modern sensitizing dyes can register light beyond the limits of the visible spectrum, from about 200 nanometers at the ultraviolet

end to more than 1300 nanometers at the infrared end.

When the tripack is exposed to an image, it registers the image by separating metallic silver grains from the silver halides. The result is invisible, however, until it is developed. In the COLOR POSITIVE or REVERSAL PROCESS, used largely for transparencies such as slides, a black-and-white version of the image is developed first from the exposed silver halide. Then each layer is developed with chemical couplers, causing dyes to be released in unexposed areas in the subtractive primaries (which are the complementaries of the light primaries in an additive color circle). The remaining silver halide in the blue-sensitive layer is developed to form a yellow dye in unexposed areas; the green-sensitive layer creates a magenta negative; and the red-sensitive layer becomes a cyan-dyed negative of the red areas. If the original object was white, all layers of the tripack will be activated, using up all the silver halide and resulting in a non-dyed white image at this stage. A black object will not affect any of the light-sensitive layers of the tripack, allowing all three layers to be activated in the dye-developing stage. When all three are superimposed, the area will appear black, the result of subtractive mixing. Areas of yellow and magenta will appear orange; yellow and cyan will make green; and magenta and cyan create blue. The yellow filter layer of the film is not activated during development, so it has no effect on the final colors. The developed film therefore appears to have the true colors of the originals.

In a COLOR NEGATIVE PROCESS, typically used for making color prints, the film is developed into a negative of the finished product. Dye-forming couplers are in the tripack itself. The initial black-and-white developing stage is omitted, and the first developer brings out the complementary colors directly in the exposed areas, rather than at a second stage in the unexposed areas. This color negative, shown at the end of the line on the right-hand side of Figure **7.21**, may then be printed onto special paper containing more dye-forming couplers in color-sensitized layers. In this case, areas that are fully pigmented in the negative will print as white; areas with no developed dyes will allow all layers to be exposed, producing black. The couplers will turn cyan, magenta, and yellow into their complements: red, green, and blue.

Many elaborate chemical adjustments and refinements are made to enable color reproduction by these methods

to be as accurate as possible, without bias toward any particular area of the spectrum. This accuracy is often aesthetically desirable, for many photographers seek out interesting or beautiful color effects in the world around them and then attempt to record them on film. The close-up of a flower (**7.22**) draws our attention to color nuances that are usually overlooked, such as the delicate pink of the stamens and the varying values of purple.

However, sometimes the artist's purposes are better served by distortion of the colors of the original image. Photographed objects may become vehicles for color experimentation that has nothing to do with their origi-

nal coloring. As the picture is taken, manipulation of exposure time and choice of film will affect value and contrast but hue will remain largely unchanged. Colored filters placed over the lens will bias the results toward a certain color; diffraction filters will bend light into prismatic effects. Dramatic alterations in color may be made in the darkroom, using techniques such as chemical toning, SOLARIZATION (whereby the development process is briefly interrupted by exposure to low-intensity colored light, reversing the colors especially in high-value areas), and POSTERIZATION (whereby continuous tone images are converted into distinct flat tones, in any color).

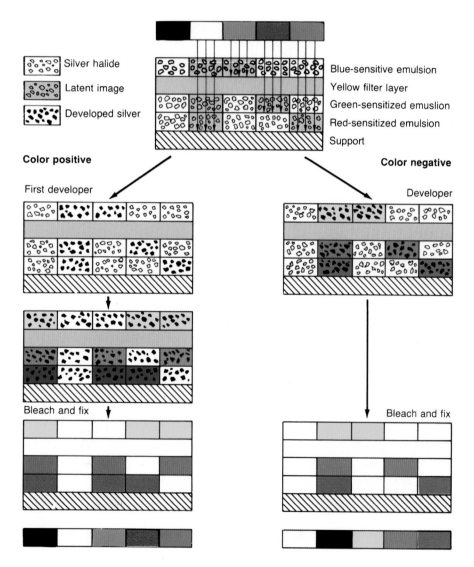

7.21 The color photography process, starting with an integral tripack and continuing through either positive or negative processes.

▲**7.22 Scott Hobson and Andrew Brand, flower study, 1988** Color slide with 135mm lens at $^1/_{16}$ second, f-stop 8, with Ektachrome 100 film.

Fiber Dyes

The growing world of fiber arts includes yarns, fabrics, basketry, and anything else created from linear materials woven together. Pre-dyed fibers can be interwoven to form patterns, or sheets of fabric can be dyed after they are woven. With modern chemistry, the range of colors possible is so vast that *The Color Index* (**7.23**), a professional color specification list, includes over 8000 dyes classified by chemical structure, properties, and applications (not all of which fall into the visual arts).

Traditional hand-dyeing of fibers—an art still carried on by many handweavers—begins with gathering of the dyestuffs. Practically any plant material can provide some colorant, but certain leaves, stems, berries, seeds, barks, and roots are known to work especially well as sources, with the most common being in the yellow and earthy brown range.

Natural dyes from plants are often quite different from their own color. Beets and strawberries, for example, yield only beige, and purple pansy blossoms give an intense blue-green dye. Moreover, colors will vary from dyebath to dyebath. Nevertheless, natural dyes are appreciated for the very features that make them unacceptable to commercial dye houses: their subtle colors may or may not be replicated, depending on seasonal variations in the dye plant itself. A sampler of natural dyes with their sources, as prepared by handweaver Pat McMullan, is shown in Figure **7.24**.

Natural dyes will only adhere to natural fibers, such as wool, cotton, jute, linen, and silk. These materials' own natural color will, of course, affect the outcome. Before dyeing, the fibers are wound into hanks and scoured to remove foreign matter that would interfere with the dyeing. Often the fiber is then simmered in a MORDANT to help set the dye and perhaps affect the color. The mordant is a chemical, such as alum, iron, tannic acid, tin, or copper. Dyeing in an iron or copper pot can substitute for mordanting; some dyestuffs have natural mordants in them, such as lichen and hickory nut hulls. The dyestuff itself is boiled in water to release its dye and the mordanted material is then simmered for a time in the dyepot. Longer dyeing typically deepens the value and may increase the intensity of the dye absorbed. Dyestuffs are not usually mixed with each other directly, for the result tends to be a drab olive. If one therefore wanted to dye fibers green using goldenrod and logwood, one would first dye them with the goldenrod to be sure of getting a good yellow and then overdye with the logwood, which by itself yields a purple or gray. On the other hand, kitchen ingredients—ammonia, baking soda, vinegar, or cream of tartar—may be added to the dyebath to alter the color. Adding vinegar to a purple grape juice dye, for instance, will turn it green!

45370 **C.I. Acid Orange 11** (*Reddish orange*)
45370:1 (C.I. Solvent Red 72) is the free acid
45370:2 (C.I. Pigment Orange 39) is the aluminium salt

Discoverer — Badische Co.

BIOS 959, 6, 26
FIAT 764 — Eosin H 8G
Am. J. Pharm. (Sept. 1942), 342 (see also *Coal-tar Color Regulations*, U.S. Food and Drug Administration. Sept. 1940, 13)

Slightly soluble in water (orange with faint yellow fluorescence)
Soluble in ethanol (orange with a greenish yellow fluorescence)
Soluble in acetone (pink with a yellow fluorescence)
Very soluble in furfuryl and tetrahydrofurfuryl alcohol
H_2SO_4 conc. — red yellow; on dilution — yellow brown with orange ppt.
Aqueous solution + NaOH — eosine red
Glycerol and liquid paraffin — good dispersion

Dibrominate **Fluorescein** in aqueous sodium hydroxide and isolate as the sodium salt

Natural Dyes

This hand-dyeing procedure is a form of DIRECT DYE-ING. Many artificial fibers, such as nylon and polypropylene, must be dyed by other means, since direct water-soluble dyes do not stick to them. DISPERSED DYES, such as acetate dyes, are not soluble in water, but nonetheless disperse through the fiber when applied in a soap solution. REACTIVE DYES, such as henna for hair coloring and procions for dyeing cellulose fibers, bond chemically with the fiber. VAT DYES respond within the fiber after it has been subjected to a certain treatment, such as being exposed to air and sunlight or an acid solution. Indigo is a vat dye, turning fibers blue as it is exposed to the air. Successive dipping and exposure will gradually deepen the color.

Such methods allow manufacturers of yarns to offer palettes of color, in both natural and synthetic fibers, that range from the subtle, unsaturated colors prized by many crafts people to very bright, pure hues that are hard to obtain with most natural dyes. Figure **7.25** shows the colors in which one commercial yarn company dyes one of its products: a four-ply 100 percent Orlon yarn. Many Indian peasant women now dress in synthetically dyed

◀ **7.23 Solvent dyes from** *The Color Index*

◀ **7.24 Pat McMullan, sampler of natural plant dyes** Most natural dyes are typically subtle, of low saturation, with exceptions such as cochineal, logwood, and *umbilicaria* (a lichen).

▼ **7.25 Heirloom, color sampler of "Reflection" 100% Orlon yarns** Commercial dyed yarns include synthetic as well as natural fibers, of varying degrees of saturation and value as well as hue.

012 Camel	058 Kelly	099 Crimson
016 Walnut	062 Christmas Green	101 Cranberry
019 Medium Taupe	065 Medium Teal	105 Burgundy
023 Dark Brown	068 Deep Teal	107 Tea Rose
026 Light Yellow	071 Light Blue	110 Blue Fox
029 Citron	074 Medium Blue	112 Slate Blue
034 Marigold	077 True Blue	115 Light Grey
038 Mustard	079 Royal Blue	118 Smoke Grey

◀ **7.26** Synthetic dyes in modern Indian saris present an appealing visual contrast amidst sun-baked dusty environments.

saris in brilliant, almost fluorescent hues (**7.26**) that add a rich and happy note in the midst of a life in the mud and dust. Such colors retain their visual impact even under bright sunlight.

Fading from exposure to light is a problem with many dyes, both natural and artificial. However, at least with blue jeans, the faded look is what consumers want. To achieve the well-worn look, manufacturers weave blue denim with synthetic, noncolorfast indigo thread for the warp (the fibers showing on the surface) and white thread for the weft (which can be seen on the underside, at right angles to the warp). Fading and wearing away of the warp increasingly expose the weft, for a blended effect that dyeing alone cannot create.

We are more aware of the influence of sunlight on fibers than on other subtractive media, but sunlight can also be extremely harmful to inks and pigments. At one time, collectors used to keep their watercolors and prints in drawers instead of displaying them, for the colors would break down. Even with today's art technologies, it is unwise to hang a painting in direct sunlight, be it oil or acrylic. The fading of colors happens gradually over some time and may not even be noticed unless there is contrast with an area that was always in the shade.

Light Mixtures

8

U ntil recently, lights have not been widely used as art media, though they have been extensively studied by scientists. Nowadays, however, technology is turning the world of light into a luminous palette for artists. Potential areas in which light can now be manipulated include video, computer graphics, lasers, and holograms.

Video

The term VIDEO is used both for electronic light signals broadcast to television sets and for images displayed on television monitors directly from videotapes. These dynamic visual images are usually recorded electronically by video cameras, which scan a scene to analyze and communicate its light patterns. The light received in the camera is divided by a system of mirrors into the three light primaries—red, blue, and green. For transmission, these are then converted into two signals indicating CHROMINANCE or CHROMATICITY (a combined DOMINANT WAVELENGTH, or hue, and PURITY, or saturation) and LUMINANCE (the light-mixture equivalent of value in pigments). The latter can be monitored on a black–gray–white scale, with no reference to hue.

This information is broadcast through the air or fed electronically to a receiving monitor, which decodes the video signals corresponding to the light primaries. These are sent through electron guns, usually one to each primary. Each sends beams to the screen of the picture tube, the inside of which is coated with hundreds of thousands of tiny dots of red, green, and blue fluorescing powders,

SCREEN OF PHOSPHOR DOTS

ELECTRON BEAMS

METAL 'SHADOW-MASK' PLATE WITH HOLES

ELECTRON GUNS

▲ **8.1 Phosphors and electron beams in a color television tube** The upper picture is a considerably enlarged diagram of the mosaic of red, green, and blue phosphors on the screen of a TV set built on the shadow-mask system. Below is an enlarged diagram of the shadow mask, showing its use to focus the electron beams on one triad of phosphors at a time during the scanning process.

called PHOSPHORS. When hit by electron beams, they give off a certain amount of light, depending on the luminance signal. In many television sets, a SHADOW MASK—a metal plate with thousands of small holes—is used to keep the electron beams focused only on one triad of phosphors at a time, preventing them from spilling over into other areas (**8.1**). The electron guns rapidly scan all the phosphors, traveling along horizontal lines, and thus rebuild the image on the entire screen just as it was when originally scanned by the video camera. This process occurs 30 times a second in a standard screen in the United States, which is composed of 525 scanning lines. The European system uses 625 lines, scanned 25 times a second. The persistence of our vision keeps the image from appearing to flicker.

Red, blue, and green are used as primaries in video transmission because they can produce the greatest range of mixtures. It comes as a great surprise to many people that there is no yellow in a television tube. In fact, the yellow that we see on a TV screen is actually an optical mixture of tiny dots of green and red. Similarly, green and blue juxtaposed in space or flashed quickly one after the other will produce a cyan sensation; red and blue juxtaposed in time or space will appear magenta. Black areas have no light coming through; white areas are a mixture of all three primaries. Luminance (value) differences are controlled by the amount of light released.

The saturation and balance of colors between the three primaries can be controlled to the viewer's taste by adjusting controls on the monitor. In early television transmission, colors were exaggerated to demonstrate the flashiness of the medium, but nowadays somewhat more subdued, natural colors are preferred. There are intricate ways of adjusting colors to approach a standard, but this can never be done satisfactorily to suit every particular image. Some of the most realistic video pictures now available are seen on an experimental 2000-line monitor developed by SONY. On these screens, one no longer sees the black scanning lines and the dots of the phosphors. Images resemble very sharp photographs, and colors look whole rather than optically mixed. However, scanning this many lines fast enough to keep a rapidly changing image visually intact presents considerable technological challenges and these sets are not available for mass consumption at present.

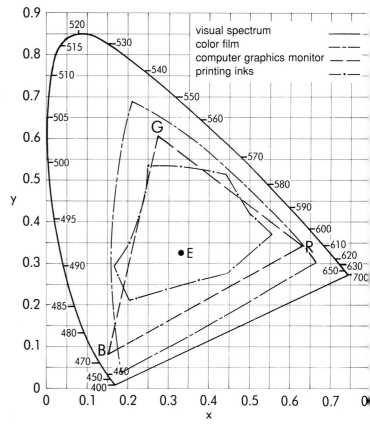

▲ **8.2 Chromaticity coordinates of the red, blue, and green primaries on the standard computer graphics monitor** Printing inks can reproduce only a comparatively small portion of the visual spectrum. Color film can reproduce a larger range than a television or computer monitor.

Computer Graphics

The burgeoning new field of computer graphics uses monitors that are essentially the same as television screens. They use the same red, blue, green primary system of phosphor activation, though they are capable of slightly higher saturation. Both video and computer graphics have within their range a greater degree of saturation in colors than is possible with any subtractive medium, for they are based on the purity of colored lights. However, phosphors are not as pure as they theoretically might be. Furthermore, the trichromatic mixing system means that certain mixtures simply are not possible.

Figure **8.2** uses the C.I.E. chromaticity chart (see page 60) to illustrate the parameters of modern computer graphics color capabilities. Chromaticity coordinates for the red, blue, and green primaries in a standard monitor form a triangle that is much smaller than the flat-iron shape formed by the whole range of spectral colors. The purest spectral colors fall along the outer edge of this shape, with saturation decreasing gradually into the central point of equal energy (E), where x and y = 0.333. This point represents neutral colors, from black to white, with their value depending upon the degree of luminance, which is not shown in this two-dimensional diagram.

The primaries do not reach the corners of the flat-iron because the phosphors are not as pure as spectral hues. Moreover, nothing outside the triangle can be mixed using the three primaries. Along each edge, hues are pure mixtures of the two connected primaries; within the triangle, all three primaries are involved to some extent in the mixture, until finally they all mix to a neutral in the center. The only way to mix a color lying outside the triangle would be to have negative hues available as mixers—such as a minus blue which would subtract enough blue from the green and red to produce a pure yellow. Mixing a high yellow is the biggest problem with the "RGB" (red, green, blue) monitor; highly saturated cyan and magenta are also impossible.

These limitations are actually not apparent to the average eye, which finds the outer limits of computer graphics colors brighter and more saturated than any pigment colors, as indeed they are. Furthermore, computer graphics programs for color mixing are becoming increasingly sophisticated and are now able to create very fine gradations of hue, value, and saturation. There are a number of ways of setting these up.

One popular graphics system is the Mac II, introduced in 1987 by Apple. Part of its basic package is a "color picker" that offers two simple ways of creating over 16 million colors, far more than the eye can actually distinguish. Firstly, in the control panel is a control that brings up a color wheel and allows the programmer to hold a "dialogue" with it. The wheel is divided into six hues (yellow, red, magenta, blue, cyan, and green). Four concentric circles show gradations in saturation. Using a "mouse" (a positioning device that allows complete free-dom of movement on the screen) to move a pointer, the programmer can point to a place on the wheel and it will be displayed in a box to the left. Possibilities exceed those shown and are controlled by exact placement of the pointer; placing the pointer close to yellow in the red area, for example, will bring up an orange. The brightness (value) of the whole wheel can be changed by moving a scroll bar that works like a sliding volume control. The center of the circle can range from white to black, with concentric rings following suit.

The second way of choosing a color is numerical, monitoring saturation and brightness on a scale of 0 to 65,535 for each of the primary hues. The box showing the first color one might pick has a split screen; to change it slightly, one could type in, or point to, a slightly different number to see the result, which is displayed next to the first color on the split screen. The ease of color mixing with such a system makes color relationships fascinating and fun to manipulate.

Adobe Photoshop, a very popular graphics program, presents a display on the monitor with a variety of ways of selecting a specific color. As shown in Figure **8.3**, the computer artist can move a small circle through a field of variations on a hue to select the one desired, or move arrows along a linear display, or type in the subtractive CMYK or additive RGB (red, green, blue) or HSB (hue, saturation, brightness) numeric values of the color. Once the hue is chosen, the numeric CMYK notation calculated by the computer can be used in specifying printing inks.

In addition to on-screen color-choosing devices, those with engineering training can program color mixtures numerically. Colorist Nathaniel Jacobson and computer specialist Walter Bender of the MIT Media Lab have collaborated to try to create computer color maps based on the Munsell system of color classification. They have created a program based on the principle of ORTHOGO-NALITY. That is, they are able to hold one variable constant while changing the other two. As we saw in pigments, when two pigments of equal value are mixed in the effort to create a middle mixture, the value will drop somewhat. However, it is possible to ask the computer to display the maximum saturation possible at each step of value, for each hue—displayed across the bottom of Figure **8.4.** Note that the configuration is irregular, like

8.3 The Photoshop program offers several different ways of selecting and changing colors in an image on the computer monitor.

▼ **8.4 Nathaniel Jacobson and Walter Bender, MIT Media Lab computer graphics color map**

the Munsell color tree, because hues reach maximum saturation at different steps of value. Across the top, value is held constant while saturation changes. Many other colors could be displayed between each of these "chips."

The colors shown in this custom computer palette are deliberately muted to approximate the softness of pigments rather than the glare of phosphors; none are shown at the maximum saturation possible for the monitor. In addition, they are programmed to vary in visually equal steps, as in the Munsell system. One might think this would be easy on the computer, but it is, in fact, quite difficult, for mathematically equal amounts of light energy do not create visually equal steps in value. They must be measured by the most sophisticated of visual instruments: the human eye.

Colors can be added to computer drawings by using an electronic drawing pad, a light pen to touch areas on the screen, or a pointing device such as a mouse to "click" the colors into place. They can also be programmed to develop along with complicated imagery, such as the fractal generating program displayed in Figure **8.5.** To create these subtly varying colors, Duane Maxwell chose his palette—near white, black with soft blues, greens, yellows, reds, and purples—in a certain

sequence and then instructed the computer to coordinate them with the organic growth of fractal imagery.

Another approach to color in computer graphics is to digitize or quantize an existing image. This basically means electronically scanning and converting it into numbers that correspond to points on the x and y axes

of the monitor screen as graphed in Figure 8.2. Computers with graphic capabilities have screens divided into PIXELS, individual picture elements, like mosaic tiles. The more pixels, the finer possible resolution in the image. Figure **8.6** shows the visual results of digitizing the *Mona Lisa* with increasing numbers of pixels. The color variations—averaged for each pixel—become finer and finer mosaics of colored blocks. It is possible to render an image with what appear to be continuous gradations in

▼ **8.5 Palette selection in a computer graphic setup, image by Duane Maxwell** Using a fractal generating program running on a Levco TransLink parallel processing board on a Macintosh II with a 1,024-by-768-pixel Spectrum high-resolution monitor.

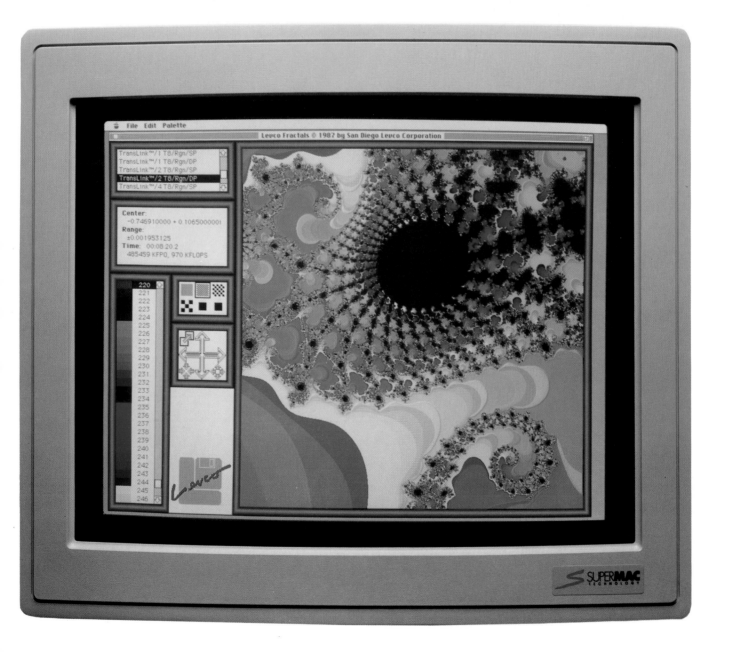

▲ **8.6 Ed Manning, Watson and Manning Inc,** *The Mona Lisa Blocpix Image* **(spatially quantized transformation)** The last frame is the painting itself—not a computer image.

tone if the computer has a substantial memory. The larger the computer's memory, the more pixels it can support.

Once the image is scanned into the computer's memory, it can be manipulated endlessly. Colors can be added and changed in hue, saturation, and brightness at will; shadows, highlights, and midtones can be added wherever the artist wants them. Figure **8.7A** shows the original unpublished, and not particularly flattering, photograph of Audrey Hepburn which Douglas Kirkland used as the starting point in a manipulation process that resulted in the final piece shown in Figure **8.7B**. Among other

changes, Kirkland converted the image to high contrast, burned in certain low-value details from the original that would have been lost in high contrast, and then used a limited palette of six colors to replace those in the original. Kirkland observes that in using such powerful computer programs,

▲ **8.7A** Douglas Kirkland's original photograph of Audrey Hepburn.

▲ **8.7B** (above right) A version of the same photograph, digitally manipulated to appear as a high-contrast image of bright, flat colors.

▶ **8.8** In Photoshop, the artist can see side-by-side comparisons of the effects of alterations in hue and value in order to digitally manipulate the colors.

You have to know when to blow the whistle on yourself. We have this incredible wide-open possibility, but we have to learn when to say no and when to say yes. It's like having a wonderful musical instrument that can make any sound in the world—but you have to put those sounds together to make a beautiful song.[1]

In Adobe Photoshop, a user-selected range of color choices in the image are displayed side by side to help in making aesthetic choices. The "current pick" is juxtaposed with other possible choices as one works with alterations in hue, value, or brightness in the shadows, midtones, or highlights. In Figure **8.8**, the original and the current pick in the hues for the bush is compared with what it would look like with more green, yellow, cyan, red, blue, and magenta, in lighter and darker values.

To avoid obvious jumps between different hues and values used in representing gradations across a three-dimensional form, the PostScript program offers up to 256 gradations between two colors, for the equivalent of an airbrushed effect. This number is not necessary in a small area, but if a program had only fifty choices and if they were stretched across 10 inches, there would be only five bands of color per inch. In such a case, the bands themselves would be noticeable as hard-edged shapes, an effect that the artist might not desire. A person with normal color vision can distinguish approximately 150 different hues in the visible spectrum. Scientists calculate that when differences in value and saturation are factored in, our eyes can probably distinguish about 7 million different colors. But high-end computer workstations can generate a palette of 16.7 million colors on the screen—almost 10 million more than we can actually see. Is this pointless extravagance? Perhaps not, for this tremendous ability allows for very gradual gradations between colors. We can visually detect very small differences between certain hues, but not between others, so such abundance of differences is necessary to ensure that nowhere in the even subdivisions of color choices can we detect unwanted jumps.

"Hard copy" output from what is created on the computer screen may take the form of high-resolution film negatives, slides, or paper prints. Usually some kind of color printer is used initially in any case to check the results before being sent to more expensive output

▲ **8.9A** An ink-jet reproduction of an image, with 500% enlargement to show how the color is laid down in dot patterns.

devices. Three kinds of color printers are now commonly employed in desktop color graphics systems. The INK-JET printer (**8.9A**) is the only fairly inexpensive option; however, it only works well for rough proofing, simple transparencies, and presentations. Beyond these functions, ink-jet output—with its banded colors, splotchy or muddy images, and loss of detail—is mediocre. Another system is THERMAL TRANSFER, in which a printhead is passed four times across thermally sensitive paper, once each for cyan, magenta, yellow, and black. Tiny pins are heated to fuse a dot of that color on the paper, or are not heated, leaving no mark. The dot patterns are DITHERED—

▲ **8.9B** Thermal wax transfer reproduction of the same image, with 500% enlargement showing dithering of the dot patterns.

▲ **8.9C** Dye-sublimation reproduction of the same image (with 500% enlargement), approaching continuous tone printing.

that is, pixels of different colors are juxtaposed to make the eye mix their colors visually, as demonstrated in the digitized reproductions of the *Mona Lisa* (8.6). Figure **8.9B** illustrates the reproduction of a computer-generated image by a thermal transfer printer.

A more expensive option is DYE SUBLIMATION. Such printers also use heat to fuse color from pins in a printhead to a page, but the pins can be heated to different temperatures. The amount of heat used determines how much dye or ink from the color transfer ribbon is applied to the paper. Controlling this factor allows color mixing without dithering, so the effect is like a continuous tone photo-

graph, with no noticeable hard edges between dots. Figure **8.9C** illustrates this effect, using the same computer-generated image as those in Figures 8.9A and 8.9B.

Although the sophistication of the printer will influence the quality of the reproduction, no process using printing inks can equal the brilliance of the hues created on the screen with pure lights. Better reproductions are possible with special cameras that photograph the screen, or even better, make a slide from the electronics. Some of these can create a very dense image by averaging the color between the pixels. Such equipment, however, is still very expensive.

▶ **8.10 Herbert W. Franke, computer film *Metamorphoses*, 1984** DIBIAS picture processing system. Computer graphics can be used to develop color stories varying through time.

The growing aesthetic capabilities of computer graphics enable designers to create computer films using color change through time as well as space. Herbert Franke's *Metamorphoses* (8.10) tells a color story. Each of the frames—and there are many more, creating sequences of changes that are sometimes gradual, sometimes abrupt—has a different color mood. The segment shown here clearly has a beginning "plot development," lulls in the action, and in the fifth frame, a sudden surprise, as the background shifts from a subdued red-purple to a strong red that contrasts vigorously with its complement, the blue-green. Such shifts are more accessible through programming than through area-by-area manual "painting" with a computer pen or stylus. Because it is based on number-crunching, however, it is intimidating to some visual artists. Herbert Franke suggests that the same thing happened when photography was first introduced:

> An experience made at the beginning of the photographic work repeated itself at this point: we thought at first that it would be painters who made use of the new medium, leading it into branches of art; in reality, such people showed a lack of interest and a new branch of the arts came into existence. Computer graphics have also been largely ignored by exponents of the visual arts. The people who are today concerned with computer animation come only to a small extent from the ranks of the visual arts. A much larger proportion of them rely on training as photographer or cameraman, mathematician or programmer. It is obvious that artistic possibilities opened up by computer graphic systems are leading to the formation of a new profession, standing somewhere between art and technology.[2]

Color Photocopying

Another major new development in color printing is the ability of photocopiers to reproduce colors from transparencies or flat prints, or even directly from digitized computer graphics files. There are three differing tech-

▲ **8.11** Using a color photocopier as an art medium, the artist can manipulate colors by leaving out one or more of the four screens. Here the original in the center is varied by subtracting the magenta screen (top left), the cyan screen (top right), the blackscreen (lower left), and the yellow screen (bottom right).

nologies now possible: reproduction by thermal transfer, photographic means, or xerographic methods. In the latter, a laser establishes a pattern of dots on a printing drum. Printing toner is attracted or repelled by the charge of each dot. The toner is then fused to the paper by heat.

Color copiers now offer relatively inexpensive and accurate color reproduction for short-run printing jobs—that is, projects in which only a few copies are desired. But they also offer to creative artists the possibility of manipulation of colors, for each color screen in the CMYK-based process can be used selectively. In Figure **8.11**, a collage of colored papers and a stamp is shown in its original colors in the central image. Surrounding it are the effects of subtracting the magenta screen, the cyan screen, the black screen, and the yellow screen. The original image uses a narrow range of hues; these differences would be even more pronounced when working from an original with strong color contrasts.

Laser Art and Holography

The merger of art and technology has also carried light mixtures into brilliances equal to that of the sun, in the form of lasers. Originally developed for scientific purposes, laser lights are also being used to create kinetic art shows.

Prior to the invention of lasers in the 1960s and 1970s, it was impossible to work with COHERENT LIGHT—light in which waves are all of the same length, in unchanging relationship. Laser light approaches this ideal. It is generated by an oscillator, which creates pulses in a thin tube filled with some electrically excitable medium, such as helium and neon. Light projected into this cavity is reflected many times from one end of the tube to the other by a system of mirrors, creating standing waves of energy. The medium used determines the spectrally pure color that results from this process. A helium and neon mixture give a coherent red light of 633 nanometers. Argon ion gas yields blues and greens, and can be tuned to the wavelength desired. Krypton ion gas emits red, yellow, blue, and green, either all at once or in beams separated by a prism. Ruby lasers, which use rods of this material rather than gas-filled tubes, emit pulses of an intense red light of 694.3 nanometers.

Laser sculptures can be created by setting up reflecting materials in the path of the thin laser beams or by projecting the beams through a smoky atmosphere so that they can be seen. For laser light shows, the beams may be moved so quickly that persistence of vision causes viewers to perceive lines of colored lights on a screen rather than moving dots of light. Their movements may be coordinated with music, either manually or electronically. Video/Laser III, constructed by music professor Lowell Cross and physics professor Carson Jeffries, has even been used to create the symphony of light envisioned by Scriabin for performances of his *Prometheus* (**8.12**).

Advances in laser technology have also made HOLO-GRAMS possible. These are two dimensional images

� **8.12 Lowell Cross,
kinetic laser imagery**
University of Iowa.
Laser deflection system
Video/Laser III. University
Symphony Orchestra
conducted by James Dixon.

▶ **8.13 Dieter Jung, *Into the
Rainbow,* 1983** White-light
transmission hologram.

formed by wave fronts of light (or sounds or electrons) that reconstruct the visual impression of a three-dimensional object. To create this effect, a laser beam is split. Part of it—the object beam—is reflected onto an object from an angle; the other part—the reference beam—is projected onto photographic film. The light waves bouncing off the object from the object beam intersect this non-reflected light on the film, creating an optically three-dimensional interference pattern. When the resulting hologram is viewed from different directions, the part of the image seen changes, just as it would if one were moving around a three-dimensional object.

Although this technology is being employed in many nonaesthetic ways, some artists have adopted it as a means of creating imagery with the glowing purity of pure spectral lights. Dieter Jung has used holograms to create compositions of light in his *Into the Rainbow* series. Unfortunately, their changing appearance and brilliant hues cannot be represented in this two-dimensional photograph (**8.13**), created by the subtractive method of ink printing. Some would maintain that lasers and holograms reveal the essence of color: having no substance, they are an optical phenomenon resulting from the eye's response to the reflection and refraction of clear light.

Color Combinations and Interactions

9

Thus far we have dealt with colors largely in isolation from each other. But in reality, we rarely see colors singly. Colors are surrounded by other colors, and they all interact in our perception. There are two ways of looking at this basic fact: we can seek pleasing or exciting combinations of color, if that is our aim, or we can study and exploit the ways that juxtapositions of specific colors affect our perception.

Color Schemes

The art of combining colors to create pleasing harmonies was approached as a science of sorts by many color theorists in the past. Certain color groupings were thought to be far more aesthetically appropriate than others, and attempts were made to list and prescribe the kinds of relationships that seemed to work best. Today, this approach is more typical of applied designers than of fine artists; interior decorators are more likely to think in terms of color schemes than are painters. And in all the visual arts, effective color combining is more a matter of adding a pinch of this and a bit of that, to taste, than of following precise recipes. The underlying structures have been studies and understood, and then used in intuitive and original ways.

The simplest color scheme is MONOCHROMATIC. A single hue is used, often with variations in value and saturation to avoid monotony. Deborah Muirhead's *Nebula* (**9.1**) is painted almost entirely in varying values of bluish grays

at low saturation, with just subtle hints of grayed yellow-green. With all the colors available to the contemporary painter, why has she so limited her palette? Muirhead explains:

> My work is about my continued interest in the ideas of elegy, memory, and mystery. In my paintings I try to evoke these sensations by creating an atmosphere of light with color. The reductiveness of my palette is not a limitation. In fact, it requires the viewer to participate longer with the painting in order to have color revealed and shrouded images emerge. The neutral grays of various tonalities of repressed hues are built up with thin glazes of paint in an attempt to suggest this ephemeral presence.[1]

Whereas the flow of Muirhead's monochromatic color shifts occurs subtly, mysteriously, with no hard edges, sharp edges may often be distinguished between areas of very similar hues, as in Ad Reinhardt's *Abstract Painting* (**9.2**). Although he has used only blues of low to medium value, the hue mixtures—a bit more green, black, or purple in the different blues—prevent the colors from flowing into each other visually. Each defines a distinct, hard-edged shape. Some of the shapes seem to come forward, as if they were sitting or floating on top of the surrounding color. Here the intentionally limited monochromatic color scheme allows us to give our full attention to

▶ **9.1 Deborah Muirhead,** *Nebula,* Oil on canvas, 72 x 60ins (183 x 152cm). Private Collection.
Despite the abundance of colors available in the modern palette, monochromatic variations on a single hue can be very effective.

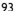

these spatial effects and to the relationships of shape across the picture plane.

Variations on a single monochromatic theme obviously do not have to be boring. Often designers break up the inherent unity of a monochromatic scheme by using neutral colors—white, black, grays, and browns—as well as variations on the chromatic hue.

The next closest harmony is an ANALOGOUS color scheme, which uses several hues lying next to each other on a color wheel. This is an imprecise concept, for color wheels can have as few as six colors or as many as hundreds or thousands of variations, depending on the size of the steps between hues. On a six-hue wheel of pigment primaries and secondaries, blue and green lie next to each other. Based on such a wheel, the azure-painted gravel paths and green gardens of Daan van Golden's *Aqua Azul* (**9.3**) would be said to constitute an analogous color scheme. However, the harmony would be closer if there were more intermediate hues, such as a range of blue-greens of varied values and saturations (as indicated on the twelve-hue color circle in Figure **9.4** and expanded in the color map in Figure **9.5**. The colors would also seem more closely related if there were less value contrast between the high-value blue (a blue 7 on the colour map) and the dark green borders (value 4 green), and if the sole blue of the gravel paths were not so highly saturated. It is clearly apparent that the artist was not intent solely on creating a quiet, calming color combination, although the color choice is actually a traditional one: in the seventeenth century, the paths of this garden were, in fact, laid in blue tiles.

A high degree of contrast is expected in the third kind of color scheme: COMPLEMENTARY, in which the two prin-

◀ **9.2 Ad Reinhardt, *Abstract Painting, Blue, 1952*** Oil and acrylic on canvas, 75 x 28ins (190.5 x 71.1cm). Carnegie Museum of Art, Pittsburgh.
Even in a monochromatic work, slight variations in hue and value allow the viewer to see differences and therefore edges between colored areas.

▶ **9.3 Daan van Golden, *Aqua Azul,* 1987** Painted gravel on the paths of the Botanical Gardens, Amsterdam.
Blue and green, an analogous color combination often used today, was deplored by earlier color theorists as offensive and vulgar.

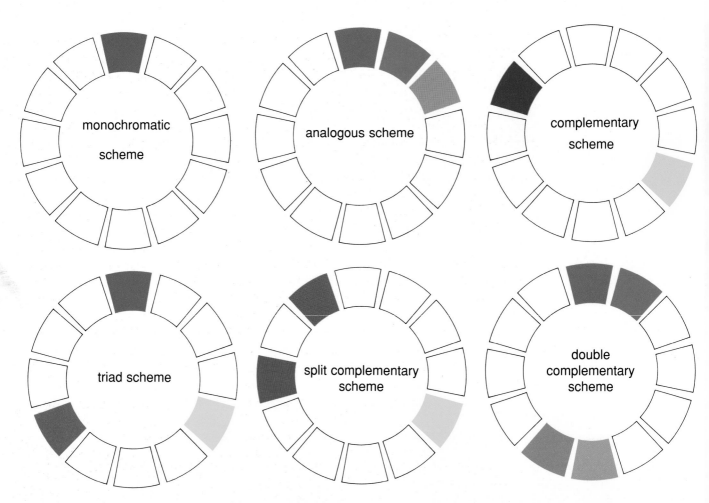

monochromatic scheme

analogous scheme

complementary scheme

triad scheme

split complementary scheme

double complementary scheme

▲ **9.4 Standard color schemes**

▶ **9.5** Broad use of analogous colors might encompass three or four adjacent hues with many variants in value.

▲ **9.6 George Sugarman, *Purple and Yellow,* 1984** Painted aluminum.
Juxtaposition of complementary colors at high saturation is inevitably exciting.

cipal colors lie opposite each other on a color wheel. In a sense, complementary hues are related like the two ends of a balancing device—they hold each other in equilibrium. If we think in terms of warm and cool colors, a complementary color scheme may provide a psychologically satisfying balance between these two extremes. Goethe even felt that the eye hungers to see the complement. He wrote of "the demand for completeness, which is inherent in the organ,"[2] supplying after-images of the complement if it is not actually present. While providing psychological completeness, complementary colors used together also intensify each other's appearance, so the result tends to be stimulating, as in George Sugarman's *Purple and Yellow* (**9.6**), in which purple and yellow are used at maximum saturation.

▼ **9.7 Charles Emile Heil, *Lotus,*** Watercolor on paper, 16 × 22 ins (40.6 × 55.8cm). Museum of Fine Arts, Boston.
An almost-black green provides a complementary foil to the high red of the lotus blossom, with toned-down complementary contrasts echoed throughout the painting.

▲ **9.8 Rufino Tamayo, part of living room with pre-Columbian pieces** Split complementary color schemes may offer unexpected color partnerships.

▶ **9.10** (above right) **Bruno Paul, Poster: Exhibition: Arts and Crafts in Munich, 1901** State Museum, Munich.
Colors of equal value may seem to belong together; variations in value within the same composition avoid monotony.

▶ **9.9 Jacob Lawrence, *Builders,* 1980** Gouache on paper, 34¼ x 25³/₈ ins (86.9 x 64.5cm) SAFECO Insurance Company, Seattle. Here values of red, yellow, and blue are used as a triad; any other colors equidistant from each other on a color wheel form a triad, but its character will differ depending on the hues chosen.

Toning down the saturation of complementary hues—and raising or lowering their value beyond the level of maximum saturation—lessens the visual contrast between them. Nevertheless, even at reduced contrast, complementaries may still subtly intensify each other's liveliness. Charles Emile Heil's *Lotus* (**9.7**) relies primarily on the contrast between green and red, both of which are painted at high value or relatively low saturation. This color scheme has been further balanced and varied by a secondary interplay of two other hues that are complementary to each other: yellow and blue-purple.

When two hues adjacent to each other on a color wheel are used with their respective complements, such as blue-green and blue with red-orange and orange, the scheme is called DOUBLE COMPLEMENTARY. Another scheme derived from the complementary pattern is SPLIT COMPLEMENTARY, in which the hues to either side of the complements are used, thus softening the contrast slightly. As used by Rufino Tamayo in his home outside Mexico City (**9.8**), a split complementary scheme offers a surprising juxtaposition of yellow, red-violets, and blue-violets. Tamayo enjoys the unexpected and had the ceilings of his home painted in chromatic hues—blue, mauve, yellow—while keeping the walls white. As he

▲ **9.11 J. M. W. Turner,** *Light and Colour (Goethe's Theory: The Morning After the Deluge, Moses writing the Book of Genesis),* **exhibited 1843** Oil on canvas, octagonal, 30½ins (77.4cm) Tate Gallery, London.
Turner was fascinated by the juxtaposition of light and shade, the principle upon which many of his compositions are based.

notes with amusement: "Usually it's the other way around." Although Tamayo strives to touch the universal in the human spirit, he does so by way of ancient pre-Hispanic and popular Mexican aesthetic themes, reflected in his color choices:

> I've used the colors of both my palettes here: those the village people use in their daily lives because they're cheap, like the blues and whites and ochres, and those bright colors they buy especially for fiestas.[3]

A broader range in contrasts is seen in the TRIAD color scheme, which draws on three colors equidistant from each other on a color wheel. In his *Builders* (**9.9**), Jacob Lawrence has used the triad of pigment primaries—red, blue, and yellow—interwoven with brown, black, and grays. These "neutral" colors are visually interlocked with the chromatic hues, like flat shapes in a jigsaw puzzle, so that they are not mere background foils for the other colors. If anything, it is the black head of the hammer that most immediately draws our attention in this busy scene. Although the colors have been painted evenly, rather than with the value gradations associated with three-

dimensional form, careful use of lines of one color extending into another—such as the blues enhancing the outline of the foremost worker's bent leg and the contours of his head—help us to recognize a slight volume in these figures. The interplay of dark blue against light blue, dark red against light red, and dark yellow against light yellow resembles the complex point and counterpoint rhythm of a vigorous jazz composition.

Another approach to harmonizing colors is to use colors together that vary in hue independently of any of the above schemes but that are nonetheless similar in value. Bruno Paul's poster (**9.10**) juxtaposes a low saturation blue-green, red, and yellow of nearly the same value—approximately value 6 on the Munsell system—making them appear to belong together. To bring striking contrast into this muted scheme he adds a slightly darker brown (a yellow 5) and fully dark black accents on the storks and the typography. Using the color map (9.5) for reference, colors of equal value are aligned with each other horizontally. For variations on the basic equal-value theme, one could include colors from above or below this line. Rigid symmetry would require balancing addi-

▶ **9.12 Mauro & Mauro, Design for Champion International, Stamford, CT** Promotional piece. Layered die-cutting. One of many possible color harmonies suggested by Chevreul was the impression of a "dominant coloured light" influencing all hues in a work.

▲ **9.13 Traditional Latvian mittens** The three different and potentially clashing yellows have been unified and harmonized by the black and white patterns that surround them.

▼ **9.14 Bessie Harvey, *Tribal Spirits,* 1988** Mixed media, 45 x 26 x 20in (114.3 x 66 x 50.8cm). Dallas Museum of Art, Texas. Spots of white give a unifying framework to this seemingly uninhibited use of color.

tions of higher value with some of lower value, but few works of art are so rigidly patterned.

Rather than using hues that balance each other around a color wheel or values that line up horizontally, artists may choose to balance lights against darks. J.M.W. Turner (1775–1851) was an artist who worked primarily in this way, analyzing color combinations in terms of the harmony of value contrasts, or as he put it, "the compelling power of colors used as shade to light, that wrought the whole to harmony."[4] A useful guideline for artists is that it is impossible to get a good light unless it is offset against a dark, and vice versa. There is, however, no need for equal amounts of darks and lights, for lights expand and appear to take up more room than darks. In Turner's *Light and Colour* (**9.11**), wherever the artist wants a light to appear more dramatically luminous, he juxtaposes it to a dark area. The whole painting is like a swirling tunnel, with light appearing through the darkness, an abstract representation of the welcome appearance of light as a storm clears.

Another means of creating harmony among colors was suggested by Chevreul. He described it as

> the harmony of a dominant coloured light, produced by the simultaneous view of various colours assorted according to the law of contrast, but one of them pre-dominating, as would result from the view of these colours through a slightly-coloured glass.[5]

In accordance with this, Mauro & Mauro's promotional piece for Champion International (**9.12**) uses varied hues of very low saturation and high value, all blended by having a single dominant color in common. The die-cut papers all appear to be seen though a film of the same pale pink-white that surrounds them.

A major factor in how well colors work together is the amounts in which they are used. Almost any colors can work together if they are used in small amounts. The Latvian folk mittens shown in Figure **9.13** combine three different yellows—wheat, mustard, and green-yellow—but the potential clash of colors seems to have been subdued. This is because the bright bands have been harmonized by the expanse of neutral colors (black and white) which surrounds them. The number of colors used often has practical as well as aesthetic benefits: the more strands of wool the knitter uses, the thicker and

warmer the mitten will be. The small-scale pattern of repeated color changes also means that the loops carrying the yarns of different colors are short on the reverse side, so that the wearer's fingers are not likely to snag on them.

Naive, folk, or "outsider" artists often use color intuitively without reference to any established system of color harmony. Bessie Harvey's *Tribal Spirits* (**9.14**) employs extremely raw colors, in no seeming order, but juxtaposes hues and combines them with black in such a way that they have a more spiritual quality than we would usually associate with bright reds, blues, golds, and yellows. The spirits she experiences, in the wood come to life with a glowing energy from the way she uses the paint, as if dynamic light patterns were emanating from their hair. The spots of white draw everything together and further add to the sensation of pulsating light. She is using color choices very confidently in her own personal way.

Color Interactions

Whether or not colors are combined according to established color schemes, one should always be aware of the optical effects that adjacent colors have on each other. Particularly in two-dimensional work, every color used will be affected by what is next to it. Colors are never seen in isolation. Even if one were asked to view a red light by itself in a darkened room, one would automatically be comparing the red with the black around it. If one were then asked to pick out that same red from a group of many reds, it would be very difficult to do so, for one would then be seeing it with other reds around it.

Optical color interactions are most apparent to those who know to look for them. Other people may not "see" them because there is no model of reality confirming their existence; they allow their brains to override their visual receptors. Some interactions happen very quickly; other take some time to develop.

One of the optical phenomena noticed by Goethe and Chevreul is what Chevreul called SUCCESSIVE CONTRAST. That is, as we noted in Chapter 3, if one stares at a color

for some time and then looks away, one "sees" its complement as a colored glow. Back in Figure 3.3, after looking at the red turtle, you probably saw a green turtle when you shifted your gaze to the white space next to it. Goethe explained this phenomenon as an innate striving for completeness:

> When the eye sees a colour it is immediately excited, and it is its nature, spontaneously and of necessity, at once to produce another, which with the original colour comprehends the whole chromatic scale. A single colour excites, by a specific sensation, the tendency to universality.
>
> To experience this completeness, to satisfy itself, the eye seeks for a colourless space next every hue in order to produce the complemental hue upon it. [6]

If, however, there is no white space next to an intense color sensation, the color we perceive when we shift our gaze is a combination of the complement of the original and the color of the space itself. Jasper Johns worked intentionally with this principle to create *Flags* (**9.15**). If you stare at the dot in the middle of the upper flag for 60 seconds and then shift your gaze to the dot in the center of the rectangle below, you may perceive the red and white stripes and white stars on blue background of the United States flag. This is a complex optical mixture and takes a while to develop.

Johns' *Flags* series is one of the few artistic efforts that purposefully use the phenomenon of successive contrast. However, the effect does occur when we look for a long time at any color. When working with a large area of red, for example, it may appear to shift toward green or gray; if one does not rest one's eyes by glancing away, one will lose the ability to see the red as another person just looking at it would. Visual fatigue can change our perception of any color.

A phenomenon that is used consciously in some artworks is what Chevreul called SIMULTANEOUS CONTRAST. In this case, complementary colors—or any strongly contrasting colors—that are adjacent will intensify each other along the edge where they meet. If you stare at the center of Figure **9.16** for some time, you will begin to see a brighter glow of each color just inside the edge where they meet. Compare this effect with the interactions of these colors when separated by widening bands of black (to the left) and white (to the right). Do the colors inten-

sify each other as much when separated by white as by black? How does widening the intermediate line alter the effect? At what point?

Simultaneous contrast, first commented upon by Leonardo (see Chapter 6), has often been used by painters and graphic designers. Milton Glaser contrasted

▲ **9.16** Look at the border between red and blue for a while and note the optical effects. Compare them with those occurring when the two hues are separated by broadening bands of white and black.

▼ **9.17** A middle texture will look like two different colors when presented against its parent colors.

◄ **9.15 Jasper Johns,** *Flags,* **1965** Oil on canvas, 72 x 48ins (182 x 122cm). Collection of the Artist.
Stare at the dot in the upper flag for perhaps a minute and then quickly transfer your gaze to the dot below to see the effect of successive contrast.

red-orange and blue-green to heighten the brightness of his Aretha Franklin poster (5.5). Just as to get a good light, you need to place it next to a dark, it is a similar rule of thumb that to get an intense hue, it helps to place it next to its complement. Josef Albers observed that strongly contrasting hues of high saturation and equal value—even if not precisely complementary—will vibrate optically along the edge where they meet, creating a sensation of transparent, glowing light that enforces the boundary line and the shapes it divides.

Albers also systematically studied the possibilities of making one color look like two different colors, pushing it in opposite directions according to the background color it is seen against. This is an optical illusion of particular usefulness in applications such as graphic designs with limited palettes. In Figure **9.17**, the same blue-green has been placed on green and blue. But because the eye automatically compares these strips with what surrounds them, it sees the strip on the left as bluish in comparison with the green and on the right, greenish in comparison with the blue. In a sense, each ground subtracts its own energy from what lies upon it. This effect is most readily created with a third color that is a MIDDLE MIXTURE between the other two; the three bars below demonstrate that the color used as the strip is actually a blue-green, a mixture of blue and green. Proportions and distances are

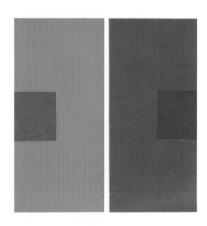

▲ **9.18** Two physically different colors can be made to appear nearly identical by careful choice of colored grounds.

▲ **9.19 Josef Albers,**
Equivocal, from *Homage to*
the Square: Ten works by Josef
Albers. Silk-screened print, 11
x 11ins (27.9 x 27.9cm).
Collection of Arthur Hoener.

▲ **9.20** (above right) **Josef**
Albers, ***Full,*** from *Homage to*
the Square: Ten works by Josef
Albers. Silk-screened print, 11
x 11 ins (27.9 x 27.9cms).
Collection of Arthur Hoener.

▶ **9.21 Dorazio,**
Construction Eurasia, **1964**
Oil on canvas, 5ft 6ins x 8ft
(1.7 x 2.4m). Private collection.
Follow the illusionary
overlappings of any of these
ribbons to discern the nuances
of multiple transparency
effects.

9.22 Michael James, *Rhythm/Color: Morris Men,* 1986
Machine-pieced cotton and silk; machine quilted, 8ft 4ins x 8ft 4ins
(2.54m x 2.54m).
*Within a general framework of transparency effects, Michael James
contradicts the effects of see-through mixtures in many of the
color "intersections" in this quilt.*

also critical; if the two strips were very close, they could more readily be compared with each other than with the grounds and one would see that they were the same.

Less useful but equally fascinating is the ability to deceive the eye into thinking it is seeing fewer colors than have actually been applied. Using the same principle that a ground will subtract its hue from anything applied to it, a blue-purple has been placed on a blue and a red-purple on a red in Figure **9.18**, creating the illusion that the small squares are nearly identical. When compared with each other below, removed from the grounds, they are readily seen as two different hues.

Notice something else in Figure 9.18: the small square almost seems to merge with its ground on the right, whereas it pops out boldly on the left. The greater the difference between colors—in hue, saturation, and/or value—the greater the apparent spatial distance between them, especially if the edges between them are hard

rather than soft. An optical glow caused by the eye's reaction to the contrast in hues begins to surround the small square on the left, further lifting it away from the red ground.

Albers devised a single framework for working with these interactions: a square within a square within a square, set off-center so that the relative proportions of the colored areas are varying rather than uniform. This great *Homage to the Square* series opened so many possibilities that experimenting with the effects of precise color combinations occupied Albers for almost thirty years. He found that in the case of a true middle mixture in hue and value, such as the rust color between the red and the olive in *Equivocal* (**9.19**), the parent colors would seem to leap across to reappear along the far edges of the middle color. Next to the red on the right-hand side, there is an olive-green glow, created by the subtraction of red from the rust. Part way across the rust band the effect begins to reverse, creating a red glow along the edge that abuts the rust, and darkest where it can be compared with the white ground. These optical variations create a fluted effect, as though the bands were rounded in or out in space.

Albers' *Full* (**9.20**) does not sandwich a middle mixture between two parents, so the fluted effect does not occur. The red-orange and blue-green are complementary to each other, but they are separated by a band of red-purple. Look at this print for a long time to see what happens. How much of it can be explained by the principles given above? Albers stated:

> In my work
> I am content to compete
> with myself
> and to search with simple palette
> and with simple color
> for manifold instrumentation
> So I dare further variants[7]

Another type of interactive use of color is found in TRANSPARENCY EFFECTS, in which one color appears like a film lying over another. To make this appear visually sound, one must mix pigments that convincingly give the appearance of visual mixtures of the colors in question. Moreover, the one that is to appear on top must dominate the blend otherwise it will not make spatial sense.

▲ **9.23 The Bezold Effect** Changing a single color in this design alters its entire appearance.

Dorazio's *Construction Eurasia* (**9.21**) presents a complex series of transparencies with, in many places, up to three ribbons overlapping each other on top of a white ground. If the colors are modified accurately, each ribbon's spatial relationship to the others should be discernable.

Often artists play with the suggestion of transparency effects without making them fully logical. Michael James' quilt, *Rhythm/Color* (**9.22**) provokes us to try to follow the effects of overlaid colors, which in this case are not at all transparent in actuality. Rather, they are pieces of opaque fabric pieced together side by side. James has created the fascinating impression of striped bands crossing each other and creating transparent color mixtures in some areas, and overlapping non-mixtures in others, with surprises at every turn.

Wilhelm von Bezold, a nineteenth-century rug designer, discovered another optical interaction, which now carries his name: the BEZOLD EFFECT. He found that he could change the entire appearance of his rugs by changing or adding only one color. Usually this is done by substituting a different color for the one that occupies the most area. In Figure **9.23** the change in the dominant hue from near-black to a high blue-green dramatically alters the whole. The overall impression becomes quite light, with the other hues as darker accents rather than light intervals in the composition. It is also possible in some cases to alter the whole by changing a color that does not occupy the largest area, especially if it is used in a striking way.

If colors of equal value or very similar hue are juxtaposed, the effect of their interaction will be vanishing boundaries: it will be very difficult to determine where one stops and the other begins. This interaction is fairly easy to produce with colors of either very low value or very high value. In painting the woman's blouse in *Breakfast* (**9.24**), Edouard Vuillard has juxtaposed reds and blues of such high value that one merges quietly into the other, even though at medium value and high saturation these are highly contrasting hues. Elsewhere, such as the black projection across the woman's lap, the rungs of her chair, and the area of the floor beneath, colors of sim-

▲ **9.24 Edouard Vuillard, *Breakfast,* 1892** Oil on canvas, 12 x 10¹/₂ ins (30.4 x 26.6cm). Paul Rosenberg and Co., New York. Colors of equal value tend to merge with each other optically along their edges, so that the boundary between them vanishes.

ilar hue but slightly differing value also tend to merge where they are juxtaposed. With highly saturated middle values, colors must be very close in hue to lose the edge between them. The color theorist Ogden Rood devoted a whole chapter of his *Modern Chromatics* to the subject of "The Small Interval and Gradation," stressing the importance of vanishing boundaries in our perceptions of the world around us:

> One of the most important characteristics of color in nature is the endless, almost infinite gradations which always accompany it. It is impossible to escape from the delicate changes which the color of all natural objects undergoes, owing to the way the light strikes them. ... Even if the surface employed be white and flat, still some portions of it are sure to be more highly illuminated than others, and hence to appear a little more yellowish or grayish; and, besides this source of change, it is receiving coloured light from all colored objects near it, and reflecting it variously from its dif-

◀ **9.25**

Phantom colors are those that tint surrounding neutral colors with their own hue. This effect is most obvious in the "yellow band" of this computer drawing, but it also occurs to a certain extent in the other bands.

◀ 9.26 Georges Seurat, *Les Poseuses*, 1888 Oil on canvas 15½ x 19¼ ins (39.3 x 48.8cm). Private collection, Switzerland. In some areas, Seurat juxtaposed dots of pure hues, mixing them optically rather than blending them on the palette.

ferent portions. If a painter represents a sheet of paper in a picture by a uniform white or gray patch, it will seem quite wrong, and can not be made to look right till it is covered by delicate gradations of light and shade and color.[8]

The last three kinds of optical color interactions concern what happens in the spaces between them. One of these is the phenomenon of PHANTOM COLORS. In some cases, colors spread beyond their physical boundaries to tint larger neutral areas in their own hue. In Figure **9.25**, the ground is a uniform white, but the thin yellow lines alongside the green- and red-dotted lines in the center spread to cast their influence over the white in the central panel. Where red and green lines cross the verticals in the next panel to the left, the effect changes to ephemeral red and green flashes of color on the white, or an overall brown sensation. And to the far left, the white may have a blue cast. These phantom colors appear most readily when the lines have a slightly jagged

edge, rather than a perfectly straight one, perhaps setting up an excited pattern in the eye. What do you see on the white to the far right, where only blue lines have been applied?

As we have discussed, the persistence of our vision allows us to see mosaics of tiny dots in a few primaries on a television screen, or in four-color process printing, as areas of visually mixed colors. The nineteenth-century experimentation with application of colors, which can be seen in the work of Delacroix (10.13) and later evolved into Impressionism and Postimpressionism, had as one of its objectives the intensification of painted colors. The Postimpressionists Paul Signac and Georges Seurat tried to achieve this goal by using a palette of pure spectral colors (Seurat used eleven hues spread evenly around the color wheel, plus white for tinting) and applying them in small unblended bits, in the attempt to coax the eye to blend them optically. In theory, this would avoid the darkening of physical subtractive mixing and approach

▲ **9.27 Arthur Hoener,** *Synergistic Color Painting,* **1978** Acrylic on canvas, 32 x 32ins
(81 x 81cm).
In Hoener's synergistic color mixtures, a white, gray, or other pale ground is the stage for
optical mixtures which become additively lighter than the colors used to mix them.

the additive effect of light mixing, with optical mixtures of high saturation. This technique was known as DIVISIONISM, or, when the white ground was allowed to show through and assist the blending, POINTILLISM. Signac claimed these results for what at the time was called "Neoimpressionism":

> By the elimination of all muddy mixtures, by the exclusive use of the optical mixture of pure colors, by a methodical divisionism and a strict observation of the scientific theory of colors, the neoimpressionist insures a maximum of luminosity, of color intensity, and of harmony—a result that has never yet been obtained.[9]

Divisionist painters actually attempted two different kinds of effects. By juxtaposing dots of analogous colors, they hoped to create luminous admixtures in spectral hues; by juxtaposing complementaries, they sought luminous gray mixtures. In Seurat's *Les Poseuses* (**9.26**), red and blue dots across the women's contours generate grayish shadows, while in the grass of Seurat's famous painting reproduced on the left of the painting—*A Sunday Afternoon on the Island of La Grande Jatte*—blues, greens, and yel-

▲ **9.28 Arthur Hoener, color diagram of synergistic color mixing**

▶ **9.29 Arthur Hoener, Duo, 1980** Ink on paper, 30 x 40 ins (76.2 x 101.6cm).
What hue do you perceive in the thin lines? Do you see any other chromatic colors?

lows are used together to stimulate the eye to mix bright greens. In fact, these experiments were not entirely successful. Chevreul had warned that interweaving of fine threads of complementary colors would create dull optical mixtures, unlike the brilliant additive effect of mixing colored lights.

Extraordinarily successful optical mixtures were, however, created by a twentieth-century artist, Arthur Hoener. Distressed that physicists could perform magic with color, which he felt was really the province of the artist, Hoener experimented with precise colors and proportions until he was able to create convincing optical mixtures, such as the reds, blue, and yellow we see in his *Synergistic Color Painting* (**9.27**). Figure **9.28** reveals

his technique at close-hand, showing the mixing hues he is using, all of them high value and none of them a traditional pigment primary. Hoener called his approach SYNERGISTIC COLOR MIXING because each color seen is the result of the cooperative effect of two colors. He explains:

> The thing that is important in order to get the synergistic color to work is to understand the relationship of color to its ground color. A dark color on a white ground will look almost black; it's hard to see the color quality of it. With a medium-value color on a white background you can see the hue of that color and you might even get a simultaneous contrast effect, which would be the opposite of that color developing in between the lines. As the color becomes lighter, the eye does not overreact to what it's looking at and allows you to see the energy of the color.
>
> When physicists talk about color, they always talk about it in terms of energy. Most of the time when artists work with color, they deal with the overreaction of the eye to the color: an after-image, vibrating colors, contrasting colors, enhancement of green by putting a red next to it, and so forth. Synergistic color is really taking advantage of the fact that the energy of the color is available to be mixed with other colors. Using that principle of how color relates to its background, it is possible to mix almost any color. The color sensation is then highly satisfying, because you, the viewer, are supplying it. But for the artist to create this effect, both the precise hues and the proportions in relationship to the ground are very, very touchy.[10]

Hoener says he has to number the jars of paint he uses because once he begins laying them down together, there is no way he can recognize them. In fact, the mixtures work so well that he intentionally throws them off just slightly so that viewers can see the lines of the mixing hues themselves; otherwise people simply think they are seeing yellow, failing to recognize that that yellow is a magic combination of thalo green and orange-pink, for instance. Like all color interaction effects, this optical mixing works best if we relax the defensive grid that makes us label things rigidly according to what we "know" we are seeing, and prevents us from recognizing the extraordinarily varied realities of color.

When this defensive grid is truly relaxed, it is even possible to see chromatic hues in a black-and-white work. Bridget Riley coaxes the eye to see vivid hues by using linear motion, precise spacing, and the contrast between black and white in her *Crest* (10.23). Arthur Hoener achieves a subtler red sensation in the thin lines of *Duo* (**9.29**). Let your eyes unfocus while looking at it from different distances. Goethe observed long ago that looking at the edge between a light and a dark area with a magnifying glass, thus pulling it out of focus, will cause one to see a spectrum of hues. The lens of the glass is curved just like the human eye. It may be that when the eye is thrown slightly out of focus—in *Duo* by being unable to focus on the thin lines while the fatter black dots are demanding attention, in *Crest* by being cast off by the repeated wavy lines—this same spectral effect occurs. Since we will perceive more of the world around us if we are carefully attentive, appreciating optical colors requires that we first abandon our attempts to control what we see and then carefully observe the optical realities of our perceptions.

Color in Fine Art

10

Over time and across cultures there have been many different ways of using color in the fine arts. To a certain extent, these have been governed by technology. The earliest peoples had a palette limited to the pigments that were common in local earth, chiefly the red and yellow ochers of iron and the black of manganese. The most primitive of cave paintings are monochromatic drawings, but some—such as those in the caves at Lascaux, France, dated around 15,000 to 10,000 B.C.—incorporated washes to suggest three-dimensional form within the drawn outlines. These were polychromatic, involving more than one color for subtle shading.

The expansion of this limited palette has been plotted on the C.I.E. diagram by Stephen Rees Jones (**10.1**), based on the colors seen in prehistoric, Egyptian, Early-Renaissance, and nineteenth-century artworks. Chevreul carefully studied the historical expansion of the artist's palette and came to the conclusion that from antiquity to the nineteenth century some 14,400 different colors had been used in works of art. Figure **10.2** summarizes his findings with reference to the appearance of some representative hues. Today, with petrochemical dyes and the explosion of color possibilities in color graphics, there are literally millions of colors in use.

As more pigments and improved media have become available, ways of using color have changed, too. In the following sections, we explore some distinctively different approaches to color across time and space.

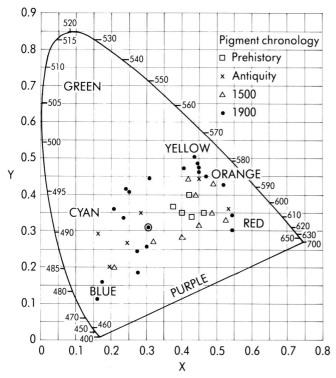

▲ **10.1 (After Rees Jones) The history of the artist's palette in terms of chromaticity** The newest colors available to artists have extended the range of saturation possible, though the purity of the spectral hues, shown around the outside of the C.I.E. diagram, still eludes us.

Non-Western Traditions

Surviving small-scale, technologically simple societies tend to use natural dyes, paints, and found objects for color in the ritual pieces we now regard as works of art.

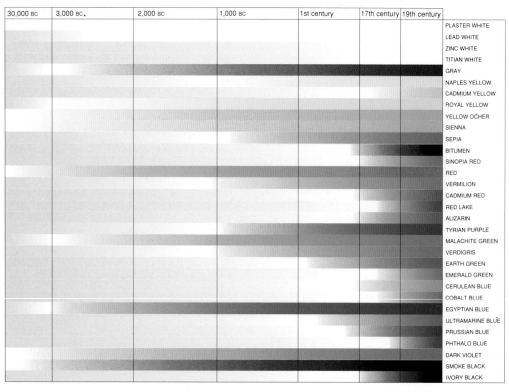

30,000 BC	3,000 BC.	2,000 BC	1,000 BC	1st century	17th century	19th century	
							PLASTER WHITE
							LEAD WHITE
							ZINC WHITE
							TITIAN WHITE
							GRAY
							NAPLES YELLOW
							CADMIUM YELLOW
							ROYAL YELLOW
							YELLOW OCHER
							SIENNA
							SEPIA
							BITUMEN
							SINOPIA RED
							RED
							VERMILION
							CADMIUM RED
							RED LAKE
							ALIZARIN
							TYRIAN PURPLE
							MALACHITE GREEN
							VERDIGRIS
							EARTH GREEN
							EMERALD GREEN
							CERULEAN BLUE
							COBALT BLUE
							EGYPTIAN BLUE
							ULTRAMARINE BLUE
							PRUSSIAN BLUE
							PHTHALO BLUE
							DARK VIOLET
							SMOKE BLACK
							IVORY BLACK

◀ **10.2 The evolution of color pigments** The earliest artworks were rendered in earth colors. Hues such as cobalt blue, cadmium yellow, and zinc white having been developed relatively recently.

Within the limitations of what is at hand, they use color with great sophistication. The colors in the inner facets of the Kwakiutl raven mask (**10.3**) are actually of rather low saturation, but presented in sufficiently large areas adjacent to areas of contrasting colors, they appear bright.

As synthetic, chemically-based colors become available to nonindustrial cultures, they readily adopt them for their brilliance. The introduction of glass beads to the Plains Indians of the United States supplanted earlier work in dyed porcupine quills with such masterpieces as Mrs Minnie Sky Arrow's seven-pound fully beaded buckskin piano recital dress (**10.4**). In rural India, some women now use brilliantly pigmented manufactured powders for their *rangoli*—designs painted on the earth or floor to welcome guests. The difference in saturation is evident in the *rangoli* pattern being created in Figure **10.5**. Some areas of the designs are created with powder made by rubbing *geru*, a soft stone that yields a red-brown dust, whereas the rest of the pattern is created with bright modern manufactured pigmented powders. Yellow was traditionally created with turmeric powder, which like the *geru* is considerably less saturated than the

synthetic powders of the same hues. Saturated or not, the hues celebrate auspicious aspects of life, such as white for purity, red for fertility, yellow for good fortune, and green for the abundance of plant life.

Being limited to what they could find or trade for in colored materials has not restricted color awareness in nonindustrial societies. The vocabulary of the Maoris in New Zealand, for example, includes forty color words used to distinguish between different kinds of clouds and over a hundred words for what Westerners call "red." In the evolution of languages, the first color terms seem to have referred to a distinction between light and dark; names of hues came later. In some languages, when talking about the surface appearance of an object, people use words that include references to texture and value; hue does not belong to a separate category of observations.

Often color use in works of art is determined by philosophical principles. Colors often carry symbolic meanings, as we have seen. Moreover, many peoples have strong ideas about which colors "should" be used. Ch'an (Zen) Buddhist and Taoist influences in China led some

▶ 10.4 Mrs. Minnie Sky Arrow, recital gown, 1890 Beaded buckskin dress. Smithsonian Institution, Washington. Among the traditional Plains Indians, the introduction of glass beads allowed intense color harmonies, worked out in precise geometric designs.

◀ 10.3 Kwakiutl wooden mask depicting raven American Museum of Natural History.
Contrast can be used to increase the apparent brightness of natural dyes.

▶ 10.5 *Rangoli*, India The few areas of traditional natural pigments in this auspicious design are of lower saturation than its areas of brilliant industrially manufactured pigment powders.

▲ **10.6 Li Ch'ing, *Buddhist Temple in the Hills after Rain,***
c. A.D. 950 Ink and slight color on silk, 44 x 22ins (11.8 x 55.9cm)
Nelson-Atkins Museum, Kansas City.
An austere aesthetic led Chinese landscape painters to avoid bright
hues, even though they were available.

▲ **10.7 Utamaro, *Ehon mushi erami,* 1788** Color woodcut,
8³/₄ x 6¹/₂ ins (22 x 16cm). British Museum, London.
Classical Japanese painters followed precise rules of color harmony,
reflected in this exquisite color woodcut.

painters to shun bright colors in favor of the subtle inks used in calligraphy, considered the highest of the arts. Li Ch'ing's *Buddhist Temple in the Hills after Rain* (**10.6**), where washes of very unsaturated color are used to create forms, reveals a highly restrained interpolation of local colors.

The principles of classical Japanese painting placed restrictions on adjacent colors. Using a color wheel of five primaries (yellow, blue, black, white, and red), the masters of this tradition say that no color should be juxtaposed with either of its parents, for to do so would detract from both colors. This observation is in alignment with principles of color interaction discussed in Chapter 9. Utamaro's book of insects, reptiles, and flowers includes the lovely print *Ehon mushi erami* (**10.7**), in which the red blossoms are kept separate from the purple ones (red plus blue) and both are presented against green, which is not a parent of either.

Historical Western Approaches

The Western tradition in painting is thought to have begun with the ancient Egyptians. Archaelogists have found their paint-boxes of stone or marble, up to 3500 years old, with eight to fourteen wells for different colors. These apparently included terracotta red, light and medium yellow ochers, turquoise-blue, green, black, and white, all used to fill in flat drawn shapes. In the fifth century B.C., certain Greek wall painters who applied tempera to wood, stone, plaster, and terracotta began to use a little shading to suggest three-dimensional form in space. Remarks by ancient historians—particularly Pliny—have led us to believe that these painters limited themselves to a bold four-color palette: red, yellow, white, and black. However, recent research reveals that

▼ **10.8 Giotto, *Lamentation* (detail), c.1304–13** Scrovegni Chapel, Padua.
Giotto's shading technique involved use of darker and lighter values of the same hues.

▲ **10.9 Michelangelo, detail from the unrestored Sistine Chapel ceiling, Vatican, Rome, 1508–12** We cannot be absolutely certain what colors the Old Masters used, but those who restored the Sistine Chapel ceiling were convinced that Michelangelo worked with bright hues, obscured here by dark accumulations of varnish and soot.

▲ **10.10 Same detail after restoration in the 1980s**

blue was also used, often for shadow effects rather than for dominant colors of objects.

Until the thirteenth century, tempera was often applied to dry walls of plaster, with a brilliant white gesso ground added to hold the paint and give it a luminous quality. The FRESCO technique, developed to a high art during the Renaissance, involved applying water-mixed pigments directly to wet plaster. Only those pigments that were water-soluble and resistant to the lime of the plaster could be used in this way—chiefly the subtle earth colors of ochers, umbers, chalk, charcoal, and pink and green clays. More brilliant mineral pigments,

such as those used for blues, had to be added *a secco* in tempera (which included a binder such as egg or glue), that is, after the plaster was dry. Those painted *al buon fresco* (true fresco) were more durable but tended to have a pale transparent quality, as in Giotto's *Lamentation* (**10.8**). Giotto (*c.* 1267–1337) was notable for his emphasis on modeling of figures by use of highlights and shading, creating the illusion of three-dimensional form on a two-dimensional surface by mimicking the way light acts in the natural world. Because colors could not be blended on the fresco but instead had to be applied stroke by stroke, gradations in tone were built up

in side-by-side value sequences and then blended by hatching with a brush.

Several centuries later, Michelangelo (1475–1564) was commissioned to fresco the ceiling of the Sistine Chapel in the Vatican. Controversy rages today among art historians about the colors he actually used, for the work has been restored from very subtle, dark hues (**10.9**) to colors of great freshness and brilliance (**10.10**). Those in favor of the restoration point out that the somber colors long associated with Michelangelo were actually the result of dust accumulation, smoke from lighting and heating devices, and dark overpaintings and darkened glue added by previous restorers. Simply removing this accumulation with special chemicals reveals very vivid colors. However, some critics prefer the frescos in their darker, less saturated state, perhaps following nineteenth-century preferences for the unifying dark, golden glow associated with Venetian oil paintings (for a while, even museums would treat paintings with dark varnish that grew darker over time).

A new surface brilliance in hues appeared with the introduction of oil as a medium for pigments. Initially difficult to work with because of its slow drying time, oil was adopted by painters in the Netherlands once drying catalysts had been invented in the late fourteenth century. The first great master of the medium was Jan van Eyck (*c.* 1390–1441), who fully exploited the greater saturation, transparency, and opacity possible when oil rather than tempera was used to carry the pigments. The many layers he used included a white ground which glowed through the upper layers of oils, an underdrawing, and then layers of paint from light and opaque to darker values or more saturated colors and transparent glazes. The optical effects of this layering created variations and vividness in hues that far transcended the limited palette of the time. One of van Eyck's early fifteenth-century palettes consisted simply of brown verdaccio (a dull pigment used for shading), red madder, ultramarine (genuine lapis lazuli), yellow ocher, terre-verte (green earth), orpiment (yellow), sinopia (iron oxide red), and peach black. Van Eyck's great *Arnolfini Marriage,* or *Giovanni Arnolfini and his Bride* (**10.11**), illustrates that skillful use of these pigments in oils allowed very subtle and continual gradations of tone. But van Eyck still maintained the old tradition of precise color boundaries between figures,

based on the original drawing, no matter how distant they were.

Color began to break loose from the rigid outlines of drawing in the sixteenth-century work of the Venetian artist Titian (*c.* 1490–1576), who is considered one of the greatest colorists of all times. Cleaning of some of his works reveals that they were originally far brighter in hue than the golden glow they have acquired through aging of the oil and accumulations of varnish. Venice was a major port and Titian had access to rare and expensive imported pigments. Even more significant is his direct use of paint as a drawing medium. Rather than beginning with an underdrawing and then filling it in, according to sixteenth-century art historian Giorgio Vasari, Titian painted "broadly with tints crude or soft as the life demanded, without doing any drawing, holding it as certain that to paint with colors only, without the study of drawing on paper, was the true and best method of working, and the true design."[1] X-ray analysis suggests that Titian reworked many areas, composing with areas of contrasting colors as he went along. If the dancing figures in the distance in Titian's *Venus and the Lutenist* (**10.12**) are compared with the brilliantly realized miniatures in the mirror of *The Arnolfini Marriage,* the difference in use of colors becomes obvious. Titian suggested form with dynamic slashes of color, though he worked in a far more controlled way to create the luminous, softly modeled nude Venus. He maintained the time-consuming practice of glazing for these transparent effects and spoke of using up to thirty or forty glazes.

By the nineteenth century, color had become one of the major focuses of certain artists. One was Eugène Delacroix (1798-1863), who observed color effects in nature very carefully and sought to recreate natural lighting by a sort of additive optical mixing on the canvas. He juxtaposed unmixed bright pigments, often in complementary colors, coaxing the eye to mix them when the work is seen from a distance. This broken color, such as the many interwoven hues in the garments of the horsemen in *Combat of the Giaour and the Pasha* (**10.13**), is quite different from earlier works, where, for example, a red form would be painted entirely in shades and tints of red. Like his contemporary, Goethe, Delacroix observed complex optical phenomena such as color shadows. From a seacoast studio he saw

◀ **10.11 Jan van Eyck, *The Arnolfini Marriage* (*Giovanni Arnolfini and His Bride*), 1434** Oil on panel, 33 x 22¹/₂ ins (84 x 57cm). National Gallery, London.
Van Eyck was a great master at using glazes to increase the brightness of hues in the limited palette of early oil paints.

▲ **10.12 Titian, *Venus and the Lutenist,* early 1560s**
Oil, 65 x 82¹/₂ ins (165 x 209.5cm). Metropolitan Museum of Art, New York.
Titian was famous in his time as a great colorist who painted directly with colors rather than filling in drawings.

◀ 10.13 Eugène Delacroix, *Combat of the Giaour and the Pasha*, 1827 Oil on canvas, 23 x 28ins (58.4 x 71cm). Art Institute of Chicago. Broken color was apparent in the evolving work of Delacroix, amongst others.

▶ 10.14 Claude Monet, *Impression—Sunrise*, 1872 Oil on canvas, 19½ x 25½ins (49.5 x 64.8cm). Musée Marmottan, Paris. This is the painting from which the Impressionist movement got its name. It is an attempt to capture ephemeral light sensations rather than solidly defined forms.

the shadows of people passing in the sun on the sands of the port: the sand here is violet in reality, but it is gilded by the sun: the shadows of these persons are so violet that the ground about them becomes yellow.

And on a person reclining in the sun against a fountain, he saw

dull orange in the carnations, the strongest violets for the cast shadows, and golden reflections in the shadows which were relieved against the ground. The orange and violet tints dominated alternately, or mingled. The golden tone had green in it. Flesh only shows its true color in the open air, and above all in the sun.[2]

With Claude Monet and his fellow French Impressionists, attempts to capture the color effects of light took precedence over depiction of forms. Monet's pioneering effort

in this direction, *Impression—Sunrise* (**10.14**), is a patchwork of colors arrayed as if they were just striking the eye, without being interpreted as forms by the brain. Monet counseled a young artist:

When you go out to paint, try to forget what object you have before you – a tree, a house, a field, or whatever. Merely think, here is a little square of blue, here an oblong of pink, here a streak of yellow, and paint it just as it looks to you, the exact color and shape, until it gives you your own naive impression of the scene before you.[3]

The nineteenth-century development of portable tubes for premixed permanent pigments in all hues had made it feasible for artists to paint outside directly from nature, as opposed to tediously grinding and mixing each color in the studio and trying to use layers and juxtapositions

to create brilliant hues that were not available in earth pigments. Monet mixed these tube colors with lead white to give them a pastel light-struck quality and then positioned them unblended on the canvas. As we saw in Chapter 3, Monet did not paint in local colors—the hues stereotypically associated with objects as seen under average lighting from close by, such as green for tree leaves. Instead, he attempted to record the evanescent realities of light as its vibrations were reflected off the material world.

Of the Postimpressionists, Seurat continued the experimentation with optical mixing of unblended dabs of color (9.26), though with a far more controlled technique than Monet, for whom speed was of vital importance in capturing a fleeting impression. Paul Gauguin

(1848–1903) took color in another direction, juxtaposing broad masses of contrasting colors which intensify each other, as in *The Day of the God* (**10.15**), rather than breaking local color into small pieces that blend optically to a gray. Gauguin said:

> A meter of green is greener than a centimeter if you wish to express greenness... How does that tree look to you? Green? All right, then use green, the greenest on your palette. And that shadow, a little bluish? Don't be afraid. Paint it as blue as you can.[4]

Gauguin used colors not only to emphasize nature but also to reflect the mysteries of inner responses to life. "feeling expressed before thought."[5]

▲ **10.15 Paul Gauguin,** *The Day of the God (Mahana No Atua),* **1894** Oil on canvas, 27³/₈ x 35³/₈ins (69.5 x 90.4cm). Art Institute of Chicago.
Gauguin was one of the first Western artists to use colors expressively, selectively intensifying certain color tones seen in the outside world for the sake of design and expressiveness.

Twentieth-Century Western Approaches

In the twentieth century, some artists have continued the tradition of representing local colors in their works, while others have carried the nonrepresentational color trend to its extreme. A particular escape from the local color of objects occurred with the Fauves ("Wild beasts," as their critics called them). Influenced by non-Western arts, they used intense colors joyously in whatever way they chose rather than trying to imitate nature. In André Derain's *The*

Pool of London (**10.16**), contrasts among flat planes of color become an end in themselves, with bright red people played against a blue boat, a bright blue shadow on a red smokestack, a green bridge, and green water carrying yellow reflections.

In the works of Sonia and Robert Delaunay, color became a playful design tool entirely divorced from form. Through explorations in the crafts, Sonia Delaunay transcended the traditional boundaries of painting and entered a world of pure color. In her *Tango-Magic-City* (**10.17**), nonfigurative color shapes seem to be in constant rhythmic motion, with many things happening simultaneously, as they do in life. They stem purely from the active imagination of the artist, the liberated child within.

Another of the many new approaches to painting evolving early in the twentieth century was the COLLAGE. In these relatively two-dimensional works, FOUND OBJECTS are glued to a flat surface in such a way that one looks from one to the next to assess their interrelationship. Kurt Schwitters' low-relief construction *Revolving* (**10.18**) leads the eye around a surface on which pieces of wood, metal, and cord define the boundaries of areas painted in subtle unsaturated colors. Areas of greater brightness

▼ **10.16 André Derain, *The Pool of London*, 1906** Oil on canvas, 25⅞ x 39ins (65.7 x 99cm). Tate Gallery, London. The Fauves—"wild beasts"—moved even farther from local colors, substituting exuberant, highly saturated hues for the duller tones of real life.

emerge as secondary discoveries, enhanced by contrast with the spatially dominant duller hues of paint and found objects. It appears as if the brilliance of the hues is largely covered by the grime of time, like the paintings of the Old Masters.

Artists working in collage or low-relief constructions with found objects are forever on the lookout for interesting and beautiful shapes and colors in objects around them. Some become very appreciative of subtleties of color that would be difficult to paint—the beauty of rust, for example, the patina of long handling, or the faded hues of something that has often been rained on. They collect discards that have caught their eye—leaves,

▲ **10.18 Kurt Schwitters, *Revolving*, 1919** Relief construction of wood, metal, cord, cardboard, wool, wire, leather, and oil on canvas. 48³/₈ x 35ins (122.7 x 88.7cm). Museum of Modern Art, New York.
In the new medium of collage, the unsaturated colors of found objects may be juxtaposed with painted hues.

▲ **10.17 Sonia Delaunay, *Tango-Magic-City*, 1913** Oil on canvas, 21³/₄ x 18¹/₈ins (55.4 x 46cm). Collection Kunsthalle, Bieflefeld, West Germany.
Delaunay's paintings reflect a total divorce of color from form, allowing it free play as a plastic element of design.

unusual stamps, bits of printed matter—the innate beauty or interesting design of which they can expose through placement and contrast.

By mid-century, the so-called New York School had established two particular directions in use of color. One was Abstract Expressionism, exemplified here by Franz Kline's *Scudera* (**10.19**). The direct use of oils—and increasingly, acrylics—without underpainting or underdrawing had with this group become an end in itself. The

▶ **10.19 Franz Kline, *Scudera*, 1961** Oil on canvas, 9 x 6¹/₂ ft (2.7 x 1.9m). Courtesy of Philip Samuels Fine Art.
In the work of some Abstract Expressionists, black and white maintain their status as true colors.

free, expressive gesture of the artist, traced through the trail of color it left on the canvas, became the focal point of the painting. Some of these artists, including Kline, used white and black as colors in themselves, of equal importance to the chromatic hues. In works such as *Scudera*, colors interlock on the same plane rather than existing in figure-to-ground relationships where one would appear to lie in front of the other in space.

Helen Frankenthaler even erased the spatial distinction between color and the canvas on which it sits by staining unprimed canvases with thinned acrylic paints. Acrylics—industrial pigments in synthetic resin—were becoming available in clear, highly saturated, sometimes even fluorescent or metallic hues that did not yellow with age as oils tend to do. Frankenthaler's *Nature Abhors a*

Vacuum (**10.20**) revels in the interplay of these radiant hues floating in a boundless space, the whiteness of which accentuates their brilliance. Acrylics dry so quickly that they are difficult to blend; pouring or mopping these thinned paints onto the canvas one at a time produces transparent overlapping rather than blended color sensations. This is not to say, however, that Frankenthaler did not mix her colors. She experimented freely with mixtures, explaining:

It occurred to me that something ugly or muddy could be a color as well as something clear and bright and a namable, beautiful known color . . . I will buy a quantity of paint but I hate it when it dries up and I haven't used it. If I have a pot of leftover green and a pot of leftover pink I will very

◀ **10.20 Helen Frankenthaler, *Nature Abhors a Vacuum*, 1973**
Acrylic on canvas, 8ft 7¹/₂ ins x 9ft 4¹/₂ins (2.63 x 2.86cm). Private collection.
In Frankenthaler's radiant stained canvases, flowing colors and background merge in an endless space.

often mix it just because I want to use it up. If it doesn't work—well, that's a loss. . . . For every [painting] that I show there are many, many in shreds in garbage cans.[6]

Frankenthaler's abstract organic color areas are somewhere between Abstract Expressionism and what is often called COLOR-FIELD painting. This label is used for works which consist of large colored fields rather than the color trails of paint gestures. Barnett Newman's *Cathedral* (**10.21**) almost hides the hand of the painter but is not laid down in solid, uniform masses of color. Rather it is built up of transparent layers of oils which give the impression of glowing light. The dedication to pure color fields, often constructed from many similar layers, is also seen in the work of Rothko (4.7).

Compare the subtle variety in coloration in Newman's painting with another development—the HARD-EDGED PAINTING typified here by the work of Ellsworth Kelly. His *Green, Blue, Red* (**10.22**) is exactly what it says it is. There is no attempt to develop subtleties of color or texture in the color field; each area is painted uniformly in unmodulated color, as if to industrial standards. One is confronted by the sheer facts of the three colors. This absolutely nonobjective approach leaves the viewer to explore the only points of drama in the painting: the hard

▲ **10.21 Barnett Newman, *Cathedra*** Oil on canvas, Stedelijk Museum, Amsterdam.
Color-field painters often create large expanses of colors built up of layers upon layers, making them glow with hidden richness.

▼ **10.22 Ellsworth Kelly, *Green, Blue, Red*, 1964** Oil on canvas, 6ft 1in x 8ft 4ins (1.8 x 2.5m). Whitney Museum of American Art, New York.
Follow the hard edges between hues to be aware of their interactive visual effects.

▶ **10.23 Bridget Riley, *Crest*, 1968** Emulsion on board, 65¹/₂ x 65¹/₂ ins (166.5 x 166.5cm). Mayor Rowan Gallery, London. Stare at this "black-and-white" work for a while to see what illusory chromatic hues begin to appear.

edges where the colors meet. If you stare at the edge shared by the red and green you may begin to see some simultaneous interaction effects. Just inside the green border a luminous glow of even more highly saturated green develops; the red on the other side of the boundary similarly becomes even redder, as each hue optically "subtracts" any trace of itself from the other. The same thing begins to happen along the edge shared by the blue and red if you stare at it long enough.

Taken to an extreme, this kind of optical interaction becomes Op Art. As we have seen, painters such as Josef Albers (9.19) and (9.20) and Richard Anuszkiewicz (3.7) give the viewer more color sensations than they have physically created. Their color combinations confuse our perceptual apparatus, and somewhere in the passage from eye to brain illusory colors begin to appear. Another figure in this movement—Bridget Riley—is highly suc-

cessful at making us perceive chromatic colors where only black and white actually exist. The eye quickly tires of trying to maintain focus on the black and white lines of her *Crest* (**10.23**) and soon begins to see all sorts of phantom colors in the white areas. Even the black lines change to unexpected brilliant hues if you look at the work long enough, letting your eyes go out of focus. Just what colors you will perceive and how long it takes them to develop will depend upon your visual flexibility (how willing you are to allow what you see to change), the lighting, and how tired your eyes are.

A final major development in the use of color in the fine arts is the infusion of crafts approaches and techniques. Many artists trained in the crafts have crossed the old boundary into fine art, undermining the traditional distinction between the two. Kit Loney, a weaver and papermaker, now brings both of these applied disciplines

into the realm of nonfunctional two-dimensional art. In works such as the triptych shown in Figure **10.24**, she "paints" with hand-dyed, handmade paper pulps, weaves tapestries of threads across them, and then works into the surface with other media such as acrylic and pastels. Such a piece exemplifies the wisdom of cultures whose words for color includes references to texture, for the hues look quite different than they would if spread flat across a canvas.

Using woven materials, Mary Billingsley creates what she terms "paintings in fabric", such as *Interior* (**10.25**). She has hand-dyed fabrics to create the colors she wants and then mixes and applies them "as freely as paint". She explains:

> My easel is the floor of my studio, where I lay in areas of color as in an underpainting, and gradually allow an idea to change and develop until the whole takes on a life of its own. I then begin to stitch the color pieces together. I continually adjust the composition until the vision becomes the completed structure. Both the liveliness of the weave of this heavy cotton twill and the subtle tones of the dyes have further inspired the painterly approach to the development of my ideas.[7]

Today many of the approaches to color developed in the past are still in use, but new ones are also continually evolving. In computer graphics, a vast range of luminous colors, some of them never before available to artists, are now readily mixed and viewed on the screen.

With the potential for creating millions of colors, more colors than the eye can even distinguish, computer artists now have the opposite challenge of that faced by the earliest artists, who had to make the most of a limited palette of earth pigments. The challenge in computer art is to make effective color choices in the midst of so many possibilities. After an initial period of gay abandon in choosing and juxtaposing highly saturated colors, many computer artists are now intentionally limiting or subduing their palettes to suit the "painterly" aesthetics of what many people would categorize as fine art, as in Figure **10.26**, which advertises the work of the Center for Creative Imaging in Maine.

Nevertheless, the luminous brilliance and variety in colors available to computer artists, especially to those using television screens or colored films rather than print-

▲ **10.24 Kit Loney, *Small Blue Triptych*** Tapestry embedded in handmade paper, 15 x 22ins (38 x 55.8cm).
The overlapping of crafts and fine art has brought fresh approaches to color in "painting."

▼ **10.25 Mary Billingsley, *Interior*, 1987** 100% heavy cotton twill colored with Spectrum Reactive Dye.
Billingsley "paints" with fabric, sewn together for a visually seamless interlocking of colored shapes.

◀ **10.26 Alan J. Kegler, *The Surveyors*, 1993** Computer image. Confronted with the availability of more color choices than the human eye can even distinguish, early computer artists often chose the brightest of colors. More mature use of the computer as an art medium now means that less saturated colors and an intentionally muted palette are more often employed.

▶ **10.27 Jan Serl, *Untitled*, 1978–82** Oil on board, 35³/₈ x 23¹/₄ ins (90.1 x 59.1 cm)
"Outsider" artists who are not operating within any historic or cultural tradition of color may achieve unique color effects.

ing inks for their final production, has initiated a new aesthetic which will be judged by different standards of taste than those of the older media, such as oil and water-color paintings. The extent of the new possibilities has not yet been fully explored. As computer artist David Em says,

> How physically and spiritually removed sitting in front of a computer terminal is from the experience of a prehistoric cave painter making a red handprint on a cave wall. Perhaps, if the prehistoric painter were presented with Velázquez's paint box and brushes it would take him a little while to grasp what had been delivered into his hands. And perhaps it will take us a little while to appreciate that the computer, which has so suddenly appeared in our midst, is likewise a wonderful and mysterious gift.[8]

And growing critical appreciation of folk art, multicultural art, and outsider art brings serious attention to works created outside the mainstream of Western aesthetic tradition, and thus uninfluenced by Western ideas of appropriate color choices. Jan Serl is a self-taught artist who confidently uses very unusual color mixtures in his oil paintings. The one shown in Figure **10.27** runs greens and blues through red fields; every area of the painting is treated with colors mixed side by side on the canvas. Serl thus creates color effects unlike anything else in Western tradition.

Each new development requires flexibility and imagination in our aesthetics if we are to explore fully its particular contribution to our work with colors.

Color in Applied Design

In applied design, as in the fine arts, color use has broken away from its traditional restrictions. There are, however, certain commercial and practical limitations on color choices. Many applied design disciplines—from giftwrap to product design—are affected by shifting tastes in color. Psychological associations with certain colors may also play an important role. Colors have compositional and spatial effects, already examined in previous chapters, that influence their commercial use. Beyond these general considerations, each discipline has its own practical and aesthetic factors influencing color use.

Color Trends

In applied design fields, color choices are strongly influenced by the demands of the marketplace. To a certain extent, trends in public color preferences are manipulated by the commercial industries; change is orchestrated for the sake of increased sales. Trends in color palettes are usually led by the fashion industry, with home fashion colors often following sometime later. As Ed. [*sic*] Newman of the American Textile Manufacturers Institute puts it:

> The word "fashion" is synonymous with the word "change." Fashion begins with fabric. Fabrics begin with color. Each season, color must make a new statement for fashion to continue its natural evolution. Our eyes need refreshment. . . We may have disliked the way we looked in last season's

clothes, but this season offers the opportunity to wear new colors, groom differently and appear as a new person. And if we are still unsatisfied, three months later there's a new season. . .[1]

In buying ready-to-wear clothing, consumers seem to be initially drawn to the two inches of color they can see in a garment sandwiched amongst others on a rack. Only if they like the color will they take it off the rack and consider its other features. Color is therefore so important that most industrial countries have color councils who gather and feed information about changing consumer preferences to manufacturers. The International Color Marketing Group of the Color Association of the United States, for example, supplies its color forecasts to members in the textile, apparel, interior design, paint, building products, automobile, and communications industries two years ahead of each selling season. Each season's palette takes into account aesthetic judgments about suggested color combinations. It considers the practicalities of translating the predictions into technically feasible dyeing and printing processes. Fanciful names are given to these trendsetting colors, such as "Wallstreet Green," "Tahitian Sunset," "Mountain Mauve," and "Barbarossa Brown." To help communicate the precise meanings of these names, color swatches and a color matching service are provided. Nevertheless, designers in certain industries—such as office furniture—maintain that they avoid specifying these "custom" colors because of color matching and production scheduling problems.

Although color trends quickly change, certain generalizations have been formulated about color preferences.

◀ 11.1 Crown Corning, Madison Avenue carafe Hues once associated only with fabrics and party goods are now well established in house-ware designs.

▲ **11.2** Bright colors such as hot pinks, once seen only in gaudy party paraphernalia, are now often used in designer luggage and backpacks to create the impression of fun rather than the reality of the difficulties of traveling and mountain climbing.

They are thought to revolve around the state of the economy. During recessions, those who can afford it surround themselves with luxurious fabrics, such as velvets and chiffons in rich colours, as an uplifting antidote to the mood of the times. In times of abundance, the balance in industrial countries tends to shift toward "naive" fabrics and colors. During the affluent 1960s, for instance, the all-white look and faded denim prevailed.

Another general expectation is that for every action there will be a reaction. Brilliant colors that glorified the limits of modern dyeing technology peaked in the late 1970s, followed by a reactionary preference for more subdued tones and a certain discretion in color combinations.

Nevertheless, freedom in commercial use of colors is probably here to stay. The days when cars came in only one color (black) and when a "color" telephone meant one in white or ivory are unlikely to return entirely. Designer colors now run to salmon and lavender office chairs, pink portable radios, tables of brilliant primary colors, and airplanes painted orange. Consumers have become accustomed to color in their kitchens as well as their living rooms, in combinations such as the blue and black of Crown Corning's carafe (**11.1**).

Backpacks were once available mostly in military khaki reflecting a sense of serious survival issues in the wilderness. But now they are now offered in gayer design hues that suggest to the consumer a sense of fun rather than the physical struggle involved in carrying a heavy pack while climbing a mountain (**11.2**).

Most magazines now include color as well as black-and-white photographs, newspapers are adding extra colored inks to basic black-and-white printing, and old black-and-white movies are being tinted for modern audiences.

Color Psychology

In addition to color trends, designers must be aware of innate psychological reactions to colors. As we found in Chapter 4, it is difficult not to generalize about the way hot colors affect us. But it is clear that warm colors tend

▲ **11.3 "Clearly Canadian" bottle** Beverages with just a faint hint of color in the liquid or the bottle give the consumers the impression that what they are drinking is as natural as water, and even more refreshing.

to stimulate, whereas cool colors have a calming influence. This information should be used thoughtfully. Research into the effect of colors in store interiors suggests that while red is alluringly striking and works well in drawing people into a good selling environment, warm colors, on the whole, may make people feel somewhat tense. Their effectiveness in promoting purchases inside stores could depend on whether the items are inexpensive, for quick impulse-buying, or whether they are costly purchases that require deliberation. If the latter, then cooler colors might encourage staying long enough to make a relaxed decision.

In packaging, the first goal is to catch the eye. Research indicates that consumers scan each package on a supermarket shelf for only 0.03 seconds. Thus the packaging must attract the customer to buy it, and the color should also help to convey an image of the contents. Considerable market research has been done about the effects of colors on buying habits, but most of it is closely guarded by the companies, who use it to get ahead of their competition. A survey of packaging design reveals that yellow, red, and orange are often effectively used to draw attention; purple is frequently associated with luxury products; blue suggests cleanliness and/or quietness; and green evokes an impression of nature. Gold, silver, and black effectively promise high quality

merchandise. They also suggest sophistication, a packaging lure, for example, for cigarette smokers.

Black is rarely used as a colorant for foods, because in the West it is associated with death. As Dr. Russell Ferstandig, a psychiatrist and marketing consultant, explains, "Color serves as a cue. It's a condensed message that has all sorts of meanings"[2]

Transparent, nearly clear colors in beverages convey to today's health-conscious affluent consumers the impression of drinking something as calorie-free and healthful as water. Sales are booming of bottled beverages stripped of color so that they have the appearance of lightly flavored water, perhaps with just a hint of hue in the packaging or liquid. In *Clearly Canadian* flavored water (**11.3**), with which this successful marketing trend began, the bottle is tinted pale blue to give the illusion of a natural spring, but the liquid is left clear as water, as shown in the glass alongside. "Clear says purity, and clear says refreshment," explains Jeffrey B. Hirsch, the marketing consultant who helped to develop "Crystal Pepsi."[3]

Combinations of warm and cool hues can be used symbolically to convey mixed messages. A package of laundry detergent printed in blue and red suggests aggressive cleaning action. In television advertising, colors can be juxtaposed in time as well as space. In the prize-winning Levi's television commercial shown in Figure **11.4**, everything is tinted blue, with a bit of yellow. The blues set a hip tone, further emphasized by the guitar music the men are playing. But all this blue creates a psychological longing for something else—the balance of the spectrum—which is finally satisfied by the small red trademark patch. It becomes the object of one's stimulated desires. Similarly, in the midst of bright colors so often used to draw attention, a "30-second seduction" where all colors are grays until the orange of orange juice is shown is highly effective in arousing desire for that product.

Designers of logos attempt to use colors alongside line and shape to establish corporate identity. Reds—which

▶ **11.4 Frames from a television commercial for Levi's jeans** In this sequence of colors, the predominant blues create a sense of incompleteness, which is resolved by the red of the Levi's logo.

Graphic Design

Graphic designers are not as bound by color trends as fashion and interior designers. Their mandate is to evolve fresh ideas in exciting and stimulating designs continually, and this includes exploring the whole range of colors and combinations. Nevertheless, graphic design does have its own special considerations. One, for instance, is where and how a design will be printed. A logo, for example, must be reproduced on a variety of surfaces. Deep blues and greens, and hot reds are often difficult to obtain because printing inks are transparent and must be applied in several layers to achieve these colors.

For budgetary reasons, graphic designers must often work with a limited palette—perhaps only one or two colors of flat-printed ink on a white or colored ground (if the latter, its hue will show through and alter the transparent inks). This limitation has led to great ingenuity to achieve the appearance of variety. Some common techniques are the use of percentage screens or half-tones for value gradations, overlapping color blends and REVERSES (in which images or typography appear in the ground color, surrounded by ink, rather than the other way around). Milton Glaser's novel cover (**11.5**) uses black and green ink on white stock, with the green ground printed first, the black printed over it for the typography and the dark areas of the half-tone figure, and a reverse for the title and cook's head and hat. This use of colors accentuates the white, which is responsible for conveying the essentials of the message. For a reverse to be effective, the ink surrounding the ground must be dark enough for the ground color to show up well by contrast. If you look back at Figure 7.18, you will see that the white ground of the reversed percentage figures soon begins to blend optically with the colored inks along the sides as the screens become lighter.

Single colors develop subtle tones when used in small amounts—such as blocks of type—across a broader area. Blocks of black letters on white paper tend to produce an overall gray effect that is best judged by squinting at the area to catch its tone rather than reading the words. You can perhaps see this tone by squinting at a page of this book, and then comparing it with the pages from other books or magazines. Typefaces with thicker lines

▲ **11.5 Milton Glaser, novel cover** Reverses—used for the white areas of this cover—are used to vary the possibilities when a graphic designer is limited to only a few ink colors.

seem to suggest a certain assertiveness and activity, as the red in the Levi's logo—are still the going favorites. However, new entries in this field include bright yellows, oranges, and purples. Banks, on the other hand, are said to prefer reds, blues, and violets. In all graphic arts, the designer's ideas are restricted by the client's requirements.

produce different tones of gray than small, fine-lined print; large, bold headlines may retain a black and white contrast rather than being seen as a gray tone. Ink colors other than black will tone the paper in the same way. These tones should be examined and worked with thoughtfully as part of the composition.

In multicolored, two-dimensional graphic design, colors have strong effects on each other because they exist side by side on the same plane. Vigorous contrasts are optically interesting but may tire the eye; customers may prefer something that does not vibrate when they look at it. One way of capitalizing on the liveliness of hue contrast without overstimulating the eye, as we saw in Chapter 9, is to separate color areas with a line of white, black, or some other neutral color. David Lance Goines has tied the shapes and colors of his Asilomar poster (**11.6**) together by wrapping a gold line around everything, but he has also added just enough of a black line beyond it to keep the gold from clashing with the other colors.

▲ **11.6 David Lance Goines, *Asilomar,* 1978** Poster, 18 x 24ins (45.7 x 60.9cm).
A line of neutral brown, gray, black, or white is often used to soften the contrasts between adjacent color areas.

Interior Design

In interior design, in addition to the client's color preferences, suspected psychological effects of colors, color fashions, and aesthetic workability, there are also certain practical considerations for color choices in furnishings, flat surfaces, and lighting. Traditionally, interior designers were taught standard color harmonies (see Chapter 9) and cautioned that: 1) Floors should be relatively low in value and saturation so they would hide soil and provide an optically firm base; 2) Walls should be rather light and neutral in hue to provide a value gradation from floor to ceiling and to avoid clashes with the colors of paintings and furniture; 3) Ceilings should be very light in value to give a sense of spaciousness and reflect lighting well.

These limitations have not inhibited the imagination of contemporary designers, however. They combine any colors they choose, so long as they can make them work. New ease of upkeep in floor-finishes has led to widespread use of high-value flooring. Similarly, dark walls and ceilings are now often used to create a cozy atmosphere. As for acceptable harmonies, consider the striking combination of hot pink and yellow in the Emmanuel Chapel of Corpus Christi Cathedral (**11.7**). Like the gem-colored lights entering Gothic cathedrals through stained-glass windows, these high-keyed, high-value colors create an inspiring color environment. The hue and strength of the lighting is carefully coordinated to harmonize with the altarpiece, rug, wall and ceiling paint, and wooden furniture and framing.

Color choices for interiors should be made under the lighting in which the materials will be seen. Lighting is equally important in other arts, but only in interior

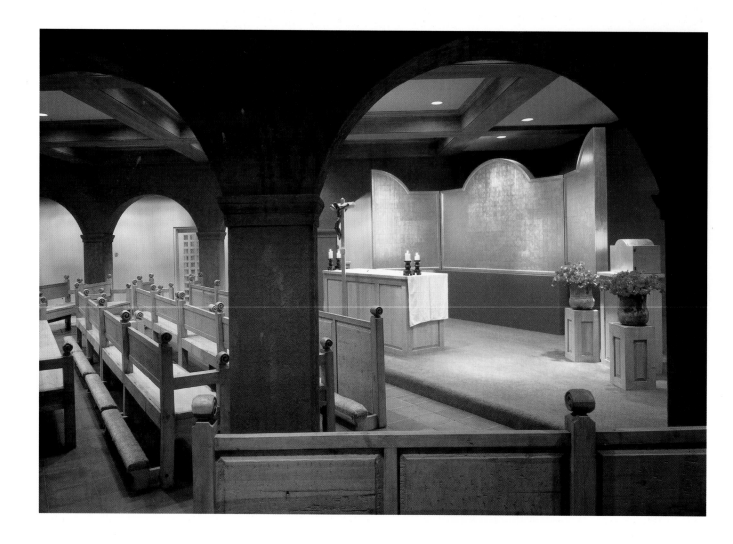

▲ 11.7 Emmanuel Chapel, Corpus Christi Cathedral
Even church interiors may be the subject of contemporary color experimentation.

designs is the type of lighting known in advance. A cool fluorescent light will emphasize blue-purple, blue, blue-green, and green but produce disastrous results in the warmer hues; warm fluorescent lights enhance the yellows, oranges, reds, and red-purples but do not show cool colors to best advantage. Incandescent light gives everything a somewhat reddish tint. Full-spectrum fluorescent lighting attempts to simulate sunlight. An alternative is to use both warm and cool fluorescent lights for color balance. In some cases, however, balance is not desired. The General Electric Company suggests use of cool white fluorescent lights alone for banks, to create a sedate mood that implies stability of the institution, and warm fluorescents for displays of baked goods, upon

which a bluish tint would be highly unappetizing.

Seen in large amounts, colors seem far more saturated than they do on small paint chips or fabric swatches. Earlier this century, Western interior designers were told that bright colors should be reserved for small accents, with large areas reserved for subdued tones. If one truly wants a quiet, subdued effect, it is often wise to choose colors from samples that are more toned down than the

11.8 Ndebele house, South Africa The strong sunlight of equatorial environments tends to wash out colors visually at midday, so brilliant colors may be used in clothing and architecture that would seem garish in cloudier climates.

final result one envisions. The standard measurement tool for color selections and relationships in interior design is the Munsell Color Atlas. It consists of 1500 detachable samples, in both glossy and matte finishes. Better still, large swatches of fabric or painted areas should be sampled in the area in question, with all colors to be used together present.

In contrast to the earlier insistence on quiet color schemes for interiors, many contemporary designers are using large areas of bright colors for certain applications, as in Rufino Tamayo's living room (9.7) and the Emmanuel Chapel (11.7). Strong colors can be invigorating, and some human environments are thought to benefit from their use. As we saw in Chapter 4, bright colors encourage activity and mental alertness, and are therefore increasingly used in interiors of schools and offices. Again, just as with quieter color harmonies, bright colors should be seen in samples large enough to judge the final effect, with particular attention to interactions between colors. Seen against backgrounds of a different hue than the white or gray of color samples, they may appear quite different. Often a range of potential colors are painted on

a wall before final choices are made. Allowance should also be made for the fact that colors affect our sense of space. Highly saturated and warm colors make things look larger and closer; bright red walls or furniture would therefore have the overall effect of making a room itself appear smaller, for they would intrude optically into the space more than, say, pale blue walls or furniture.

Architecture

The lighting across the outsides of buildings changes continually. Exterior colors are therefore dynamic, and their appearance depends partly on the local climate and relationships to the sun. Under a bright tropical sun, bright colors tends to wash out visually, especially at midday, so very strong colors may be used without an overwhelming effect. The brilliantly contrasting synthetic pigments used by Ndebele women of South Africa to decorate architectural details, such as the house entrance in Figure **11.8**, are powerful enough to retain their excite-

◀ **11.9 The Masjid-i-Shah mosque at Isfah, Iran, Safavid period (1612)** Cool colors are a welcome visual oasis in hot desert environments. Lustrous finishes on tiles gleam near-white when reflecting the brilliant sunlight.

▲ **11.10 Frank Lloyd Wright, Taliesin West, Arizona** Wright, the apostle of "Organic Architecture," worked with the colors of the earth.

ment even under the naturally brilliant lighting conditions.

In areas further from the equator with less direct, and also less frequent sunlight—such as often overcast parts of Europe—colors appear more brilliant. Hues of walls and roofs will also affect absorption of solar energy. Hot climates often necessitate white walls and roofs to reflect heat away from the interior; darker walls and roofs will help warm a building in a cold climate. Even darker values may give a cooling visual impression if they are from the cooler range of hues, such as the blues used in the magnificent tilework of Muslim mosques. To the desert nomads living in a hot sand-colored environment, the

cool blues and greens were a refreshing foretaste of a heavenly paradise. Lustrous finishes were created by applying and firing metal oxides on the surface of initially glazed and fired tiles. This effect reflected highlights which visually raised the value of the hues to near-white (**11.9**).

In addition to the geographical and climatic considerations unique to architecture, aesthetic concerns also come into play. Throughout time and space, there have been two major directions in exteriors: use of the colors of nature or of the materials themselves, or use of applied colors. The latter has been common throughout history. The exteriors of great public buildings of ancient South

and Central America, Greece, Egypt, the Middle East and the Far East were often richly colored with applied paints and tiles. The conservative, no-color approach to exteriors entered Western history with the Protestant Reformation, when ostentatiousness was declared vulgar and inappropriate for spirituality. This sparse aesthetic culminated in twentieth-century International Style architecture which celebrated the integrity of unadorned modern building materials—raw concrete, glass, and steel.

Frank Lloyd Wright led one reaction to this trend, denouncing vivid chromatic hues as the province of "interior desecrators" and honoring the earthy colors of nature, in an attempt to make buildings blend with the land. He worked with the warm colors of wood and local rock, and eschewed paint, using only a sand-finish coating or a terracotta red, the color of clay, when necessary. His famous Arizona home, *Taliesin West* (**11.10**) is a monument to his "Organic Architecture".

A very different reaction to the International Style is manifested in the eccentricities of what is called "Postmodern" architecture. No one style predominates, but versions range from the romantic to the playful, and often involve explorations back into the world of applied exterior color. Perhaps the most infamous and eccentric of Postmodern buildings is the Pompidou Center for modern arts, designed by Renzo Piano and Richard Rogers (**11.11**). It strikes a brilliant contrast to the sober hues of historic Paris, flaunting its exposed air-conditioning, electrical, water, and elevator equipment, color-coded in blue, yellow, green, and red respectively. These colors, which mimic those used for industrial safety classifications, are intended to make the machinery of the building easily recognized and fun to see. Whereas ancient temples featured painted statues of the gods, in this building the gods of the machine age are given top billing.

◀ **11.11 Renzo Piano and Richard Rogers, Pompidou Center, Paris (detail), 1971–78** Industrial color-coding provides a brilliant exterior color scheme for the controversial—and highly popular—Pompidou Center.

Landscape Design

In landscaping, designers work with all the colors of natural foliage: coppery reds, purple-greens, blue-greens, and yellow-greens, plus the blazing yellows, oranges, and reds of fall in some temperate areas. For the most part, greens predominate. To enliven the schemes produced by the hues of leaves, flowering plants and shrubs are often introduced. They yield displays that change with the seasons and whose shifting harmonies must be carefully anticipated. Springtime at Exbury Gardens in England (**11.12**) brings out the magnificent blossoms of over a million species of rhododendrons and azaleas. They were collected in the mountains of China and the Himalayas, where their colors cloaked the hillsides, and bred by Lionel de Rothschild, ever in search of pure and beautiful colors.

Landscape designers work with color on many planes, planning effects that change through time and space as one walks through the garden. Within a single impression, for example, there may be large areas of relatively low saturation, accented with brighter hues in smaller quantity. Some plantings have a filmy color atmosphere, such as a field of heather, while others have the intensity of a few red tulips seen against duller greens. Jarring color contrasts may be broken up by intermediate plantings of white flowers or non-flowering foliage plants. Close color harmonies among flowers, such as the many reds in Exbury Gardens, or analogous purple and blue, are usually pleasing and are automatically varied by their juxtaposition to foliage hues. Gray-leafed foliage plants, such as artemisia, help to bring out the vitality in neighboring soft-colored flowers.

Foliage may also provide a compositional framework for the design. Leaf and trunk colors and textures suggest visual weights, with dark, massed colors appearing heavier, and paler, more openareas appearing lighter. In a naturalistic planting, such as the Exbury Gardens, these weights may be distributed throughout, rather than arranged in rigid hierarchies; nevertheless visually heavy weights at the base will give the whole scheme a sense of being firmly anchored.

Planting will also affect spatial illusions within a garden. Highly saturated and warm colors will seem close;

▲ **11.12 Lionel De Rothschild, Exbury Gardens, Hampshire, England** In this corner of the gardens, a mono-chromatic color scheme unites the varying reds of rhododendrons, but they are in complementary contrast to the many greens of the foliage.

▶ **11.13** (Right top) **Philip Moulthrop, wooden bowl** Tulip poplar, 14ins high x 19ins wide (35.5 x 48.2cm).

▶ **11.14 Emile Gallé,** *La Nature*, *c.* **1900** Internally decorated glass bowl, height 5¹/₂ins (14.5cm).
Gallé developed a wide range of glass colors, many of them unnameable, relatively unsaturated hues.

cool, less saturated colors will seem further away. If bright colors are placed in the foreground, with cool colors and less hue contrast in the distance, perspective will be stretched, increasing the apparent size of the area. A garden entirely in warm, bright colors will seem small.

Crafts

Natural materials, the media of the landscape designer, also form the basis for most crafts. In handmade functional items, today's aesthetic tends to honor the earthy, unsaturated hues of nature. Woods, for example, are often left unpainted to expose their natural beauty. Wood with rich or interesting coloration is prized for color

effects such as those in Philip Moulthrop's bowl (**11.13**). Fine sanding and glossy finishes heighten the saturation of these natural colors.

Even when brighter colors could readily be used, craftspeople may intentionally select a subdued palette. Although earlier artists had developed ways of staining glass in the brilliant, jewel-like hues seen in Gothic cathedral windows, for instance, the great nineteenth-century glassmaker Emile Gallé often used less saturated colors. Those in his *La Nature* (**11.14**) suggests a mystical communion with the elements, with colors softly suffused with the light shining through them.

Fiber arts often reveal a similar reverence for hues of low saturation in subtle harmonies. Even bright hues will tend to dull when used in thin interwoven lines rather than larger shapes. However, modern dyeing techniques and fibers allow fiber artists to work the whole range of colors. In fact, one of the artist's greatest difficulties is being selective when faced with a store full of beautiful colors. Fortunate in having a special arrangement with a yarn company, Jacquelyn Roesch-Sánchez does not have to restrain her appreciation of all the colors of the rainbow. Her workroom is filled with over 3000 colors of rayon yarns. As she begins a garment, she selects from this enormous palette ten to twenty-five colors that appeal to her and then experiments with sample combinations on her knitting machine. Subtle gradations from one to the next lead to pieces such as her *Autumn Glory*

▲ **11.15 Jacquelyn Roesch-Sánchez, Autumn Glory kimono**
Machine-knit rayon.
By some traditional standards, this color scheme should not work—but it does.

kimono (**11.15**). It stands as our final testimony to the excitement and limitless potential of color in the hands of the artist.

Notes

Chapter 2

1 Sir Isaac Newton, *Opticks*, 4th edition. MDCCXXX. Reprinted by McGraw-Hill Book Co., New York, 1931, p.156

Chapter 3

1 Edwin H. Land, "The Retinex Theory of Color Vision," *Scientific American*, December 1977, p. 108

2 Claude Monet, conversation with W.G.C. Byvanck, quoted in Robert Gordon and Andrew Forge, *Monet*, New York: Harry N. Abrams Inc., 1983, p.163

3 Louis Kahn, quoted in John Lobell, *Between Silence and Light: Spirit in the Architecture of Louis I. Kahn*, Boston: Shambhala Publications Inc., 1979, pp. 6, 22

4 Mark Rothko, quoted in Bonnie Clearwater, "How Rothko Looked at Rothko," *ARTnews*, November 1985, p. 102

5 Scriabin, quoted in Kenneth Peacock, "Synesthetic Perception: Alexander Scriabin's Color Hearing," *Music Perception*, Summer 1985, (vol 2, no.4), p. 483

6 Scriabin, quoted in Corinne Dunklee Heline, *Healing and Regeneration through Color*, Santa Barbara, California: J. F. Rowny Press, 1944, p. 21

7 Wassily Kandinsky, *Concerning the Spiritual in Art*, New York: Dover Publications Inc., 1977; London: Constable & Co Ltd, 1977, p. 25 (originally published in 1914 as *The Art of Spiritual Harmony*).

Chapter 4

1 Chris, quoted in Harry Wohlfarth and Catherine Sam, "The Effects of Color Psychodynamic Environment Modification upon Psycho-physiological and Behavioral Reactions of Severely Handicapped Children," *International Journal of Biosocial Research*, 1982 (vol. 3, no. 1), p. 31

Chapter 5

1 Gene Davis, interview with Walter Hopps, in *Gene Davis*, Donald Wall, ed., New York: Praeger Publishers, 1975, pp. 117–118

2 Mark Rothko and Adolf Gottlieb, 1943, quoted in Howard Hibbard, *The Metropolitan Museum of Art*, New York: Harper and Row, Publishers Inc., 1980, p. 517

3 Leonardo da Vinci, *The Notebooks of Leonardo da Vinci*, Pamela Taylor, ed., New York: The New American Library Inc., 1970; London: Cape Ltd, 1977, p. 36

4 Gene Davis, op. cit., pp.119–20

Chapter 6

1 Aristotle, *De Coloribus*, quoted in Faber Birren, *History of Color in Painting*, New York; London: Van Nostrand Reinhold Company Inc., 1965, p. 16

2 Leonardo da Vinci, op. cit., p. 38; and in Faber Birren, op. cit., p. 79

3 Ibid.

4 Newton, op. cit., pp. 156–157

5 Johann Wolfgang von Goethe, *Theory of Colors*, trans. Charles Lock Eastlake, Cambridge. Mass: The MIT Press. 1970, pp. 34–35

6 Johannes Itten, *The Elements of Color*. English ed., New York: Van Nostrand Reinhold Company Inc., 1970, p. 66, (originally published in 1961 as *Kunst der Farbe*)

7 M.E. Chevreul, *The Principles of Harmony and Contrast of Colors*, 1839, quoted in Faber Birren, *Principles of Color*, New York; London: Van Nostrand Reinhold Company Inc., 1973, p. 163

8 Ogden N. Rood, *Modern Chromatics*, 1879. Facsimile edition, New York: Van Nostrand Reinhold Company Inc., 1973, p. 163

9 Ibid., p. 219

10 Roland Rood, *The Scrip*, April 1906, quoted in Rood, op. cit., p.28

11 Paul Klee, quoted in *Color*, London: Marshall Editions Ltd., 1980, p.95

Chapter 7

1 Dale Chihuly, quoted in Margaret Moorman, "Venetians, Persians, and

Niijima Floats," *ARTnews*, April 1993, pp. 11–12

Chapter 8

1 Douglas Kirkland, quoted in Lynda Weinman, "Celebrity Makeovers in Photoshop," *Step-by-Step Graphics*, 1993, (vol. 9, no. 4) p. 36
2 Herbert W. Franke, "Computer Graphics/Computer Film Metamorphoses," in Igildo G. Biesele, Experiment Design, Zurich: ABC Verlag, 1986, p. 54

Chapter 9

1 Deborah Muirhead, personal communication, November 1993
2 Goethe, op. cit., p. 319
3 Rufino Tamayo, in Roger Toll, "An Artist's Mexico," *House and Garden*, November 1985, p. 150
4 J. M. W. Turner, Lecture V, 181, in John Gage, *Color in Turner*, New York: Praeger Publishers, 1969, p. 208
5 M. E. Chevreul, *The Laws of Contrast of Color*, trans. John Spanton, London: Routledge, Warner, and Routledge, 1859, p. 48

6 Goethe, op. cit., p. 317
7 Josef Albers, in *Albers: Josef Albers at the Metropolitan Museum of Art*, undated, unpaginated exhibit catalog.
8 Rood, op. cit., p. 231
9 Paul Signac. "The Color Contributions of Delacroix, the Impressionists, and the Neoimpressionists," Paris, 1899. Quoted in *Artists on Art*, Robert Goldwater and Marco Treves, eds., third edition, New York: Pantheon Books Inc., (originally published 1945): J. Murray Ltd. 1976, p. 378
10 Arthur Hoener, personal communication. November 1987

Chapter 10

1 Cited in Birren, *History of Color in Painting*, op. cit., p. 238
2 Ibid., p. 83
3 Claude Monet, 1889 letter to a young American artist, in Hugh Honour and John Fleming, *The Visual Arts: A History*, second edition, New York: Prentice-Hall Inc., 1986, p. 547
4 Paul Gauguin, in Helen Gardner, *Art*

through the Ages, seventh edition. New York: Harcourt Brace Jovanovich Inc., 1976. p. 788
5 Paul Gauguin, 1885 letter quoted in Rene Huyghe, *Gauguin*, New York: Crown Publishers Inc., 1959, p. 39
6 Helen Frankenthaler, in Barbara Rose. *Frankenthaler*, New York: Harry N. Abrams Inc., 1970, pp. 61–2
7 Mary Billingsley, personal communication, November 23, 1987
8 David Em, *The Art of David Em*, by O. David Ross and David Em, New York: Harry N. Abrams Inc.

Chapter 11

1 Ed. Newman. "Color in Textiles." *American Fashion and Fabric* magazine, September/October 1986, p. 53
2 Dr. Russell Ferstandig, quoted in Trish Hall, "The Quest for Colors that Make Lips Smack," *New York Times*, November 4, 1992, p. C1
3 Jeffrey B. Hirsch, quoted in Trish Hall, ibid.

Credits

The authors, the publishers, and Calmann & King wish to thank the artists, museums, collectors, and other owners who have kindly allowed works to be reproduced in this book. In general, museums have supplied their own photographs; other sources, photographers, and copyright holders are listed here.

1.1 © Jules Olitski/DACS, London/VAGA, New York 1994; gift of Mr and Mrs Eugene M. Schwartz; photograph by Lynton Gardner. **1.2** Gift of Mr and Mrs Eugene M. Schwartz. **2.2** From *Webster's Third International Dictionary of the English Language,* Springfield, MA: Merriam 1976. **2.7** from Heinz-Otto Peitgen and Peter H. Richter, *The Beauty of Fractals*, Berlin: Springer Verlag. **2.8** Artwork by David Kemp. **2.11** Alfred Stieglitz Collection, 1969. Photograph by Malcolm Varon. **2.13** From Binney and Smith, "How to Mix and Use Color with the Liquitex Acrylic and Oil Color Map," Easton, PA. **3.4** © DACS 1994; from "Interaction of Color," New Haven, CT: Yale University Press. **3.6** John Theodore Deifert IV. **3.7** © Richard Anuszkiewicz/DACS, London/VAGA, New York 1994; photograph by Geoffrey Clements, New York. **3.8** Photograph by M. Routier/Studio Lourmel, Paris. **3.9** Service Photographique de la Réunion des Musées Nationaux. **3.10** Kimbell Art Museum; photograph by Michael Bodycomb. **3.11** © 1986 House and Garden, New York. **4.2** Photograph by David Glomb. **4.4** © Hamlyn; photograph by Michael Holford. **4.5** Commissioned by the Museum of Contemporary Art, Los Angeles, for the exhibition "Individuals: A Selected History of Contemporary Art, 1945–1986;" photograph by Squidds and Nunns. **4.7** Photograph by Hickey and Robertson. **4.8** Eben Ostby: modeling, rendering, design, and textures; Bill Reeves: modeling, rendering, design, and lighting; © 1987 Pixar. **5.1** Photograph courtesy of the artist and the Fabian Walter Gallery, Basle, Switzerland. **5.3** Tyne and Wear Museums Service, Great Britain. **5.5** The Overlook Press, New York. **5.7** © King Features Syndicate. **5.9** Thames and Hudson Ltd, London. **6.8** From Johannes Itten, "The Elements of Color," © Otto-Maier Verlag, Ravensburg, Germany. **6.10** © Tintometer Ltd. **6.11** From *A Color Notation,* 2nd edition, Boston: George H. Ellis Co.; photograph by Beverly Dickinson. **7.8, 7.10, 7.11** Binney and Smith, op. cit. **7.13** Glenn C. Nelson. **7.14** From Susan Petersen, *The Craft and Art of Clay*, Englewood Cliffs, NJ: Prentice Hall, 1992. **7.15** Photograph by Claire Garoutte. **7.18** Hennegan, Cincinatti, OH. **7.19, 7.20** Pantone Inc., Moonachie, NJ. **7.23** Reproduced from *The Color Index*, 3rd edition, Pigments and Solvent Dyes volume, published in 1982 jointly by the Society of Dyers and Colorists. **7.24** Photograph by Beverly Dickinson. **7.25** Caron International/Heirloom. **7.26** Photograph by Mary Pat Fisher. **8.3** J. Baker Collection. **8.5** *Macweek*, San Francisco, CA. **8.7** Photograph by Douglas Kirkland. **8.8, 8.11** Photographs by Frank Noelker. **8.9** Courtesy of Tektronics, Marlow, Great Britain. **8.10** From Igildo G. Biesele, *Experimental Design*, Zurich, Switzerland: ABC Verlag. **8.12** University of Iowa. **8.13** Courtesy of Holo-Service, Basle, Switzerland. **9.1** Photograph by Frank Noelker. **9.2** Photograph by Richard Stoner. **9.3** Photograph by Jannes Linder from the exhibition, "Century '87: Today's Art Face to Face with Amsterdam's Past," August 7th to September 14th 1987. **9.6** Photograph by Steven Sloman, New York. **9.8** © Allen Carter **9.13** J. Baker Collection. **9.14** Metropolitan Life Foundation Purchase Grant. **9.15** © Jasper Johns/DACS, London/VAGA, New York 1994. **9.16, 9.18** Noemi Zelanski. **9.17** Artwork by David Kemp. **9.19, 9.20** © DACS 1994: photographs by Beverly Dickinson. **9.21** Photograph by David M. Thum. **9.22** Photograph by David Caras. **9.23, 9.25** Photographs by Liz Dowling. **9.26** David Carritt Ltd, London. **10.2** Artwork by David Kemp. **10.3** Photograph by Stephen S. Myers. **10.5** Photograph by Mary Pat Fisher. **10.9** © Photograph courtesy of Vatican Museums. **10.13** Gift of the Potter Palmer family. **10.16** © DACS 1994. **10.17** © DACS 1994; photograph © 1980 Buffalo Fine Arts Academy. **10.18** © DACS 1994; Advisory Committee Fund (MOMA). **10.19** Photograph by Mali Olatunji. **10.23** Collection British Council. **10.26** Alan J Kegler, University at Buffalo, New York. **10.27** Photograph courtesy Ricco/Maresca Gallery, New York. **11.1** Crown Corning. **11.2** J. Baker Collection; products courtesy of Baldocks, East Grinstead, Great Britain. **11.3** Photograph by Frank Noelker. **11.4** Leslie Caldwell/Bernie Guild, art directors; Mike Koelker, writer/creative director; Steve Neely, producer; Leslie Dektor, director; Peterman/Dektor, production company; Foote, Cone Belding (San Francisco), agency; Levi Strauss and Co., client. **11.5** Milton Glaser and The Overlook Press, New York. **11.7** Michael Tracy, designer; James Rome, architect; photograph by Hickey and Robertson. **11.8** Photograph by M. Courtney-Clarke. **11.9** Sonia Halliday Photographs. **11.10** Photograph by Adam Bartos. **11.11** Photograph by John Foley. **11.12** Photograph by Mick Hales. **11.13** Philip Moulthrop. **11.15** Photograph by Bob Hanson, model Wendy Townsend. The authors and publishers would also like to thank Tim Imrie for his photography.

Glossary

Where a definition includes a term that is itself defined elsewhere in the Glossary, that word is printed in italics.

addititive colors Colors made by lights which, when mixed, become lighter in *value*.

aerial perspective The tendency of forms seen at a great distance through a hazy atmosphere to blur toward uniformity in *hue* and *value*, with no sharp distinctions between colors or edges. In many atmospheres, everything will take on a blue cast.

after-image The illusion of color and shape produced in the visual apparatus after staring at a strong color for some time. A positive after-image is the same color as the original; a negative after-image is its complement. See *successive contrast*.

analogous hues Those lying next to each other on a *color wheel*.

aniline dyes A family of colorants synthesized from coal-tar, including blue-reds, black, greens, and reds.

azo dyes A large family of colorfast, highly saturated, synthetic colorants developed from petroleum.

Bezold Effect The possibility of changing a design considerably by simply changing one of its colors; discovered by rugmaker Wilhelm von Bezold in the nineteenth century.

broken color Layers of different colors applied to a painting so that they show through each other as opposed to being physically blended on the canvas or mixed on the palette.

chiaroscuro The use of light and shadow effects in a painting.

chromatic hue Any color other than black, grays, and white

chromaticity In lights, a measure of the combination of *hue* and *saturation* in a color.

Chromaticity Diagram The plotting of *hue* and *saturation* coordinates on a two-dimensional grid.

chrominance In television, a signal indicating both *hue* and *saturation*.

chromotherapy The use of colored lights for healing purposes.

CMYK The four-color screen system (cyan, magenta, yellow, and black) commonly used in reproducing color photographs.

coherent light Theoretically, light in which the waves are all of the same length and in unchanging relationship to each other, as approximated by a laser beam.

collage A two-dimensional work of art in which *found objects* are glued to a flat surface.

color constancy The psychological tendency to see colors as we think they are rather than as we actually perceive them.

Color-Field painting A style originating from the mid-twentieth-century New York School featuring large, nonobjective areas of color.

color negative process In color print photography, the activation of dyes in the film to release colors that are complementary to those in the original scene. A positive print in the original colors is then created from this negative.

color positive (reversal) process In the creation of color transparencies, a series of steps which culminates in the release of magenta, cyan, and yellow dyes in the film's three layers. These mix to form the colors of the original when the developed film is seen in the light.

color separations In printing, colored images are broken down into screens of certain primaries (in a *four-color process*, they are magenta, cyan, yellow, and black) which when superimposed, and printed, will yield an approximation of the original colors.

color wheel A circular, two-dimensional model showing color relationships, originating from Sir Isaac Newton's bending of the straight array of *spectral hues* into a circle.

colorimeter A computerized instrument that measures the amount of power in each *wavelength* in a light source. See *specrophotometer*.

complementary hues Colors that lie opposite each other on a *color wheel*. When placed side by side they will intensify each other visually: when

mixed as *pigments* they will dull each other.

cones Special cells in the *retina* at the back of the eye which enable us to distinguish hues in daylight.

continuous tone In printing, referring to any image with a range of gradually changing values.

critical color matching The precise mixing of *pigments* or ink dyes to match a given sample.

direct dyeing Coloring of materials by immersion in water with water-soluble dyes.

dispersed dye A material colorant that is not water-soluble but can be applied in a soap solution.

dithering Juxtaposition of dots of different colors in computer printing to produce optical color mixtures.

Divisionism The juxtaposition of tiny dots of unmixed paints, giving an overall effect of color when mixed optically by the viewer's eye from a distance: usually associated with the Postimpressionists. See *pointillism*.

dominant wavelength In light mixtures, another term for *hue*.

double complementary A color combination in which hues adjacent to each other on the *color wheel* are used with their respective *complementaries*. See *split complementary*.

dye Coloring material dissolved in a liquid solvent.

dye sublimation Computer printing technology similar to *thermal transfer*, but with variations in the amount of heat applied to produce varying colors.

expressionistic color Colors chosen for their emotional impact rather than their fidelity to "standard" colors perceived in the external world.

flat (match) color In printing, the use of solid areas of unbroken color, often specified by a numerical system such as PMS (Pantone Matching System). See *four-color process*.

found object An object presented as a work of art or forming part of one, which was not initially intended for artistic purposes.

four-color process In printing, a technique for reproducing colored images by separating them into the primaries magenta, cyan, yellow, and black and printing each color from a separate plate. See *color separation*.

fresco A wall painting in which pigments are ground in water and stroked onto fresh plaster; when the plaster dries, the pigments form part of the surface itself.

fritted glaze A ceramic *glaze* that includes finely ground bits of water-soluble chemicals, which have been made insoluble by melting and shattering; such glazes are noted for their clear colors.

glaze In oil painting, a transparent film of color painted over another layer of color. In ceramics, a glass-like coating of silicates that melts and fuses to the clay when it is fired.

Hard-edged painting A painting with precise boundaries between non-objective colored areas, characteristic of some mid-twentieth-century work.

hologram A two-dimensional image that appears three-dimensional, created from waves of light or other energy forms which develop interference patterns when deflected off a three-dimensional object.

HSB Hue, saturation, and brightness—the variables in color specified in television technologies.

hue The color quality identified by color names, such as "red" and "blue." This is determined by the color's *wavelength*.

integral trippack the common format for today's photographic film, in which three thin layers of gelatin containing chemicals that are sensitive to blue, green, or red lights are sandwiched together.

iodopsins Light-sensitive *pigments* in the *cones* of the eyes, thought to be somehow involved in our ability to distinguish *hues*.

lakes *Pigments* that are made from *dyes*.

limited palette The use of relatively few colors in a work of art.

local color The color sensation received from a nearby object under average lighting conditions.

luminance The degree of lightness or darkness in light mixtures, corresponding to *value* in *pigments*.

monochromatic Referring to a color combination based on variations in *value* and *saturation* of a single hue, perhaps with the addition of some *neutral* colors.

mordant In fabric dyeing, a fixative.

nanometer One billionth of a meter, used in measuring *wavelengths* of light.

neutral A black, white, or gray—one of the nonchromatic hues.

open palette The use of a wide range of colors in a work of art.

Opponent Theory A model that accounts for color vision by means of hypothetical pairs of receptors responding to opposing colors; if they respond to one, its opposite is inhibited.

phantom colors Colors that spread beyond their physical boundaries causing illusory color sensations on adjacent neutral surfaces.

phosphors On the back of a television screen, tiny dots of blue, green, and red fluorescing powder, which radiate light when struck by an electron signal.

pigment Powdered coloring material used to give *hues* to paints and inks.

pixel In computer graphics, one of many tiny points on the computer screen determined by intersections of x and y axes.

Pointillism A technique in painting whereby dots of pure *hues* are placed close together on a white ground to coax the viewer's eye to mix them optically. (*Divisionism* is a similar technique, but without the white ground showing.)

polychromatic Multicolored.

posterization In photography, a developing process in which continuous tone images are converted into flat areas of any colors.

primary colors Those *hues* from which all others can theoretically be mixed; in *refracted colors*, red, green, and blue; in *reflected colors*, red, yellow, and blue.

principal hues Albert Munsell's term

for the five pigment primaries used in his color model (green, blue, purple, red, and yellow).

purity In *video*, another word for *saturation*.

reactive dye A colorant that bonds chemically with the fiber.

reflected color Color seen when light is reflected from a *pigmented* surface.

refracted color Color resulting from passing light through a prism, breaking it down into its constituent *wavelengths*

retina The inner surface of the back of the eye, where *rods* and *cones* respond to qualities of light.

reverse In graphic design, designation of shapes or letters that will not be printed with ink but remain the color of the paper, as a negative of the positive image provided.

RGB Red, green, and blue – the additive primaries used in color television.

rhodopsin Visual purple, a light-sensitive *pigment* in the *rods* of the retina.

rods Light-sensitive cells in the eye that operate in dim light to distinguish *values*.

saturation The relative purity of a color, also called intensity.

screen In printing, a dot pattern used to create the impression of a certain *value*.

secondary colors *Hues* made by mixing two *primary colors*.

sfumato Softly graded tones in an oil painting, giving a hazy atmospheric effect, highly developed in the work of Leonardo da Vinci.

shading In Ostwald's model, the color change that results when one adds black and decreases the percentage of the original *hue*.

shadow mask In common television sets, a metal grid with tiny holes lying opposite triads of *phosphors*, used to focus electron beams directly on the phosphors.

simultaneous contrast In general, the optical effect of adjacent colors on each other; more specifically, the tendency of complementary colors to intensify each other when placed side by side

solarization A special photographic development effect in which development includes brief exposure to low-intensity colored light, thus reversing colors.

spectral hues Those colors seen in a rainbow, or in the spectrum created when white light passes through a prism.

Spectral Sensitivity Curve A graphic representation of the degree of brightness perceived by the human eye in lights of different *wavelengths*.

spectrophotometer a machine used to measure properties of energy in each part the spectrum in a sample of light or a *pigmented* surface. See *colorimeter*.

split complementary A color combination whereby a hue is used with the hues lying to either side of its direct *complementary*. See *double complementary*.

subtractive color mixing Combination of *pigments*, which result in darkened mixtures.

successive contrast The color phenomena observed when differently colored areas are viewed one after another, as in looking at a white area after staring at a red one. If the initial image is highly saturated, its complement may seem to appear in the second area. See *after-image*.

synergistic color mixing Allowing the energies of certain *hues* to combine optically on a *neutral* ground color.

synesthesia The ability to gather sense perceptions from perceptual systems not usually associated with them, such as hearing colors.

tertiary colors The colors created by mixing a *primary* and an adjacent *secondary*.

thermal transfer A computer-based printing technology in which small dots of cyan, magenta, yellow, and black ink are fused by heat to paper.

tinting In Oswald's model of color relationship, the effect of adding white and decreasing the percentage of the original *hue*.

toning In Oswald's system, the effect of adding both black and white and decreasing the percentage of the original *hue*.

transparency effect The painted illustration that one film of color is lying over another color.

triadic color scheme The use of three colors equally spaced from each other on a *color wheel*.

triadic color system An early-twentieth-century rule that there should be equal proportions of "sunlight" and "shadow" *hues* in a painting.

Trichromatic Theory The idea that there are basically three kinds of *cones* in the human eye: red-sensitive, green-sensitive, and blue-sensitive.

value The degree of lightness or darkness in a color.

vat dye A colorant that does not give the desired *hue* in a fiber until a second influence has been added, such as exposure to sunlight or an acid solution.

video Electronic light signals recorded from images and then displayed on a television monitor.

visible spectrum The range of *wavelengths* seen by the human eye.

wavelength The distance from crest to crest in a wave of energy.

Weber-Fechner Law The observation that to mix visually equal steps in *value*, one must mix geometrically increasing proportions of black or white.

Index